W9-CNP-809

ACTIVISION AND TREYARCH
PRESENTS

THE OFFICIAL COMIC COLLECTION OF

# CALL OF DUTY®
## BLACK OPS

TREYARCH     ACTIVISION®

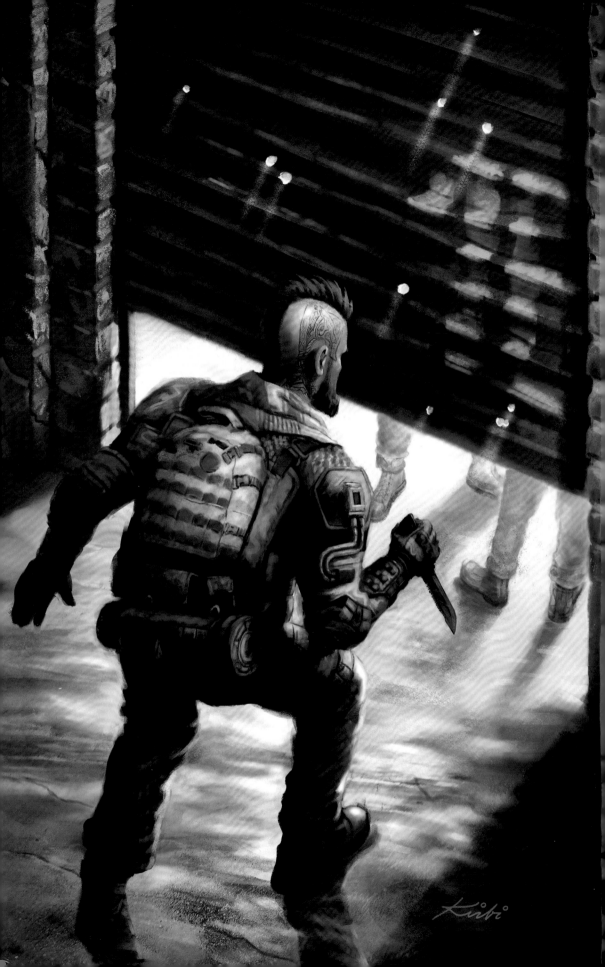

THE OFFICIAL COMIC COLLECTION OF

# CALL OF DUTY
## BLACK OPS

Editor: **Scott Allie**

Letterer: **Clem Robins**

Production: **Kathryn S. Renta and Sara Proctor** (Issues 1 & 2)

Letter (Japanese, Arabic, Korean): **Sophia Hong**

Head Writer: **Greg Rucka**

Story Team: **Chris Roberson, Jeremy Barlow, K.A. McDonald, Aaron Duran, Matthew Robinson, and Tony Shasteen**

**SPECIAL THANKS:**
Carolyn Wang, Jared Castle, Justin McFarland, and everyone at Activision

Dan Laufer, Jay Puryear, Dan Bunting, Dave Anthony, and everyone at Treyarch

David Campiti at Glass House Graphics
Elisabeth Allie and Lisa Robins

THAT WOULD BE CRAZY.

KRYSTOF "FIREBREAK" HEJEK

Distributed by Blizzard Entertainment, Inc., Irvine, California, in 2018. No part of this book may be reproduced in any form without permission from the publisher.

Library of Congress Cataloging-in-Publication Data available.

ISBN: 978-1-945683-94-7

10 9 8 7 6 5 4 3 2 1

Manufactured in China

TREYARCH

ACTIVISION®

Since the release of the first Black Ops game, we've been building a universe.

From the Cold War, to robotics in warfare, to the near-future, no matter the setting, Black Ops has always been about operating in the shadows and dealing with bad things in dark places. Along the way, the operators are the ones that have brought that experience to life.

From Woods, to Reznov, from Mason to Menendez, from Ruin to Battery, the characters of the Black Ops universe have always driven the action forward. And that's what we've loved most about the comic series: it's all about the characters.

In this series, we're able to go beyond the game and deeper into the backgrounds of ten Specialists that currently comprise the Black Ops universe. It's their backstories, their motivations — it's about the history that makes them what they are — and how we meet them here in Black Ops 4.

Thank you for joining us on this ride.

## TREYARCH

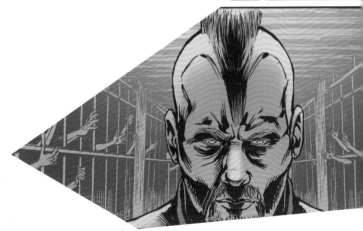

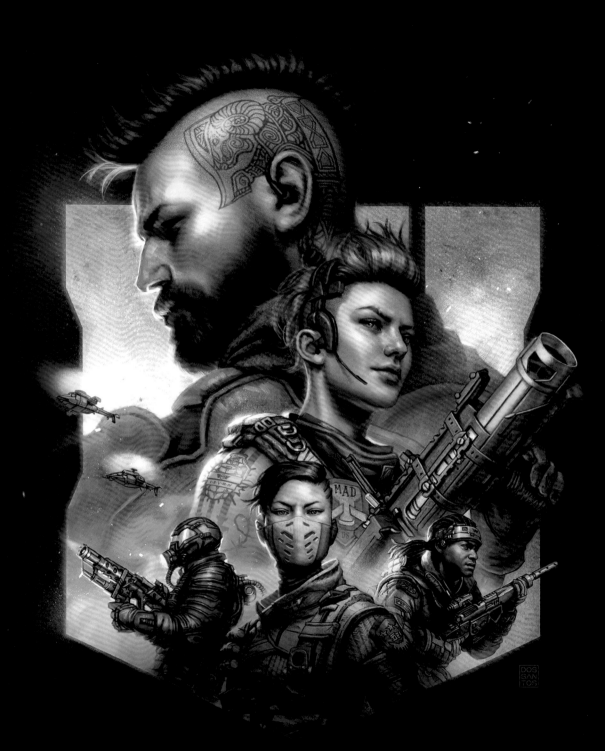

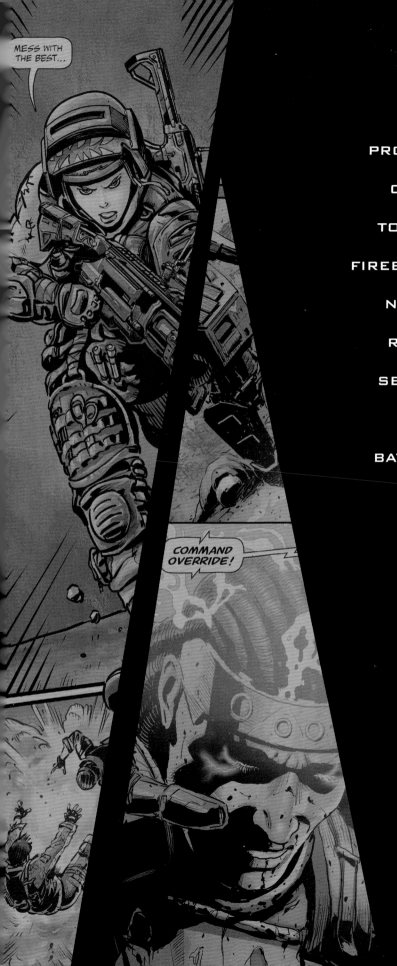

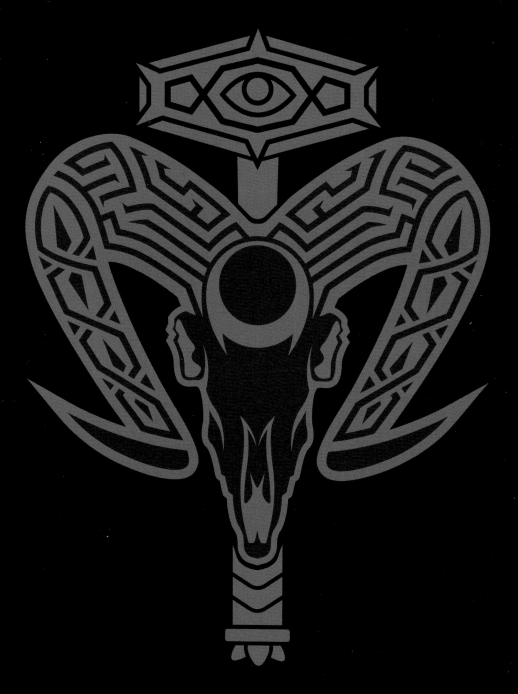

# R U I N

Writer: **Chris Roberson** / Artist: **Débora Carita** / Colorist: **Jay David Ramos**
Cover Artist: **Adam Hughes** / Variant Cover Artist: **Kirbi Fagan**

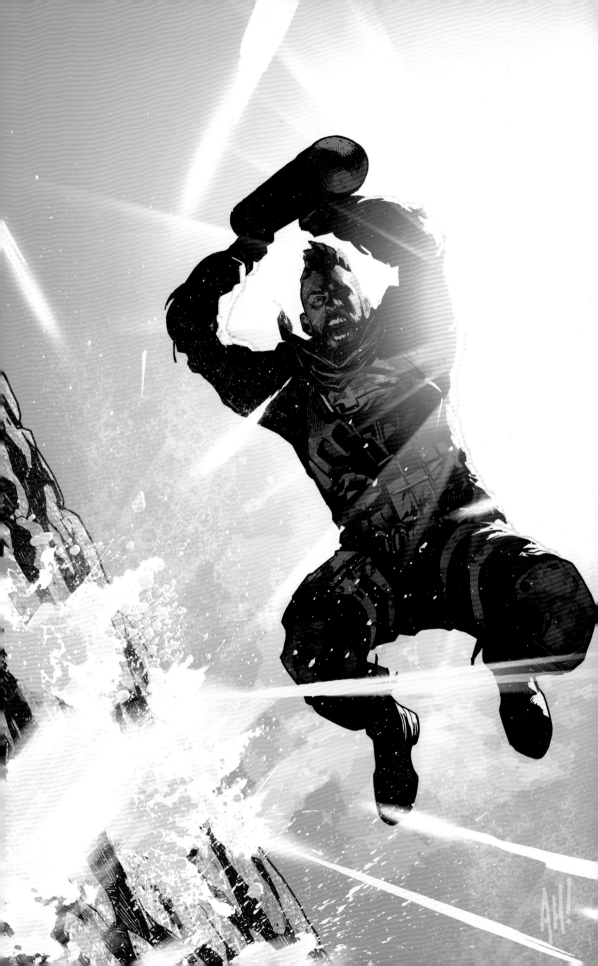

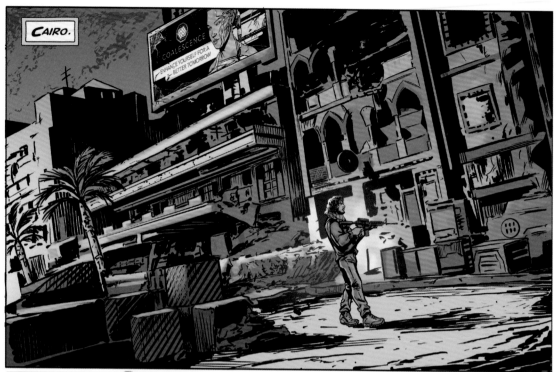

CAIRO.

COALESCENCE
ENHANCE YOURSELF FOR A
BETTER TOMORROW

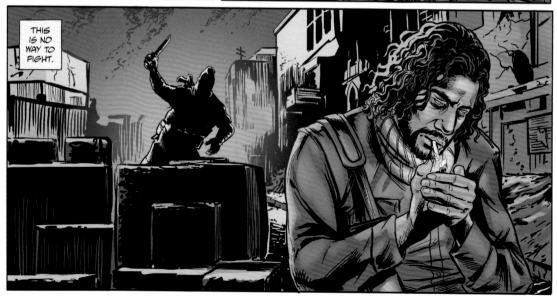

THIS
IS NO
WAY TO
FIGHT.

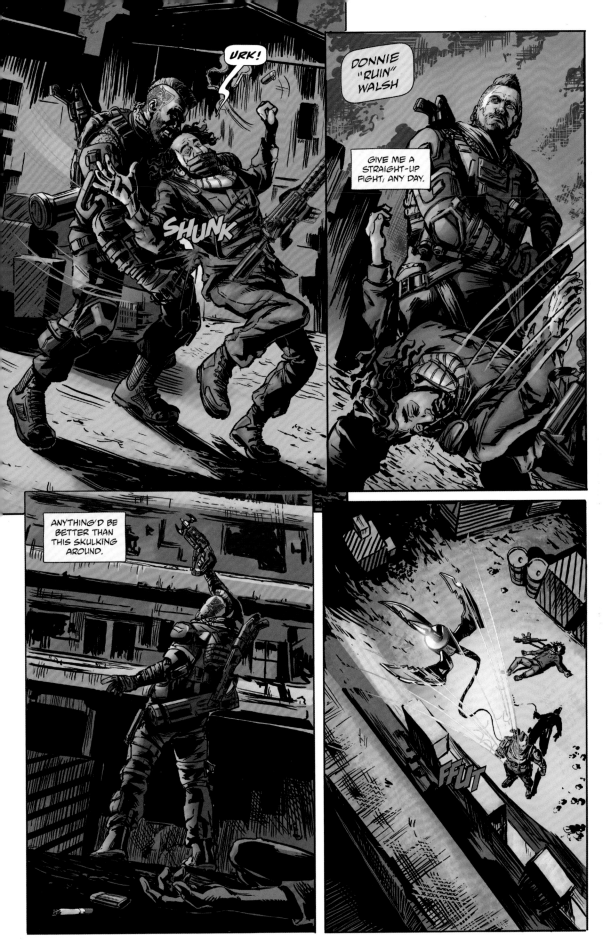

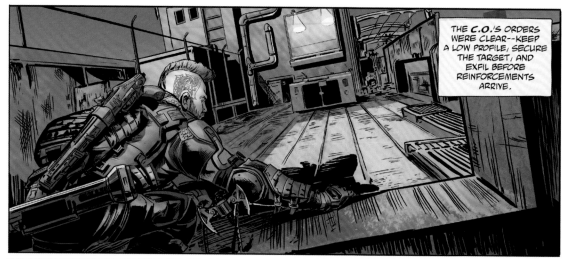

THE **C.O.**'S ORDERS WERE CLEAR--KEEP A LOW PROFILE, SECURE THE TARGET, AND EXFIL BEFORE REINFORCEMENTS ARRIVE.

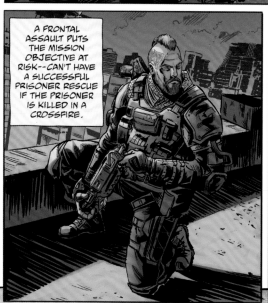

A FRONTAL ASSAULT PUTS THE MISSION OBJECTIVE AT RISK--CAN'T HAVE A SUCCESSFUL PRISONER RESCUE IF THE PRISONER IS KILLED IN A CROSSFIRE.

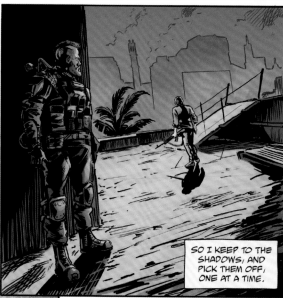

SO I KEEP TO THE SHADOWS, AND PICK THEM OFF, ONE AT A TIME.

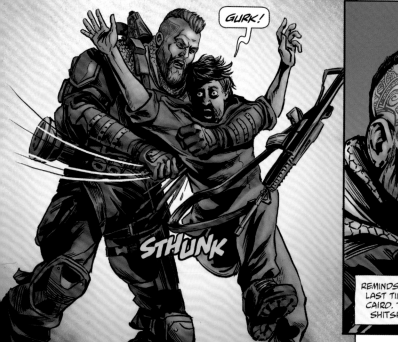

GURK!

STHUNK

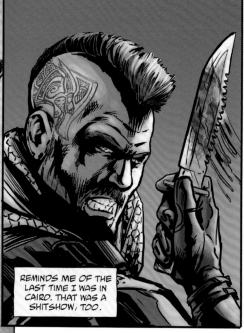

REMINDS ME OF THE LAST TIME I WAS IN CAIRO. THAT WAS A SHITSHOW, TOO.

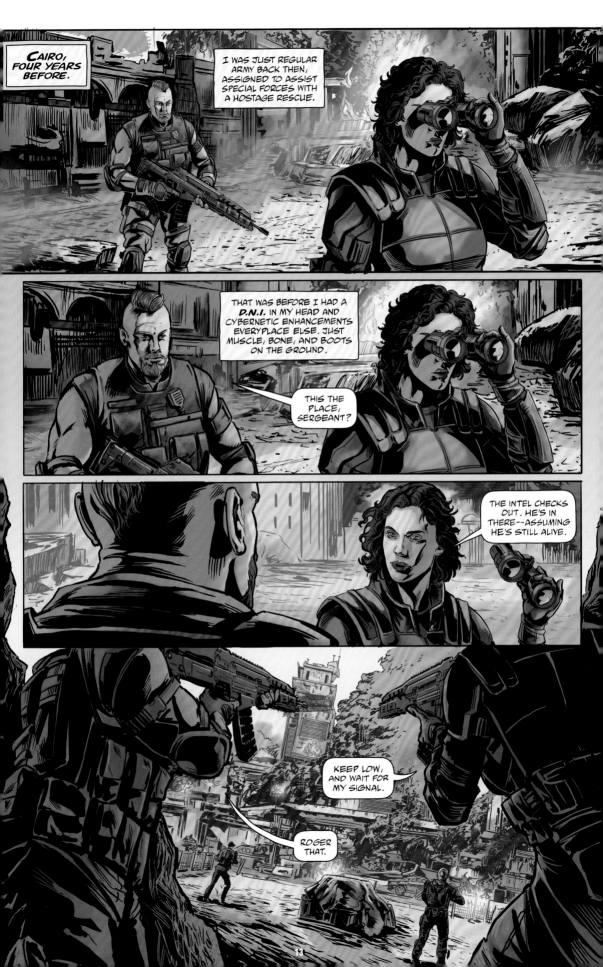

I ALWAYS HATED COVERT-OPS CRAP. BUT THIS WASN'T EVEN AN OFFICIAL *WINSLOW ACCORD* OP.

WE WERE OFF THE BOOKS, AND HAD CUT OFF OUR TAGS BACK AT THE SAFE HOUSE.

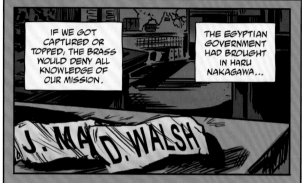

IF WE GOT CAPTURED OR TOPPED, THE BRASS WOULD DENY ALL KNOWLEDGE OF OUR MISSION.

THE EGYPTIAN GOVERNMENT HAD BROUGHT IN HARU NAKAGAWA...

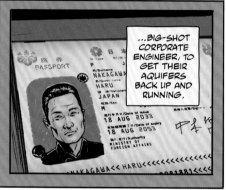

...BIG-SHOT CORPORATE ENGINEER, TO GET THEIR AQUIFERS BACK UP AND RUNNING.

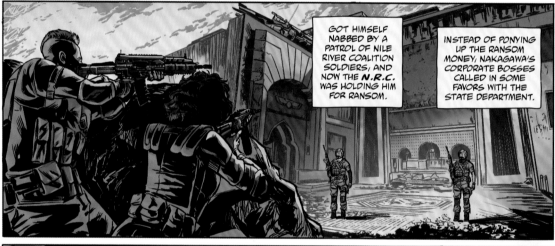

GOT HIMSELF NABBED BY A PATROL OF NILE RIVER COALITION SOLDIERS, AND NOW THE *N.R.C.* WAS HOLDING HIM FOR RANSOM.

INSTEAD OF PONYING UP THE RANSOM MONEY, NAKAGAWA'S CORPORATE BOSSES CALLED IN SOME FAVORS WITH THE STATE DEPARTMENT.

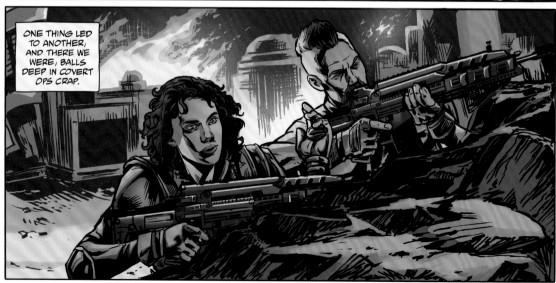

ONE THING LED TO ANOTHER, AND THERE WE WERE, BALLS DEEP IN COVERT OPS CRAP.

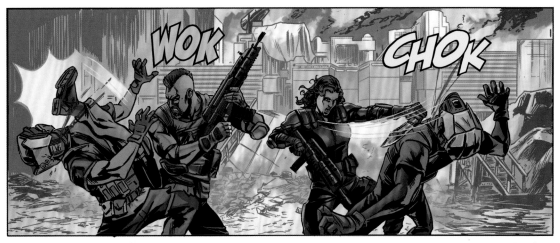

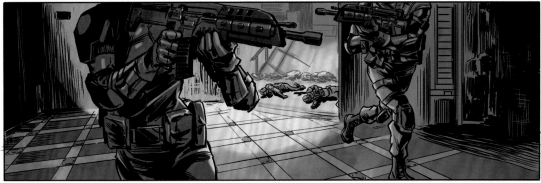

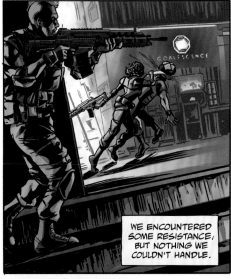

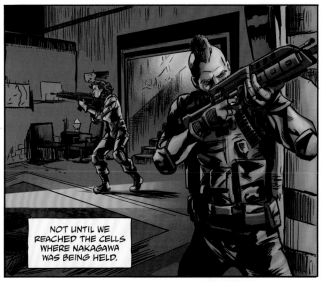

WE ENCOUNTERED SOME RESISTANCE, BUT NOTHING WE COULDN'T HANDLE.

NOT UNTIL WE REACHED THE CELLS WHERE NAKAGAWA WAS BEING HELD.

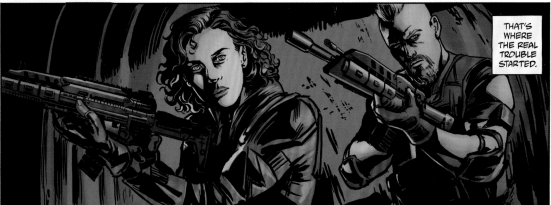

THAT'S WHERE THE REAL TROUBLE STARTED.

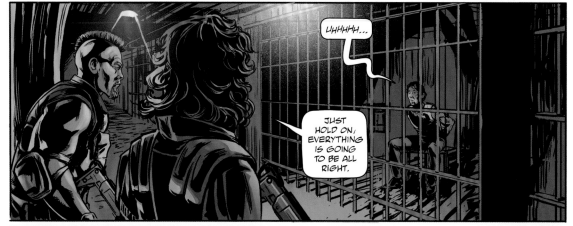

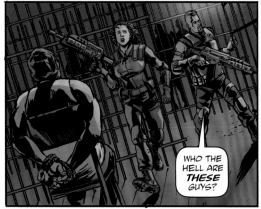

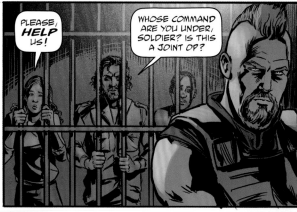

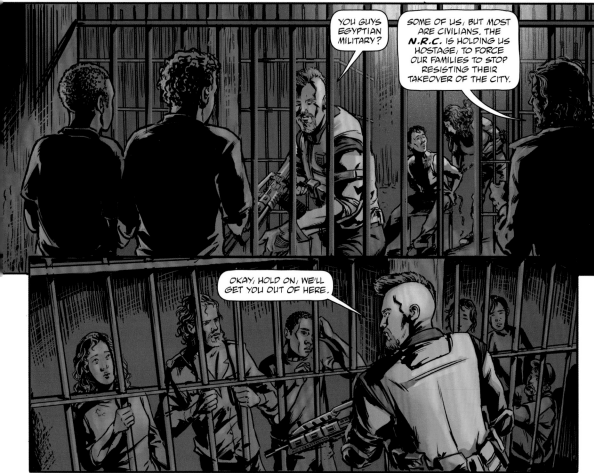

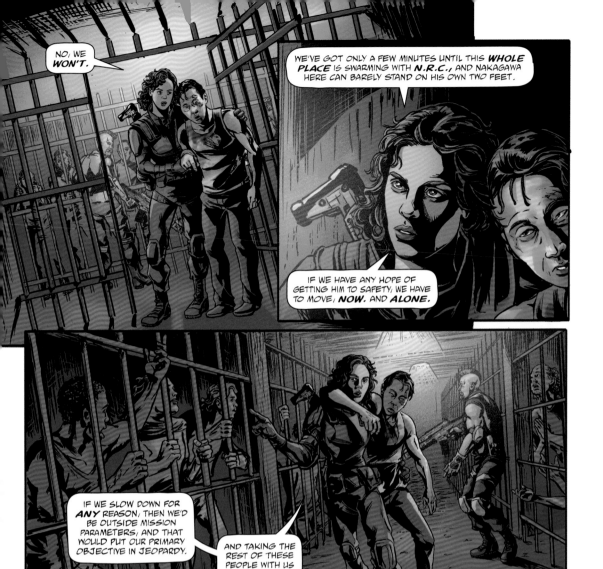

NO, WE **WON'T.**

WE'VE GOT ONLY A FEW MINUTES UNTIL THIS **WHOLE PLACE** IS SWARMING WITH **N.R.C.,** AND NAKAGAWA HERE CAN BARELY STAND ON HIS OWN TWO FEET.

IF WE HAVE ANY HOPE OF GETTING HIM TO SAFETY, WE HAVE TO MOVE, **NOW.** AND **ALONE.**

IF WE SLOW DOWN FOR **ANY** REASON, THEN WE'D BE OUTSIDE MISSION PARAMETERS, AND THAT WOULD PUT OUR PRIMARY OBJECTIVE IN JEOPARDY.

AND TAKING THE REST OF THESE PEOPLE WITH US WOULD SLOW US **WAY** DOWN.

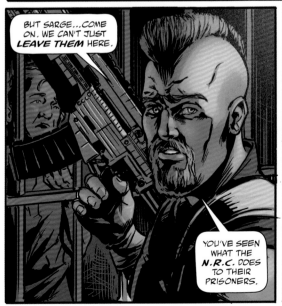

BUT SARGE...COME ON. WE CAN'T JUST **LEAVE THEM** HERE.

YOU'VE SEEN WHAT THE **N.R.C.** DOES TO THEIR PRISONERS.

**I'M** NOT CRAZY ABOUT THIS EITHER, WALSH, BUT ORDERS ARE ORDERS.

NOW **COME ON**--WE HAVE A **JOB** TO DO.

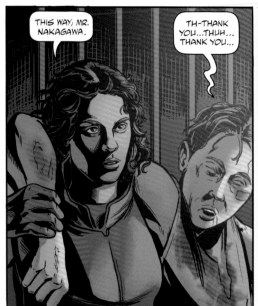

THIS WAY, MR. NAKAGAWA.

TH-THANK YOU...THUH... THANK YOU...

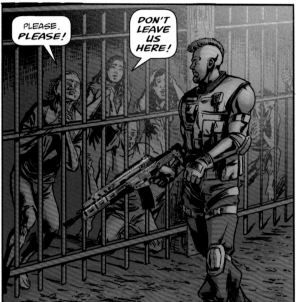

PLEASE. PLEASE!

DON'T LEAVE US HERE!

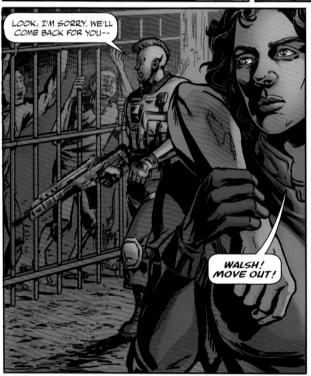

LOOK, I'M SORRY. WE'LL COME BACK FOR YOU--

WALSH! MOVE OUT!

DAMN IT.

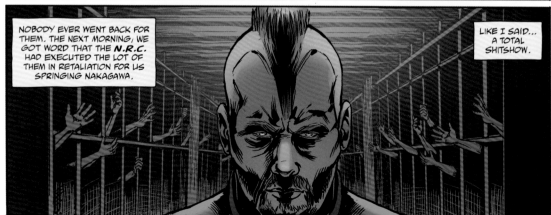

NOBODY EVER WENT BACK FOR THEM. THE NEXT MORNING, WE GOT WORD THAT THE N.R.C. HAD EXECUTED THE LOT OF THEM IN RETALIATION FOR US SPRINGING NAKAGAWA.

LIKE I SAID... A TOTAL SHITSHOW.

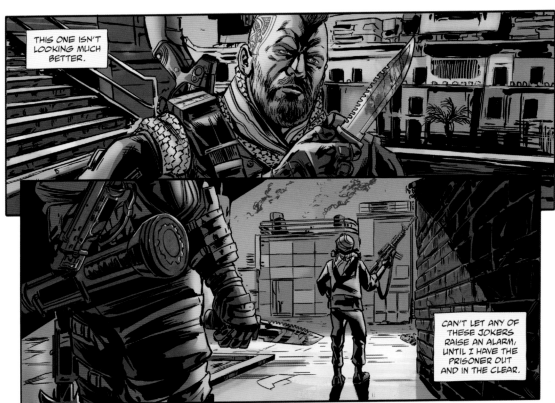

THIS ONE ISN'T LOOKING MUCH BETTER.

CAN'T LET ANY OF THESE JOKERS RAISE AN ALARM, UNTIL I HAVE THE PRISONER OUT AND IN THE CLEAR.

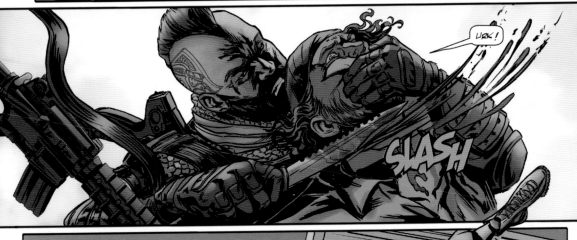

URK!

SLASH

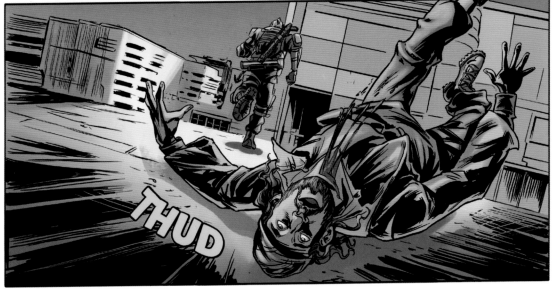

THUD

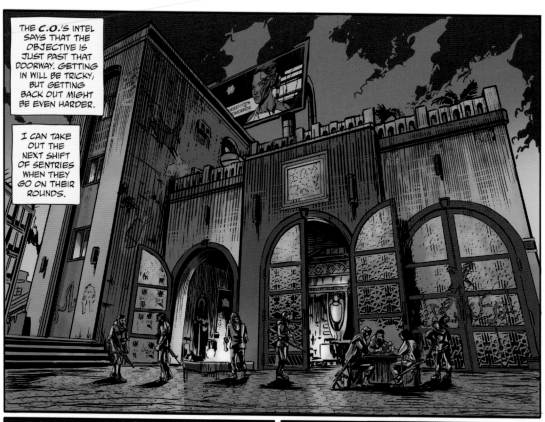

THE **C.O.**'S INTEL SAYS THAT THE OBJECTIVE IS JUST PAST THAT DOORWAY. GETTING IN WILL BE TRICKY, BUT GETTING BACK OUT MIGHT BE EVEN HARDER.

I CAN TAKE OUT THE NEXT SHIFT OF SENTRIES WHEN THEY GO ON THEIR ROUNDS.

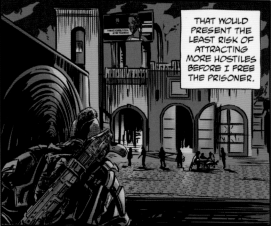

THAT WOULD PRESENT THE LEAST RISK OF ATTRACTING MORE HOSTILES BEFORE I FREE THE PRISONER.

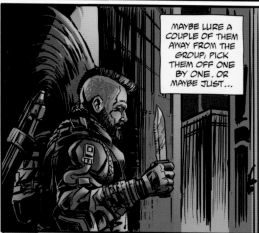

MAYBE LURE A COUPLE OF THEM AWAY FROM THE GROUP, PICK THEM OFF ONE BY ONE. OR MAYBE JUST...

NO, SCREW THAT.

I'VE HAD ENOUGH OF THIS.

HOW ABOUT I SHOW THESE JOKERS HOW IT'S DONE?

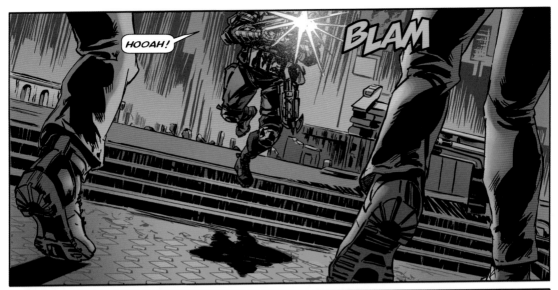

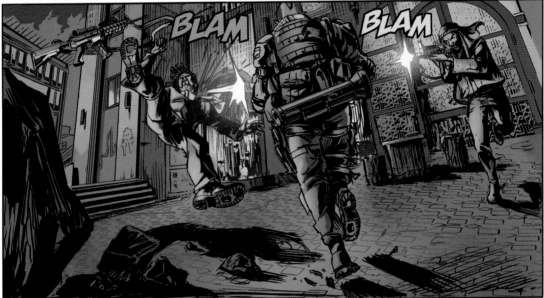

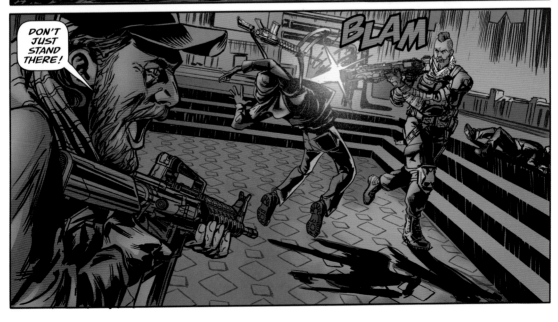

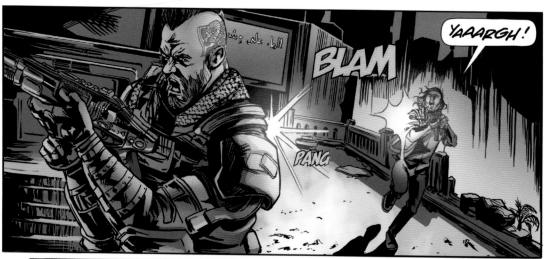

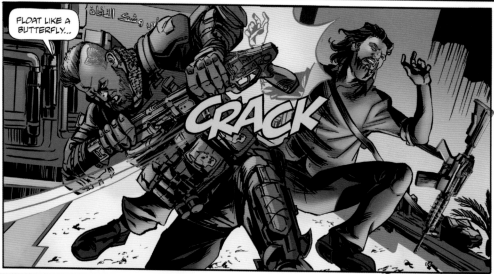

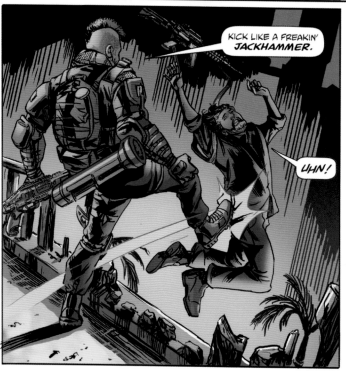

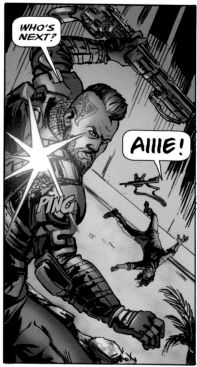

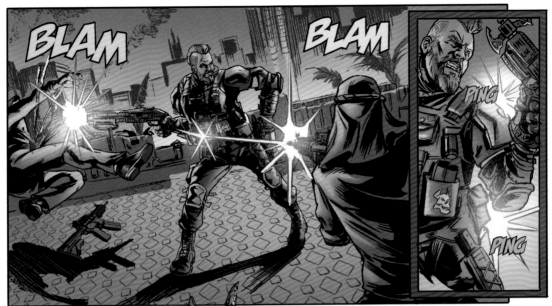

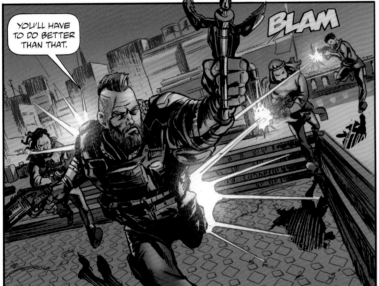

YOU'LL HAVE
TO DO BETTER
THAN THAT.

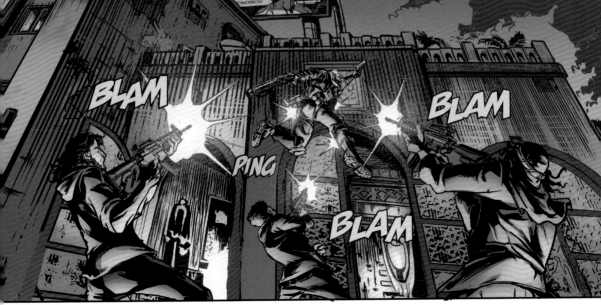

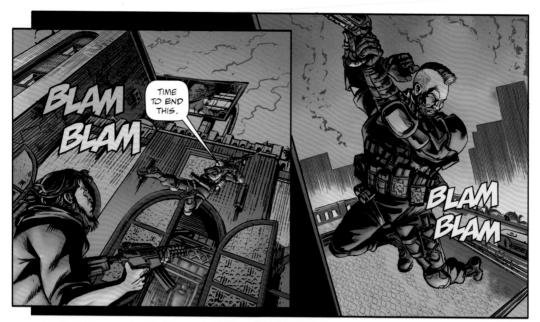

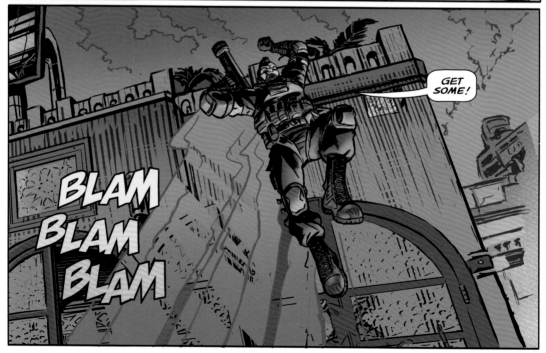

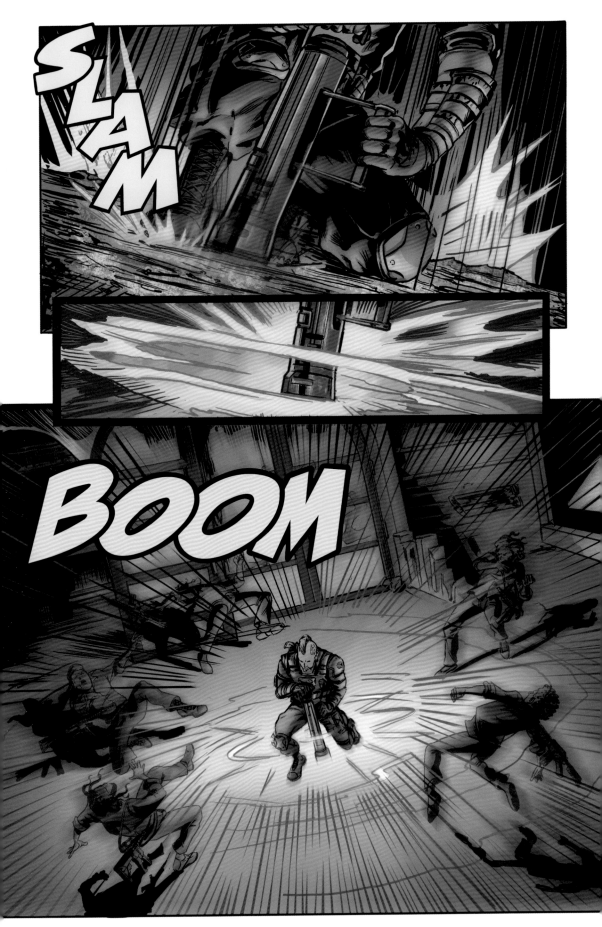

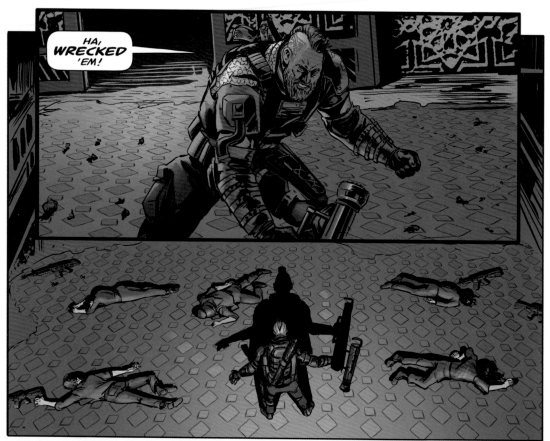

HA, **WRECKED** 'EM!

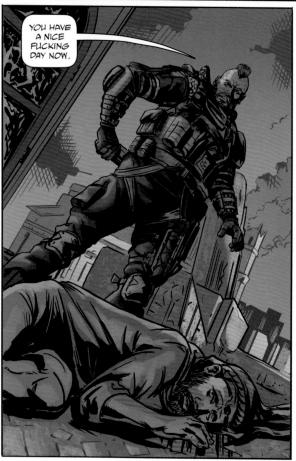

YOU HAVE A NICE FUCKING DAY NOW.

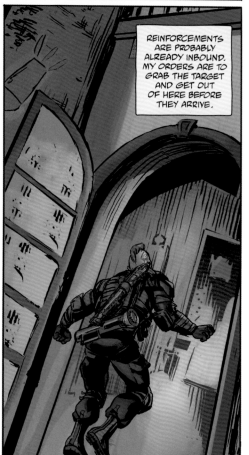

REINFORCEMENTS ARE PROBABLY ALREADY INBOUND. MY ORDERS ARE TO GRAB THE TARGET AND GET OUT OF HERE BEFORE THEY ARRIVE.

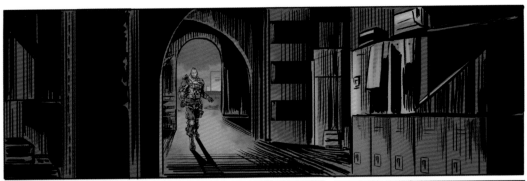

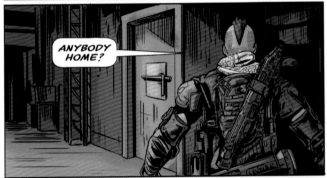

ANYBODY HOME?

OKAY, WELL, STEP BACK.

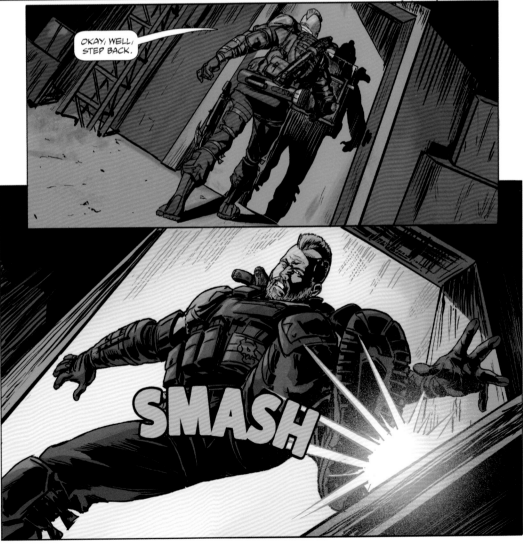

SMASH

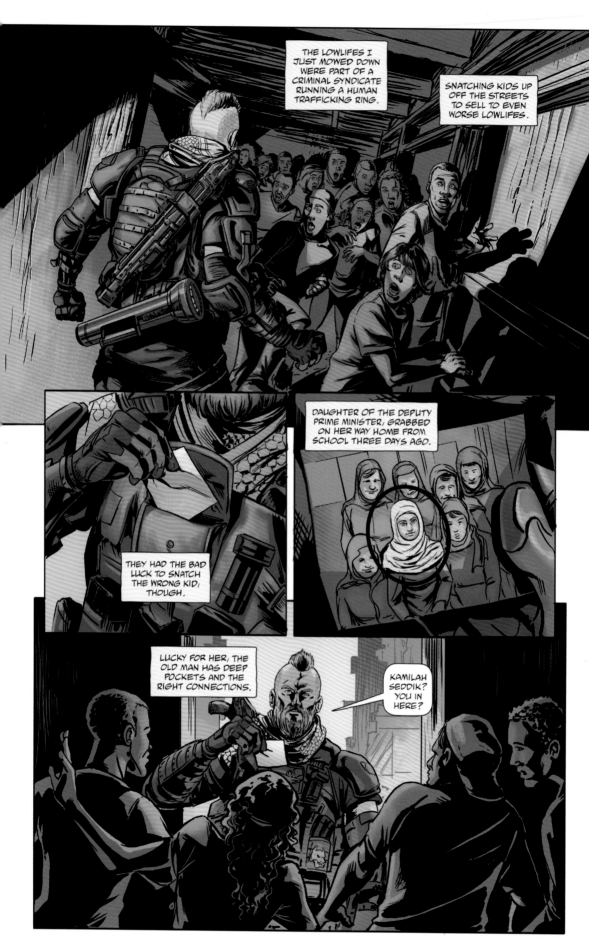

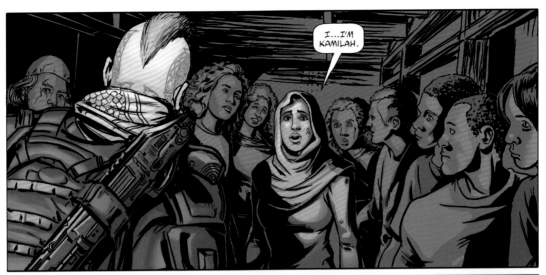

I...I'M KAMILAH.

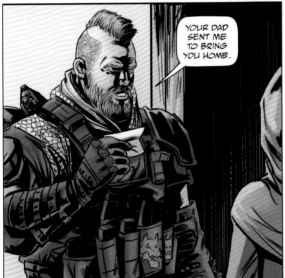

YOUR DAD SENT ME TO BRING YOU HOME.

OH...I WAS STARTING TO WORRY...I DIDN'T THINK HE'D...

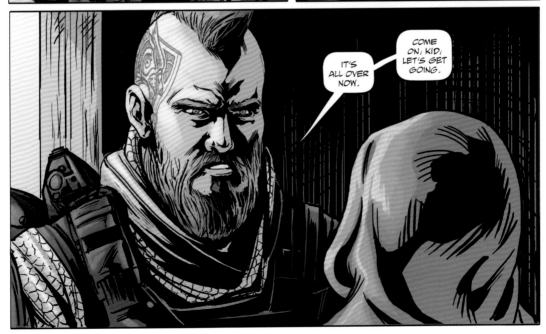

COME ON, KID, LET'S GET GOING.

IT'S ALL OVER NOW.

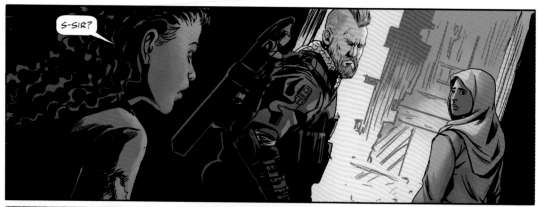

S-SIR?

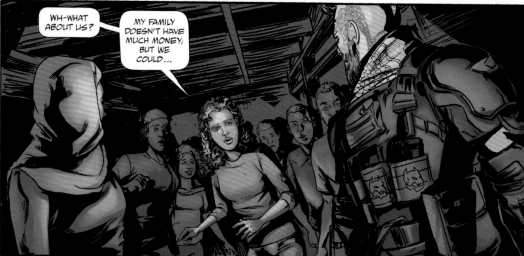

WH-WHAT ABOUT US?

MY FAMILY DOESN'T HAVE MUCH MONEY, BUT WE COULD...

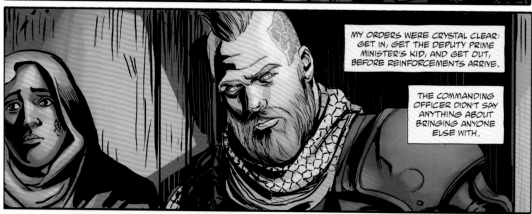

MY ORDERS WERE CRYSTAL CLEAR: GET IN, GET THE DEPUTY PRIME MINISTER'S KID, AND GET OUT, BEFORE REINFORCEMENTS ARRIVE.

THE COMMANDING OFFICER DIDN'T SAY ANYTHING ABOUT BRINGING ANYONE ELSE WITH.

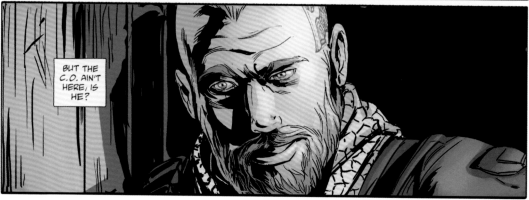

BUT THE C.O. AIN'T HERE, IS HE?

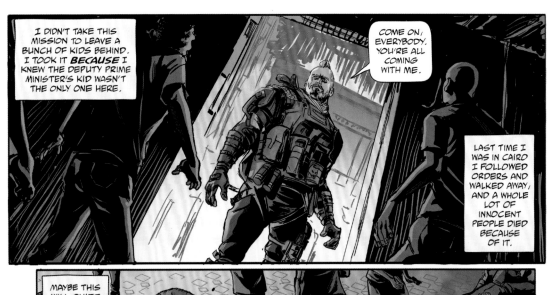

I DIDN'T TAKE THIS MISSION TO LEAVE A BUNCH OF KIDS BEHIND. I TOOK IT *BECAUSE* I KNEW THE DEPUTY PRIME MINISTER'S KID WASN'T THE ONLY ONE HERE.

COME ON, EVERYBODY. YOU'RE ALL COMING WITH ME.

LAST TIME I WAS IN CAIRO I FOLLOWED ORDERS AND WALKED AWAY, AND A WHOLE LOT OF INNOCENT PEOPLE DIED BECAUSE OF IT.

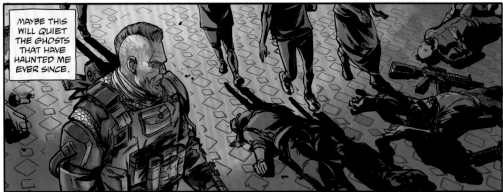

MAYBE THIS WILL QUIET THE GHOSTS THAT HAVE HAUNTED ME EVER SINCE.

SURE, MAYBE I'M OUTSIDE OF MISSION PARAMETERS, BUT SCREW IT. NOBODY'S GETTING LEFT BEHIND.

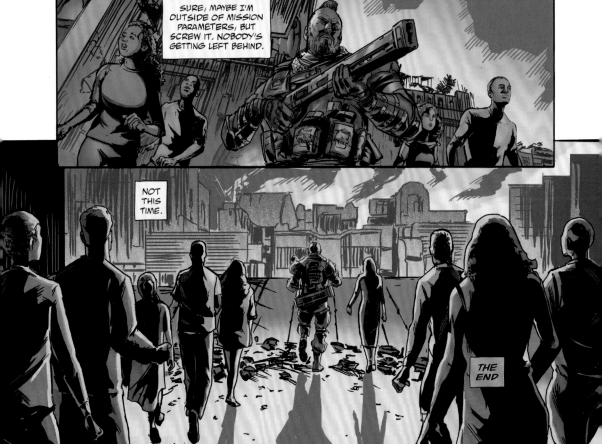

NOT THIS TIME.

THE END

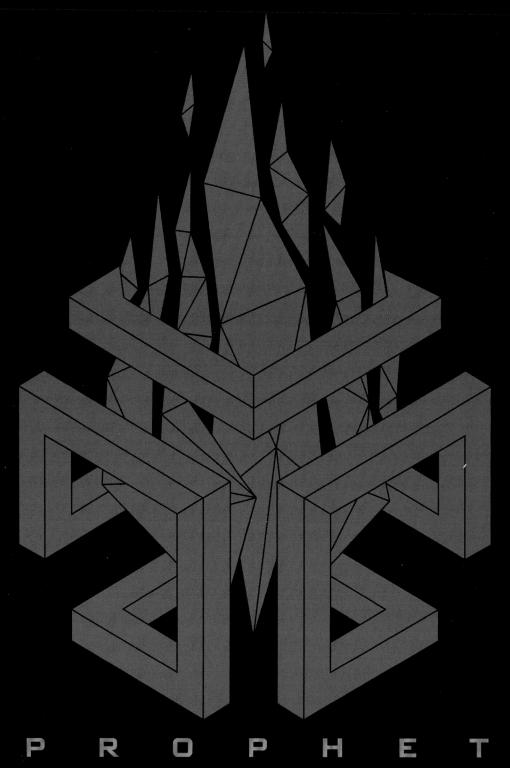

# P R O P H E T

Writer: **Jeremy Barlow** / Artist: **Cliff Richards** / Colorist: **Katrina Mae Hao**
Cover Artist: **Eric Wilkerson**

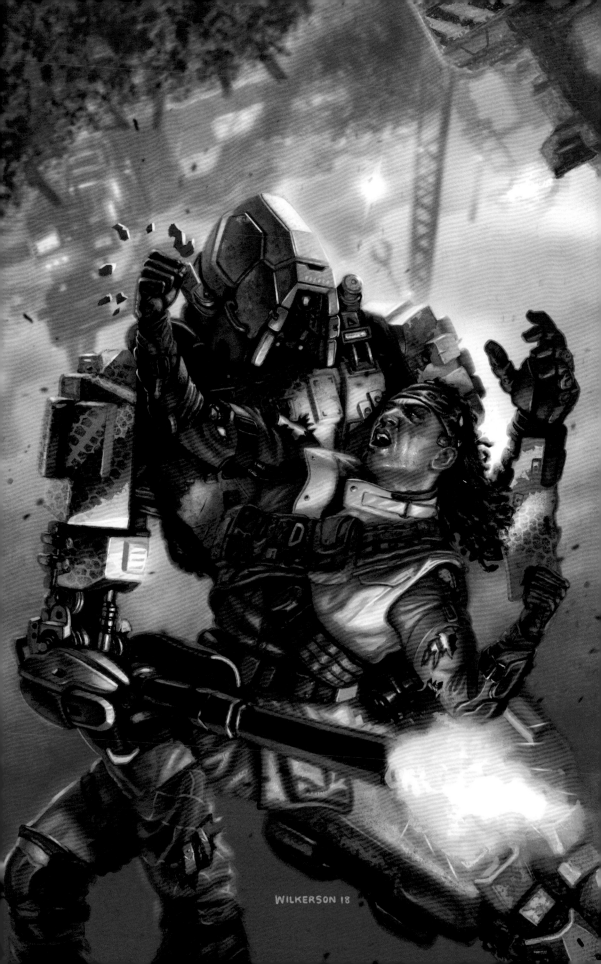

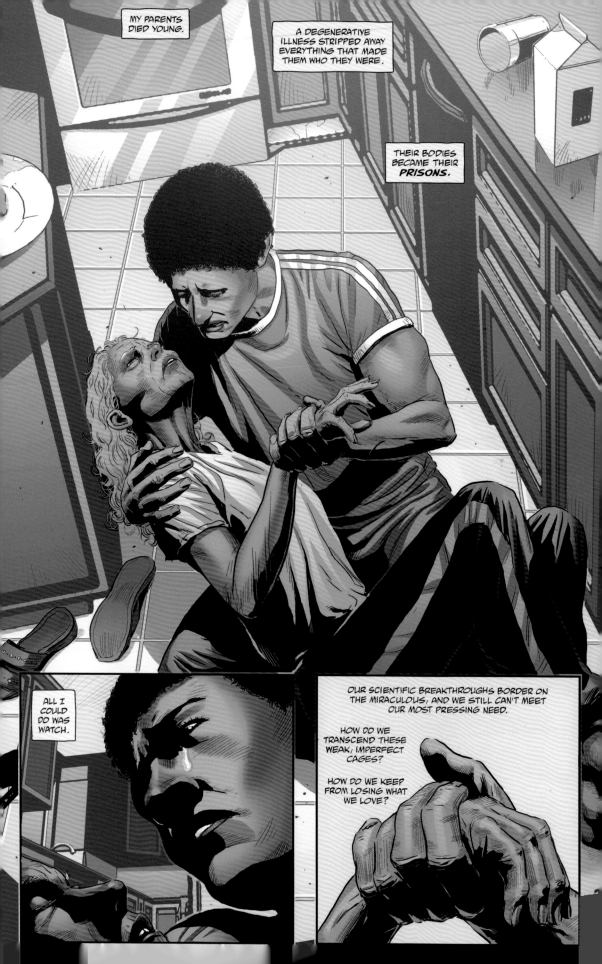

DAVID "PROPHET" WILKES

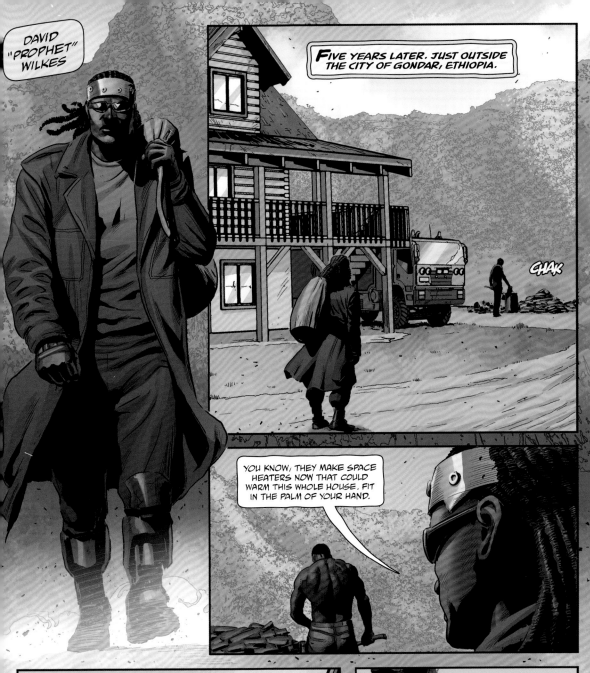

FIVE YEARS LATER. JUST OUTSIDE THE CITY OF GONDAR, ETHIOPIA.

CHAK

YOU KNOW, THEY MAKE SPACE HEATERS NOW THAT COULD WARM THIS WHOLE HOUSE. FIT IN THE PALM OF YOUR HAND.

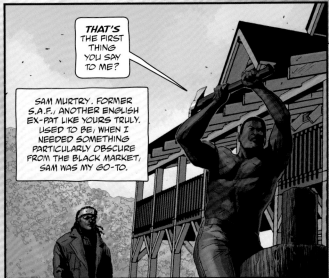

THAT'S THE FIRST THING YOU SAY TO ME?

SAM MURTRY. FORMER S.A.F., ANOTHER ENGLISH EX-PAT LIKE YOURS TRULY. USED TO BE, WHEN I NEEDED SOMETHING PARTICULARLY OBSCURE FROM THE BLACK MARKET, SAM WAS MY GO-TO.

USED TO BE.

CHAK

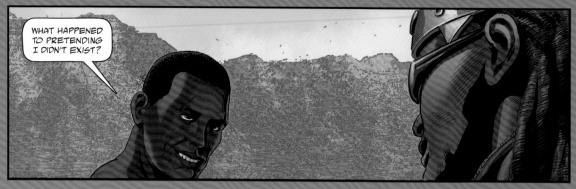

WHAT HAPPENED TO PRETENDING I DIDN'T EXIST?

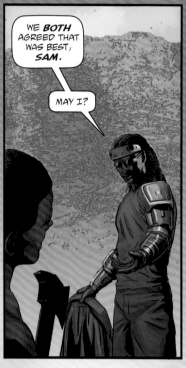

WE **BOTH** AGREED THAT WAS BEST, **SAM**.

MAY I?

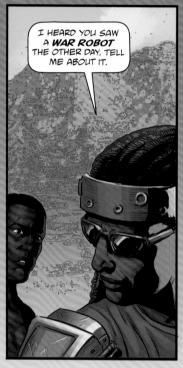

I HEARD YOU SAW A **WAR ROBOT** THE OTHER DAY. TELL ME ABOUT IT.

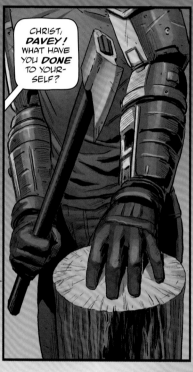

CHRIST, **DAVEY!** WHAT HAVE YOU **DONE** TO YOURSELF?

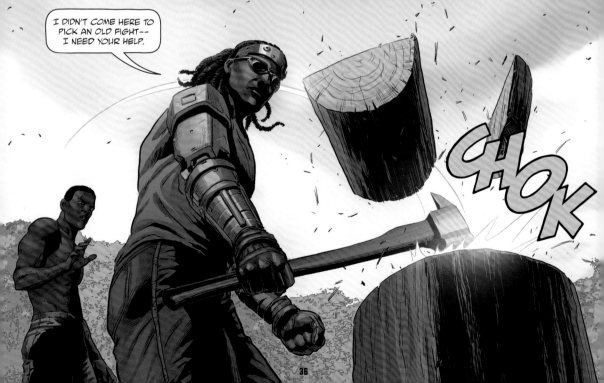

I DIDN'T COME HERE TO PICK AN OLD FIGHT-- I NEED YOUR HELP.

CHOK

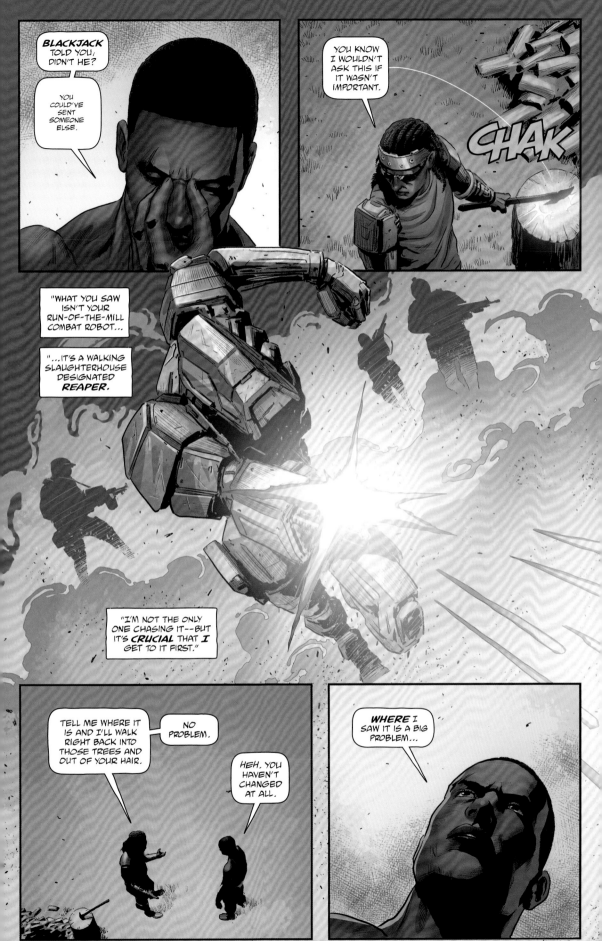

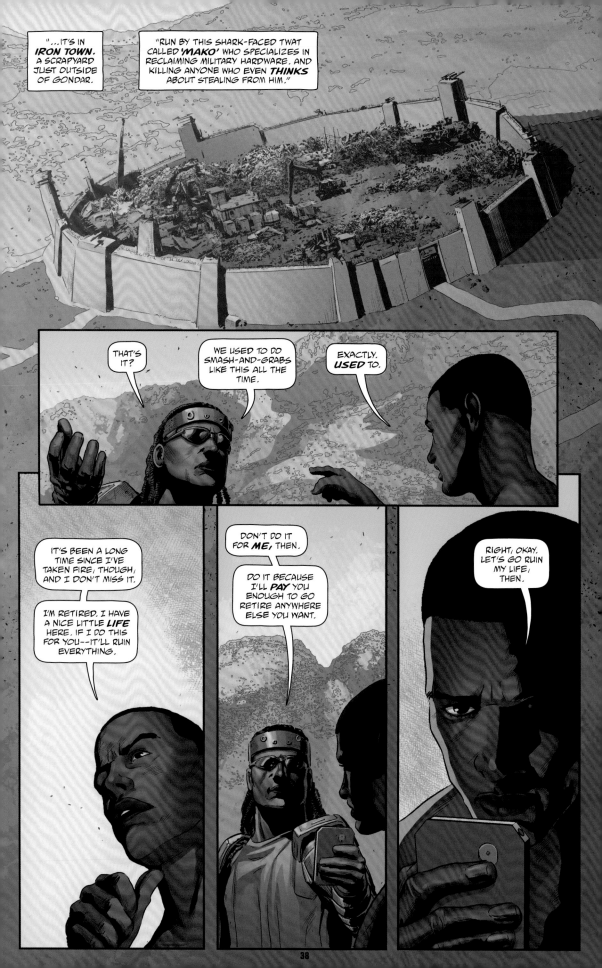

"...IT'S IN *IRON TOWN.* A SCRAPYARD JUST OUTSIDE OF GONDAR."

"RUN BY THIS SHARK-FACED TWAT CALLED *'MAKO'* WHO SPECIALIZES IN RECLAIMING MILITARY HARDWARE. AND KILLING ANYONE WHO EVEN *THINKS* ABOUT STEALING FROM HIM."

THAT'S IT?

WE USED TO DO SMASH-AND-GRABS LIKE THIS ALL THE TIME.

EXACTLY. *USED* TO.

IT'S BEEN A LONG TIME SINCE I'VE TAKEN FIRE, THOUGH, AND I DON'T MISS IT.

I'M RETIRED. I HAVE A NICE LITTLE *LIFE* HERE. IF I DO THIS FOR YOU--IT'LL RUIN EVERYTHING.

DON'T DO IT FOR *ME*, THEN.

DO IT BECAUSE I'LL *PAY* YOU ENOUGH TO GO RETIRE ANYWHERE ELSE YOU WANT.

RIGHT, OKAY. LET'S GO RUIN MY LIFE, THEN.

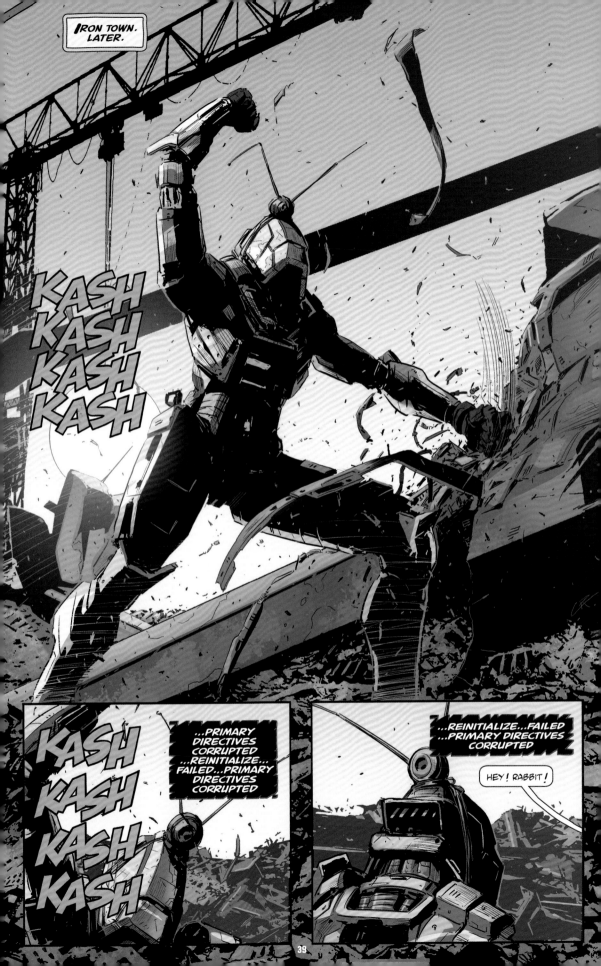

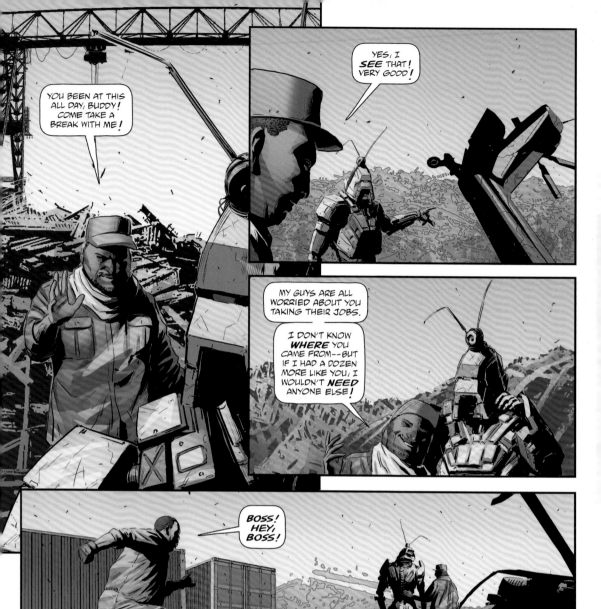

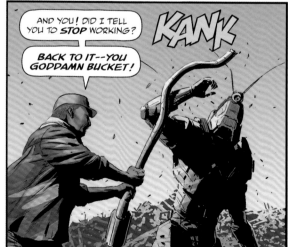

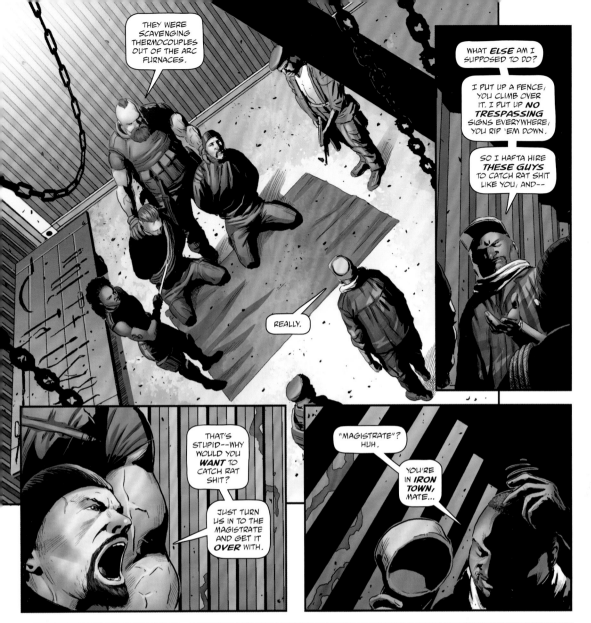

THEY WERE SCAVENGING THERMOCOUPLES OUT OF THE ARC FURNACES.

WHAT *ELSE* AM I SUPPOSED TO DO?

I PUT UP A FENCE, YOU CLIMB OVER IT. I PUT UP *NO TRESPASSING* SIGNS EVERYWHERE, YOU RIP 'EM DOWN.

SO I HAFTA HIRE *THESE GUYS* TO CATCH RAT SHIT LIKE YOU, AND--

REALLY.

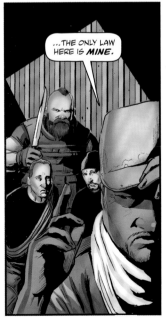

THAT'S STUPID--WHY WOULD YOU *WANT* TO CATCH RAT SHIT?

JUST TURN US IN TO THE MAGISTRATE AND GET IT *OVER* WITH.

"MAGISTRATE"? HUH.

YOU'RE IN *IRON TOWN*, MATE...

...THE ONLY LAW HERE IS *MINE*.

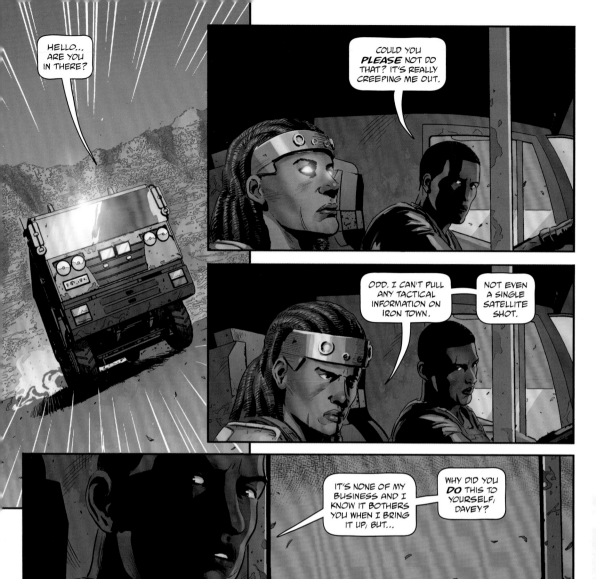

HELLO... ARE YOU IN THERE?

COULD YOU **PLEASE** NOT DO THAT? IT'S REALLY CREEPING ME OUT.

ODD. I CAN'T PULL ANY TACTICAL INFORMATION ON IRON TOWN.

NOT EVEN A SINGLE SATELLITE SHOT.

IT'S NONE OF MY BUSINESS AND I KNOW IT BOTHERS YOU WHEN I BRING IT UP, BUT...

WHY DID YOU **DO** THIS TO YOURSELF, DAVEY?

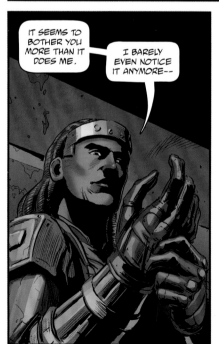

IT SEEMS TO BOTHER YOU MORE THAN IT DOES ME.

I BARELY EVEN NOTICE IT ANYMORE--

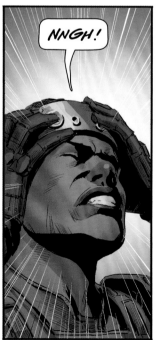

NNGH!

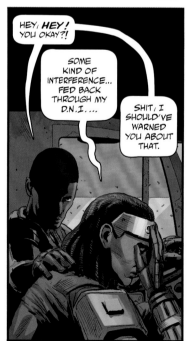

HEY, **HEY!** YOU OKAY?!

SOME KIND OF INTERFERENCE... FED BACK THROUGH MY D.N.I. ...

SHIT, I SHOULD'VE WARNED YOU ABOUT THAT.

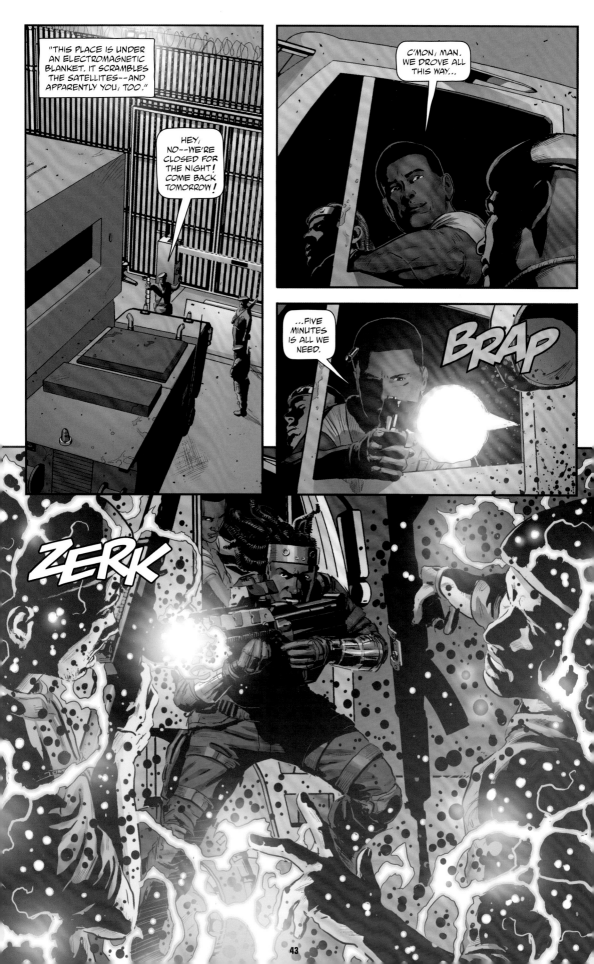

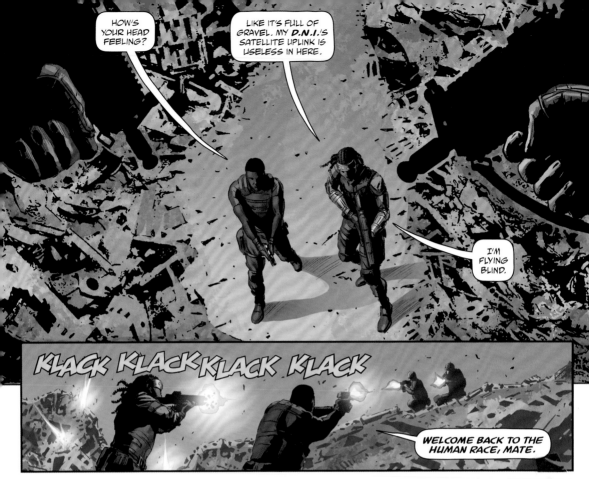

HOW'S YOUR HEAD FEELING?

LIKE IT'S FULL OF GRAVEL. MY *D.N.I.*'S SATELLITE UPLINK IS USELESS IN HERE.

I'M FLYING BLIND.

KLACK KLACK KLACK KLACK

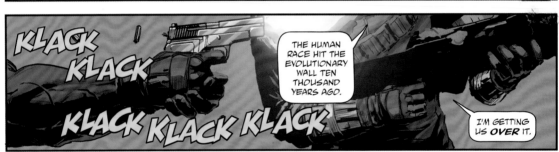

WELCOME BACK TO THE HUMAN RACE, MATE.

KLACK KLACK

KLACK KLACK KLACK

THE HUMAN RACE HIT THE EVOLUTIONARY WALL TEN THOUSAND YEARS AGO.

I'M GETTING US *OVER* IT.

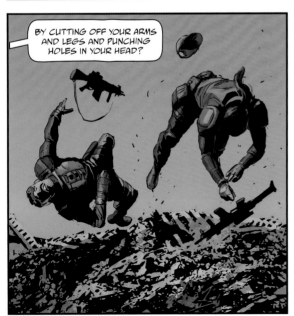

BY CUTTING OFF YOUR ARMS AND LEGS AND PUNCHING HOLES IN YOUR HEAD?

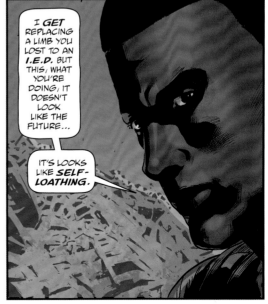

I *GET* REPLACING A LIMB YOU LOST TO AN *I.E.D.* BUT THIS, WHAT YOU'RE DOING, IT DOESN'T LOOK LIKE THE FUTURE...

IT'S LOOKS LIKE *SELF-LOATHING.*

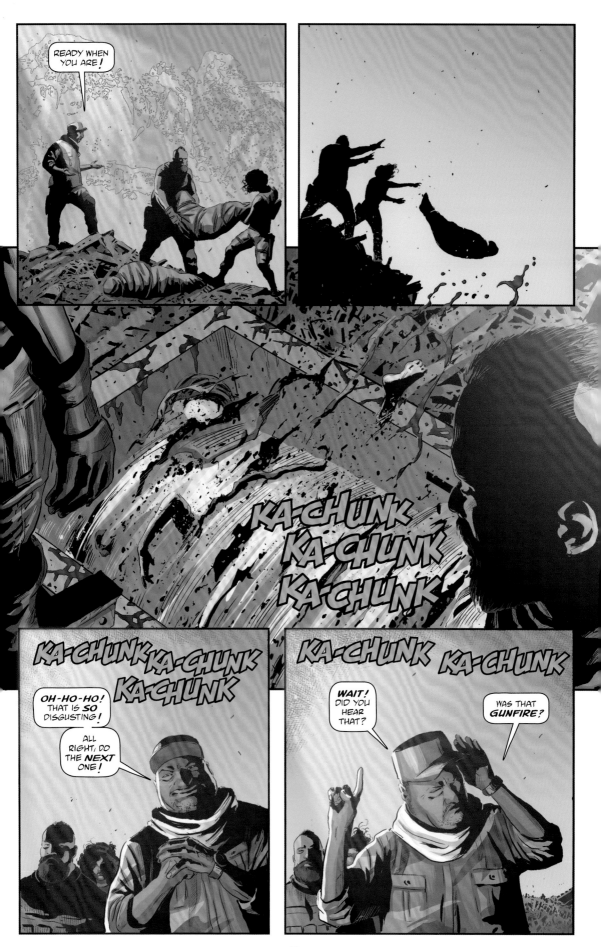

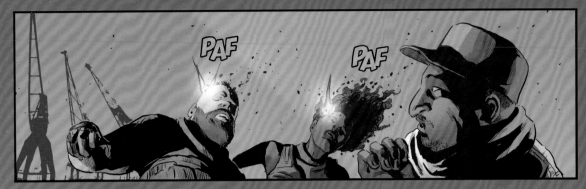

PAF

PAF

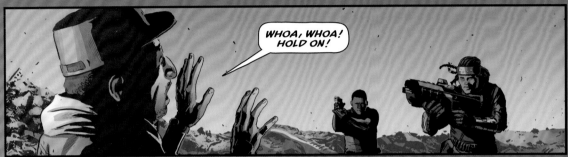

WHOA, WHOA! HOLD ON!

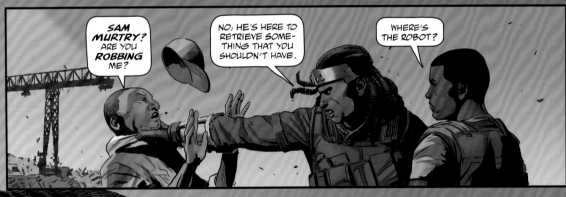

SAM *MURTRY?* ARE YOU *ROBBING* ME?

NO, HE'S HERE TO RETRIEVE SOME-THING THAT YOU SHOULDN'T HAVE.

WHERE'S THE ROBOT?

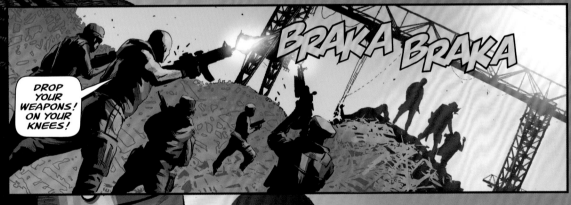

BRAKA BRAKA

DROP YOUR WEAPONS! ON YOUR KNEES!

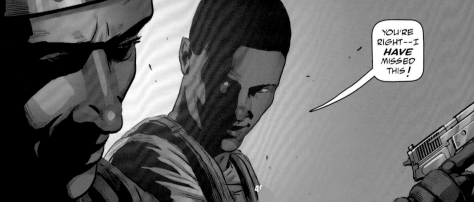

YOU'RE RIGHT--I *HAVE* MISSED THIS!

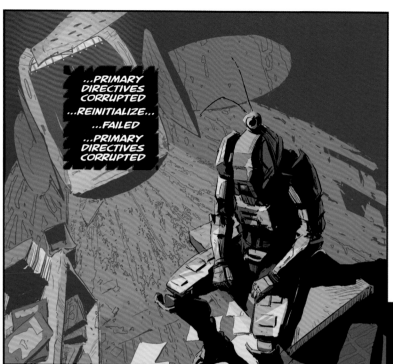

...PRIMARY DIRECTIVES CORRUPTED

...REINITIALIZE...

...FAILED

...PRIMARY DIRECTIVES CORRUPTED

BRAKA-BRAKA CHOOM CHOOM

?

KA-CHAK BRAKA-BRAKA CHOOM

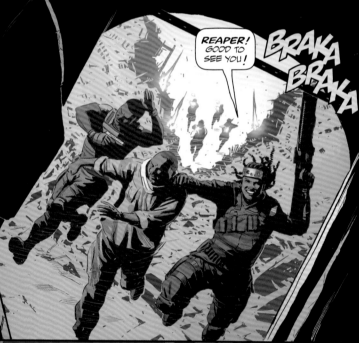

REAPER! GOOD TO SEE YOU!

BRAKA BRAKA

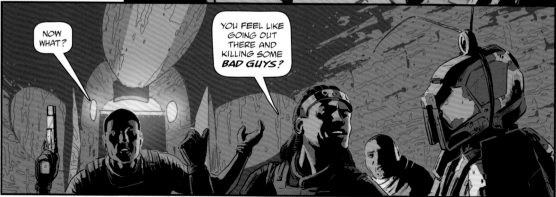

NOW WHAT?

YOU FEEL LIKE GOING OUT THERE AND KILLING SOME BAD GUYS?

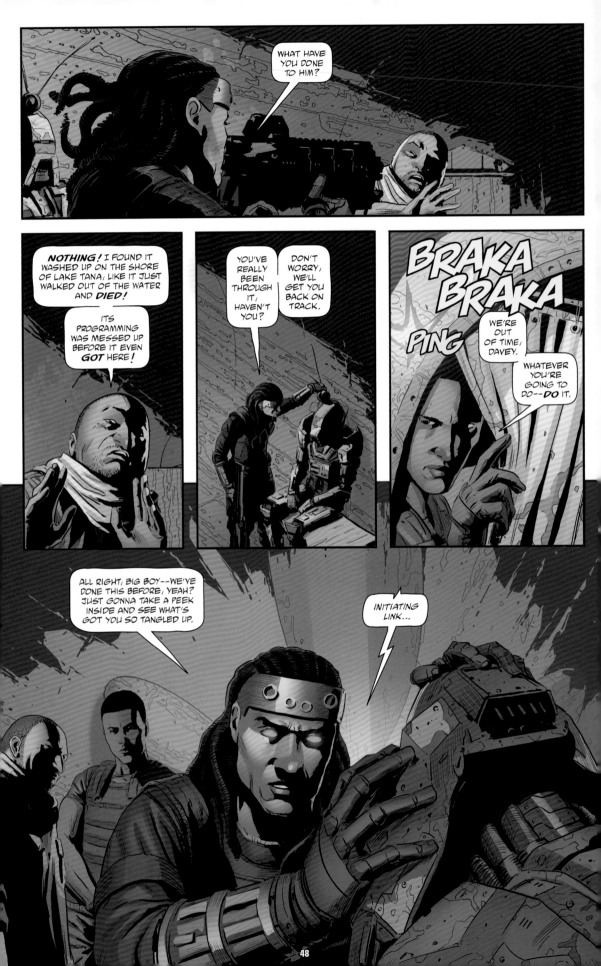

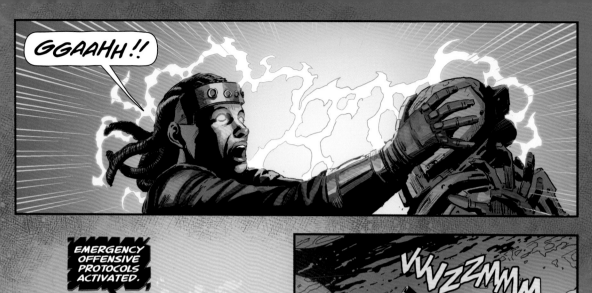

GGAAHH!!

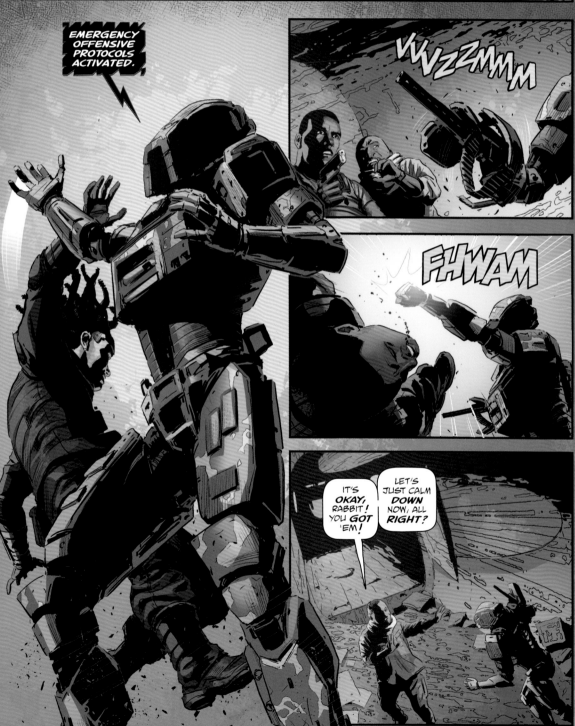

EMERGENCY OFFENSIVE PROTOCOLS ACTIVATED.

VWVZZMMM

FHWAM

IT'S *OKAY,* RABBIT! YOU *GOT* 'EM!

LET'S JUST CALM *DOWN* NOW, ALL *RIGHT?*

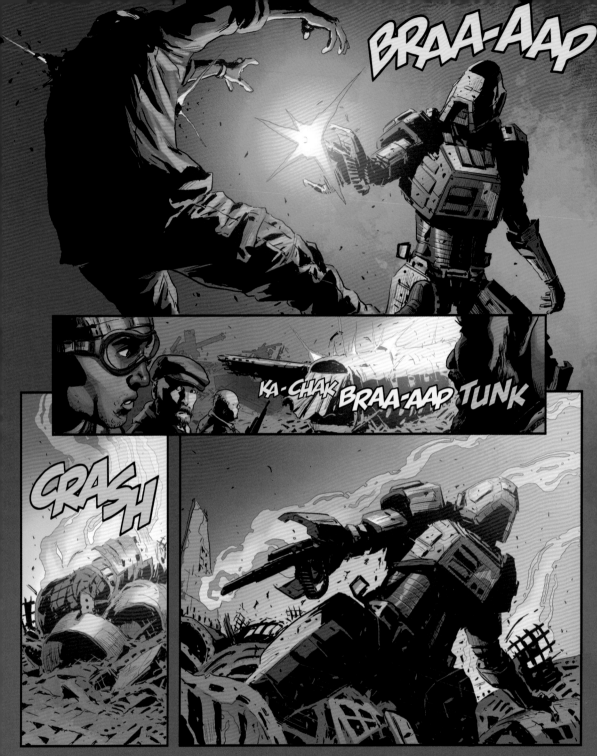

BRAA-AAP

KA-CHAK BRAA-AAP TUNK

CRASH

FIRE!! BRAKA BRAKA BRAKA BRAKA

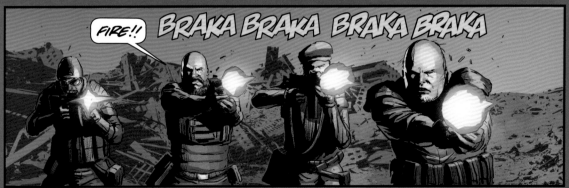

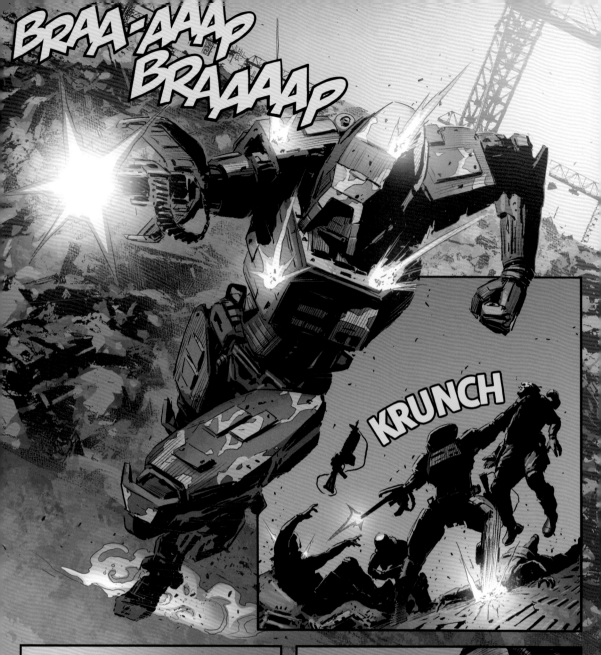

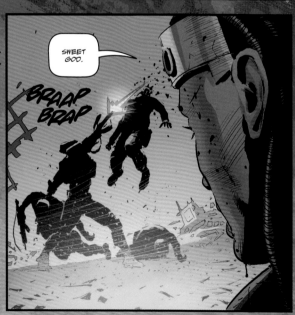

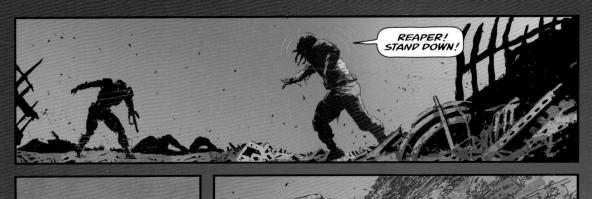

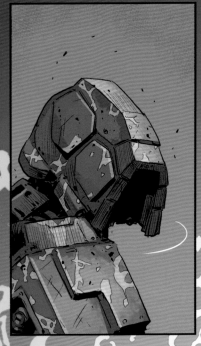

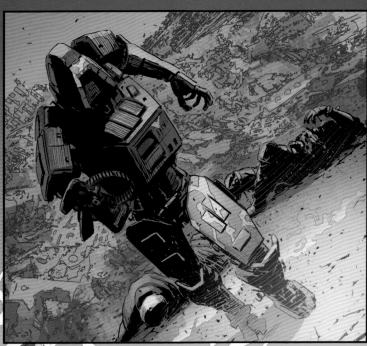

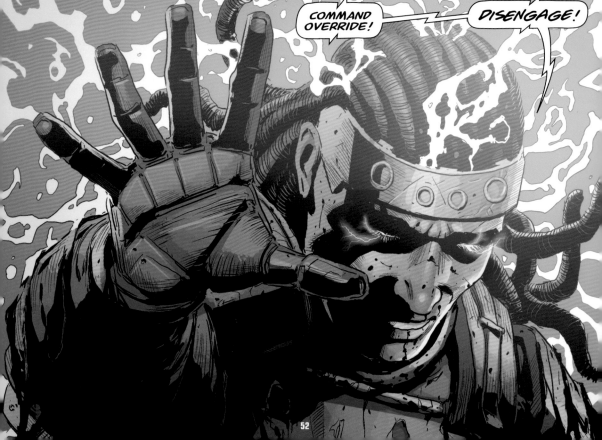

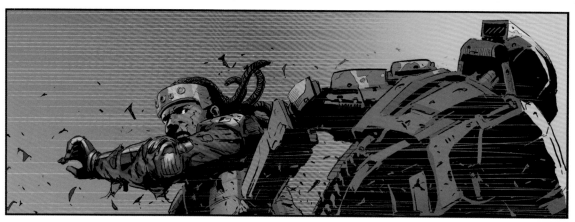

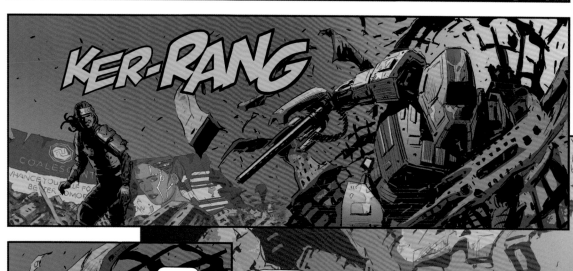

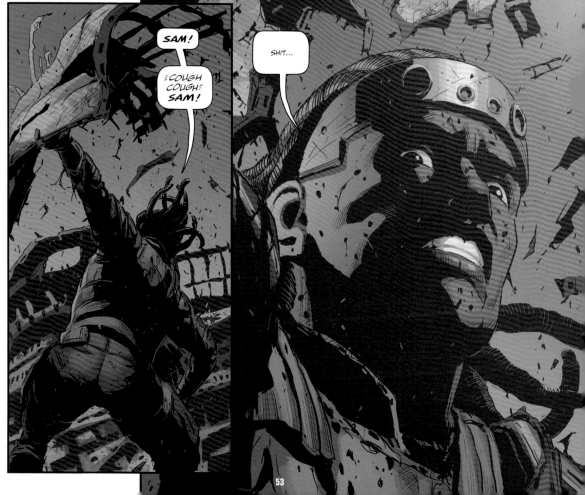

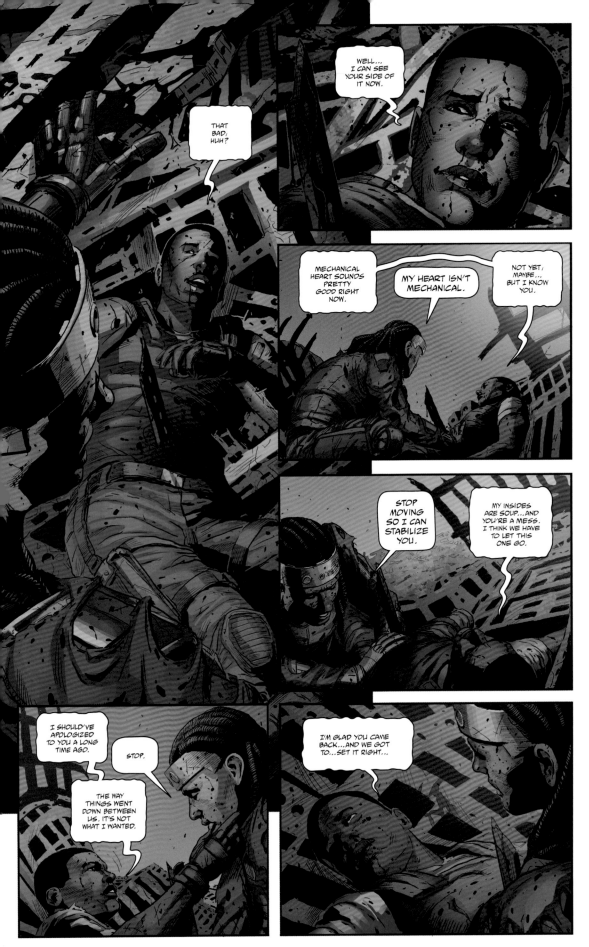

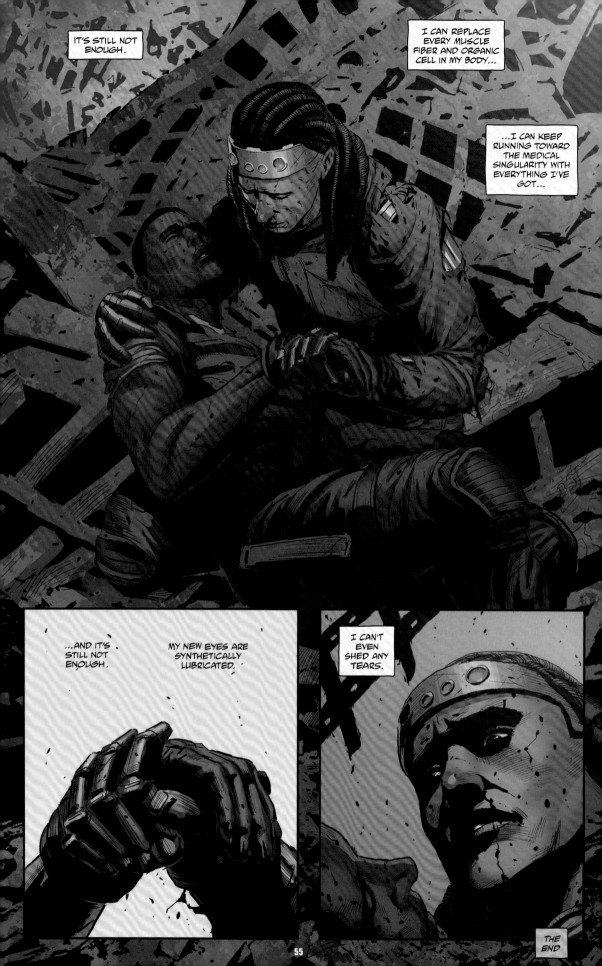

# C R A S H

Writer: **K.A. McDonald** / Letterer: **Pedro Pimentão** / Inker: **Carlos Eduardo** / Colorist: **Candice Han**
Cover Artist: **Kirbi Fagan**

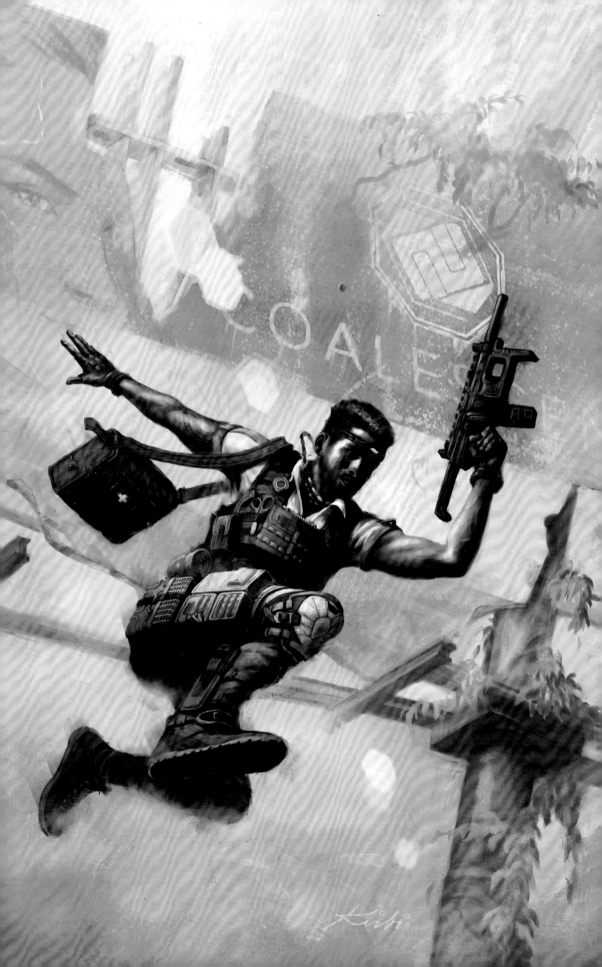

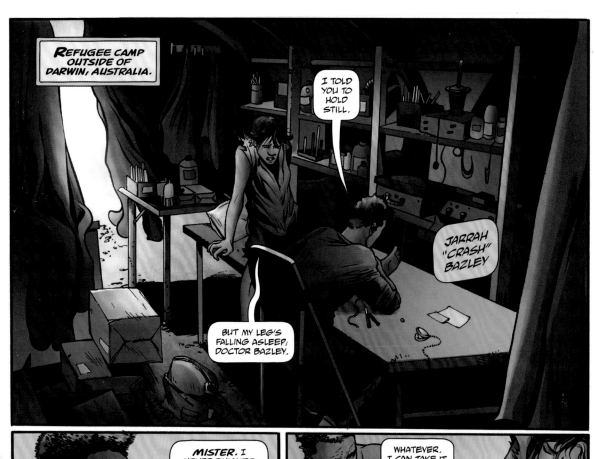

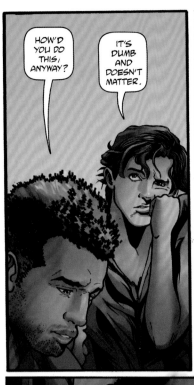

HOW'D YOU DO THIS, ANYWAY?

IT'S DUMB AND DOESN'T MATTER.

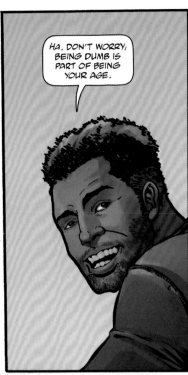

HA, DON'T WORRY, BEING DUMB IS PART OF BEING YOUR AGE.

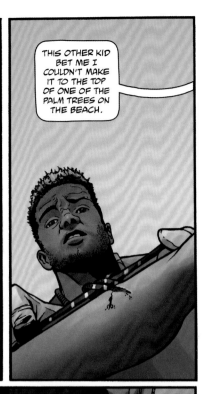

THIS OTHER KID BET ME I COULDN'T MAKE IT TO THE TOP OF ONE OF THE PALM TREES ON THE BEACH.

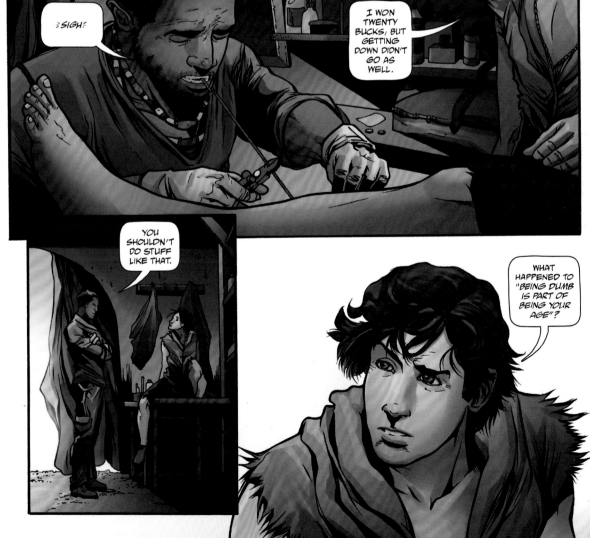

≷SIGH≷

I WON TWENTY BUCKS, BUT GETTING DOWN DIDN'T GO AS WELL.

YOU SHOULDN'T DO STUFF LIKE THAT.

WHAT HAPPENED TO "BEING DUMB IS PART OF BEING YOUR AGE"?

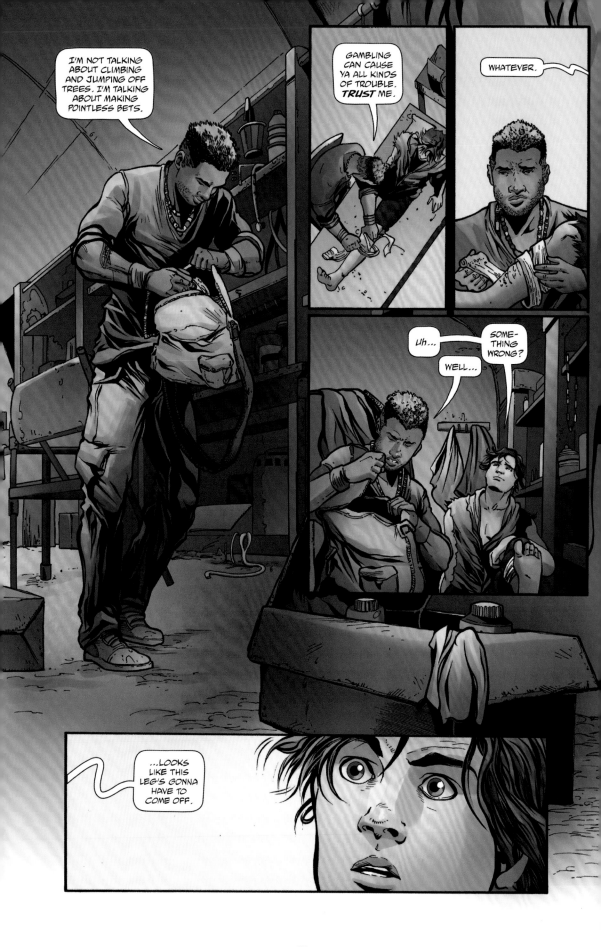

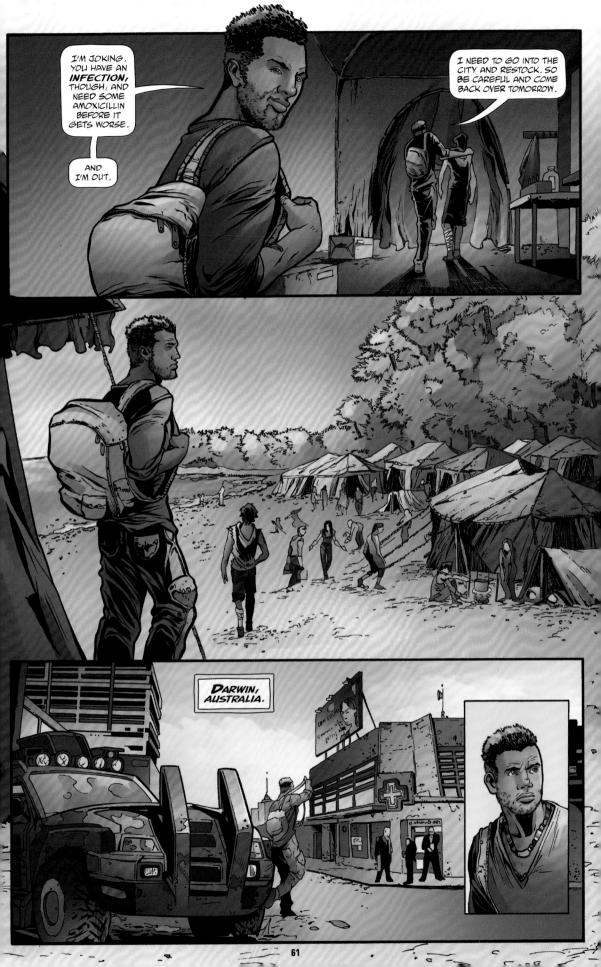

I'M JOKING. YOU HAVE AN **INFECTION,** THOUGH, AND NEED SOME AMOXICILLIN BEFORE IT GETS WORSE.

AND I'M OUT.

I NEED TO GO INTO THE CITY AND RESTOCK. SO BE CAREFUL AND COME BACK OVER TOMORROW.

DARWIN, AUSTRALIA.

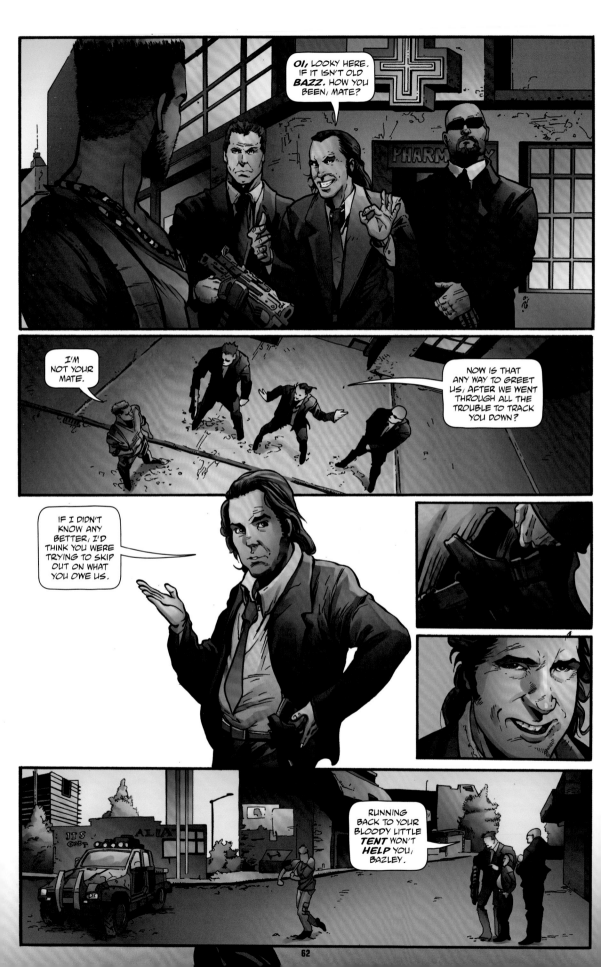

YEAH, HE WOULDN'T WANT ONE OF HIS PATIENTS TO GET HURT WHEN HE'S NOT AROUND TO HELP.

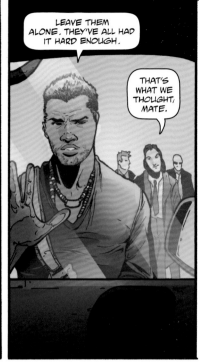

LEAVE THEM ALONE. THEY'VE ALL HAD IT HARD ENOUGH.

THAT'S WHAT WE THOUGHT, MATE.

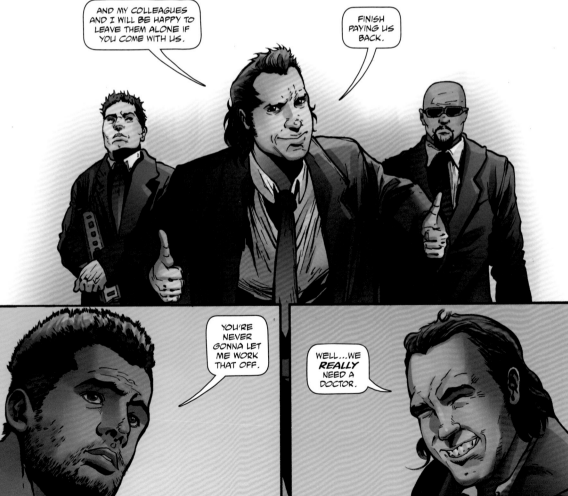

AND MY COLLEAGUES AND I WILL BE HAPPY TO LEAVE THEM ALONE IF YOU COME WITH US.

FINISH PAYING US BACK.

YOU'RE NEVER GONNA LET ME WORK THAT OFF.

WELL...WE *REALLY* NEED A DOCTOR.

SO DO THEY.

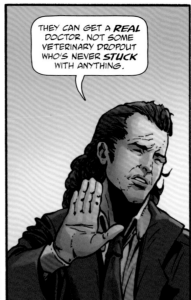

THEY CAN GET A **REAL** DOCTOR. NOT SOME VETERINARY DROPOUT WHO'S NEVER **STUCK** WITH ANYTHING.

**WE** APPRECIATE THAT YOU'RE OFF THE BOOKS, THOUGH.

RIGHT. I'VE LET A LOT OF PEOPLE DOWN...

OKAY THEN, JUST A SEC...

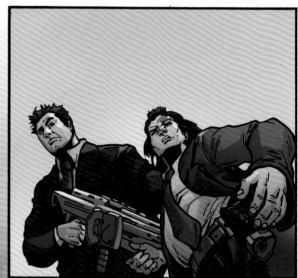

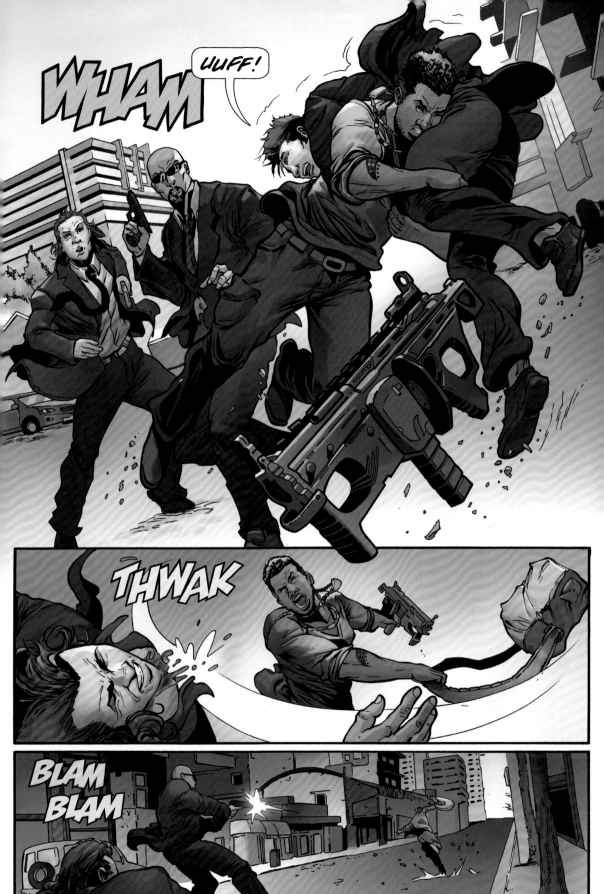

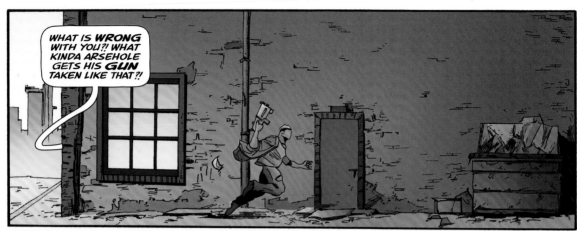

WHAT IS **WRONG** WITH YOU?! WHAT KINDA ARSEHOLE GETS HIS **GUN** TAKEN LIKE THAT?!

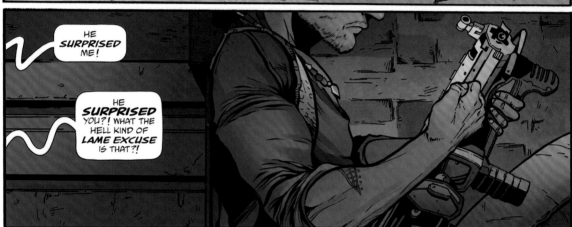

HE **SURPRISED** ME!

HE **SURPRISED** YOU?! WHAT THE HELL KIND OF **LAME EXCUSE** IS THAT?!

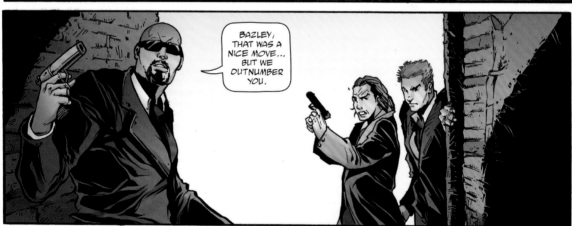

BAZLEY, THAT WAS A NICE MOVE... BUT WE OUTNUMBER YOU.

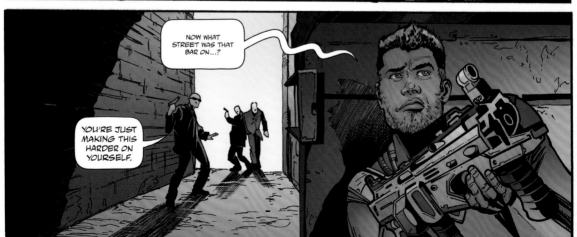

NOW WHAT STREET WAS THAT BAR ON...?

YOU'RE JUST MAKING THIS HARDER ON YOURSELF.

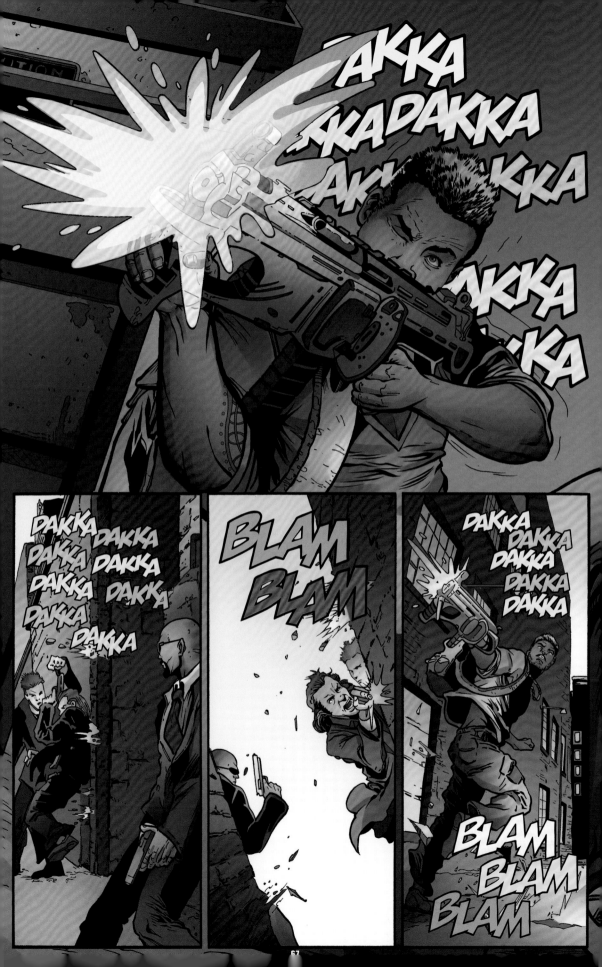

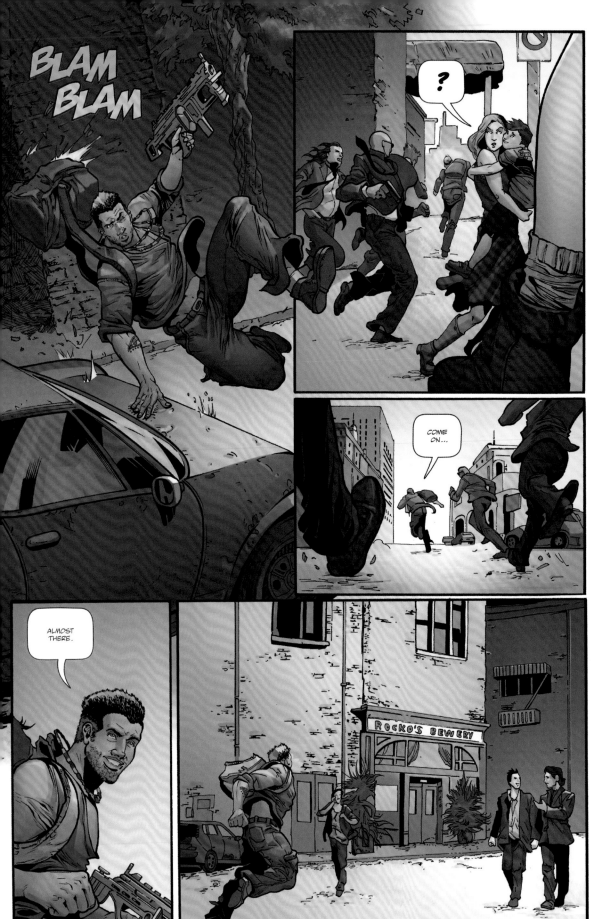

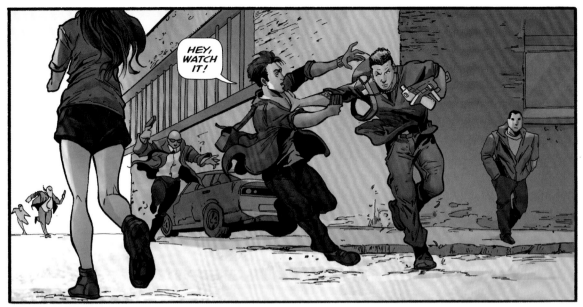

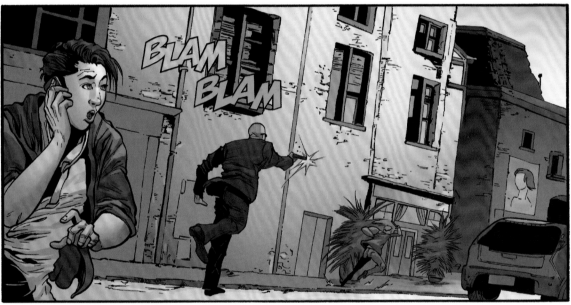

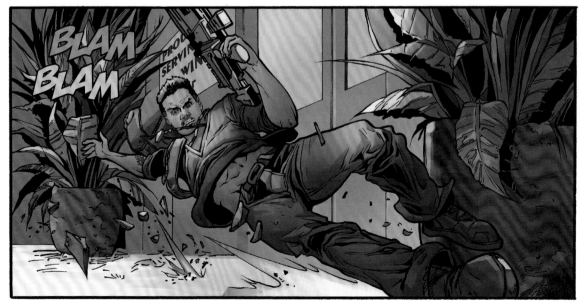

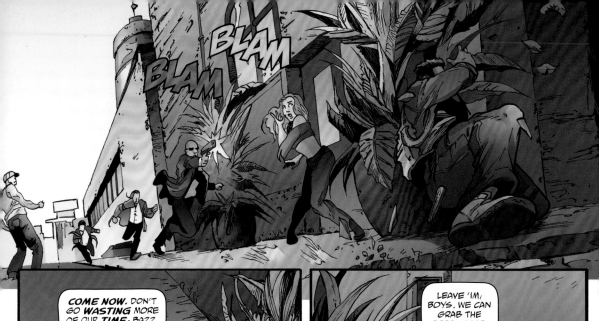

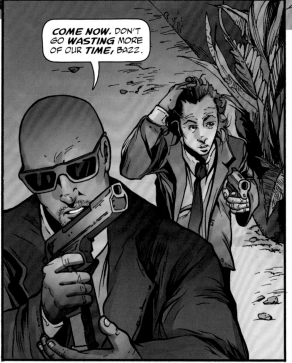

COME NOW. DON'T GO **WASTING** MORE OF OUR **TIME**, BAZZ.

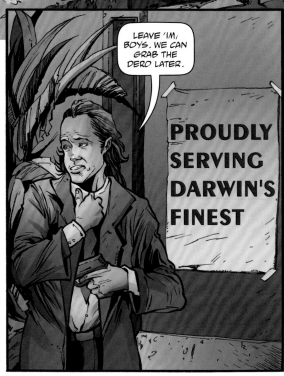

LEAVE 'IM, BOYS. WE CAN GRAB THE DERO LATER.

PROUDLY SERVING DARWIN'S FINEST

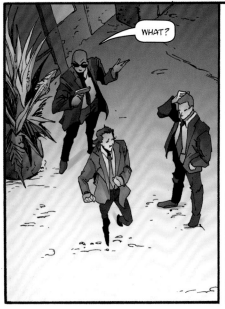

WHAT?

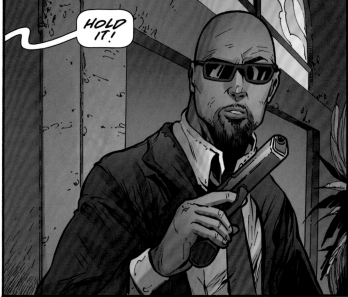

HOLD IT!

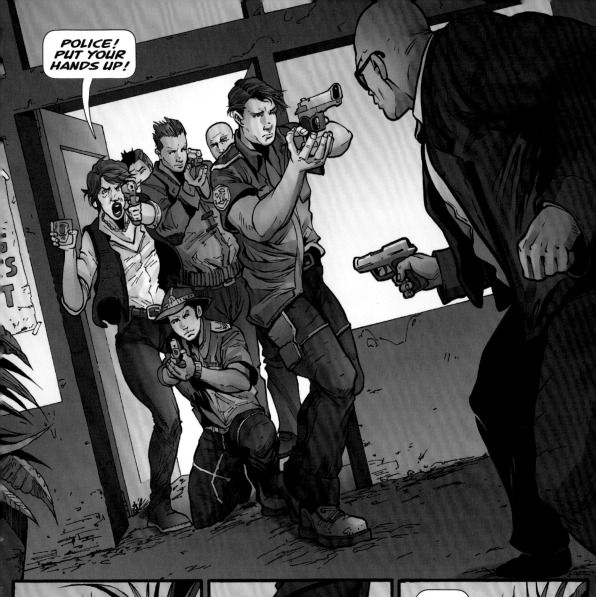

POLICE! PUT YOUR HANDS UP!

DROP THE WEAPON!

K-CHANK

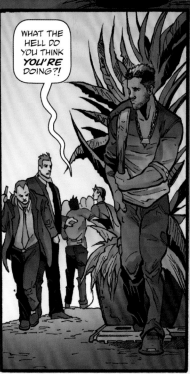

WHAT THE HELL DO YOU THINK YOU'RE DOING?!

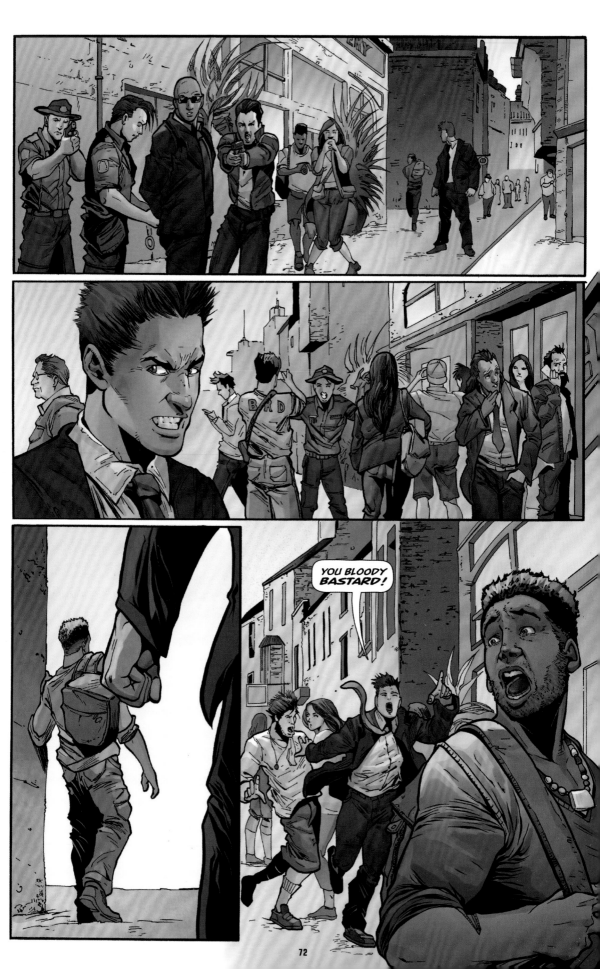

YOU BLOODY
BASTARD!

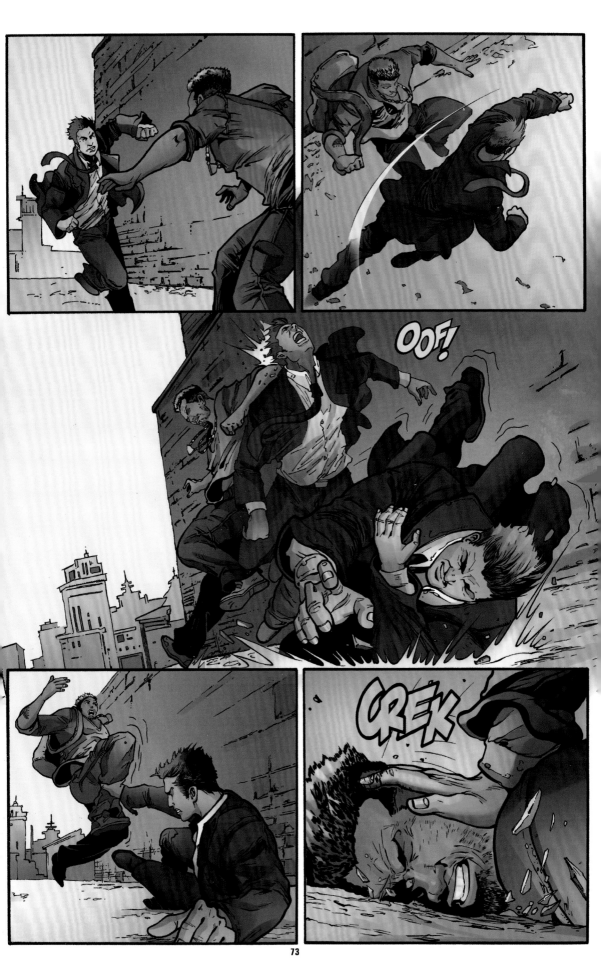

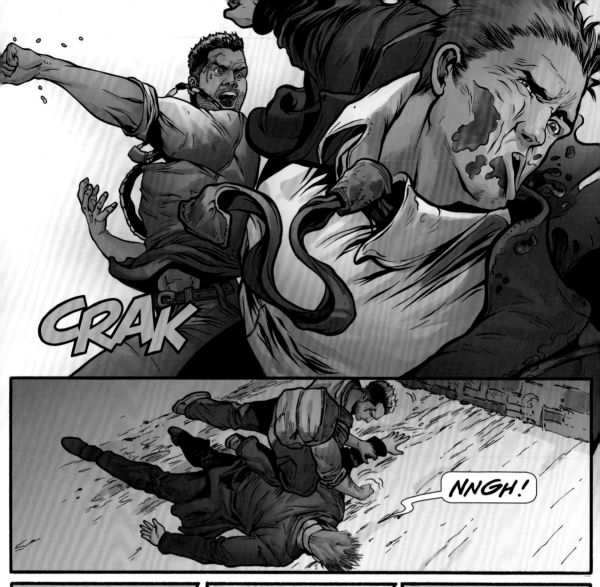

CRAK

NNGH!

WWAK

RIGHT, THAT'S *ENOUGH*--!

MFPH!

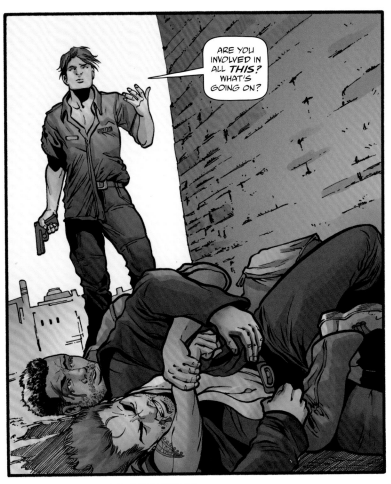

ARE YOU INVOLVED IN ALL *THIS*? WHAT'S GOING ON?

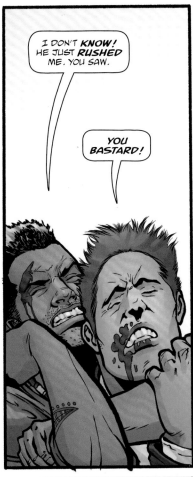

I DON'T *KNOW!* HE JUST *RUSHED* ME. YOU SAW.

YOU *BASTARD!*

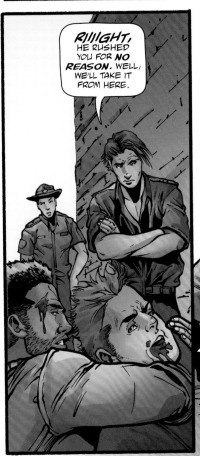

RIIIIGHT, HE RUSHED YOU FOR *NO REASON.* WELL, WE'LL TAKE IT FROM HERE.

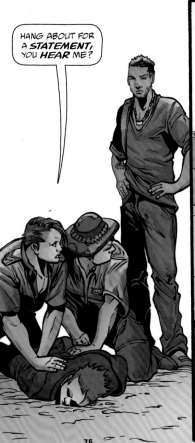

HANG ABOUT FOR A *STATEMENT,* YOU *HEAR* ME?

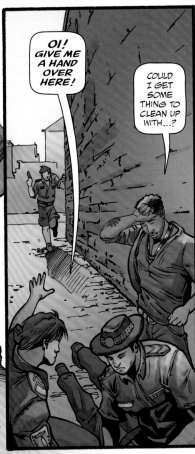

OI! GIVE ME A HAND OVER HERE!

COULD I GET SOMETHING TO CLEAN UP WITH...?

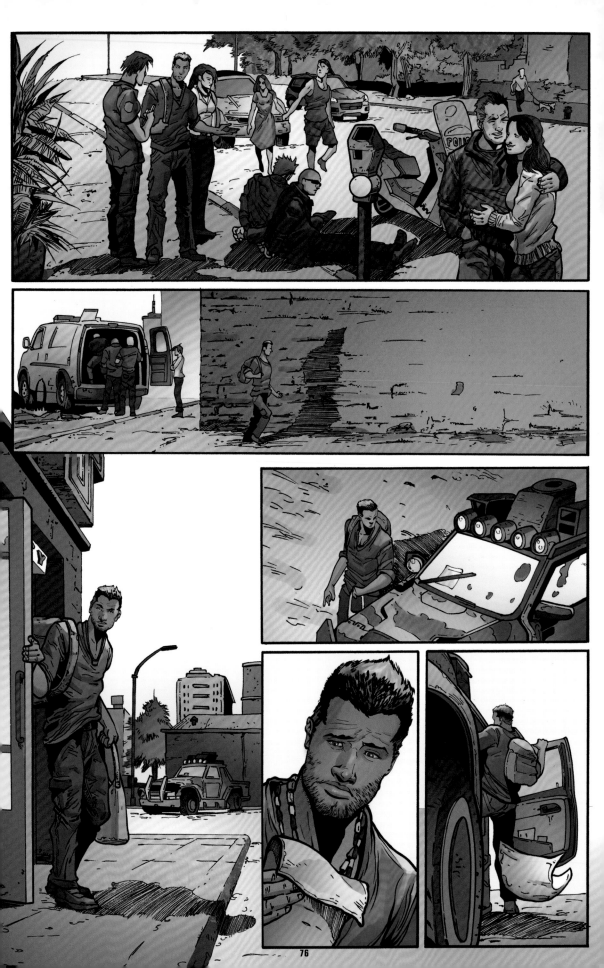

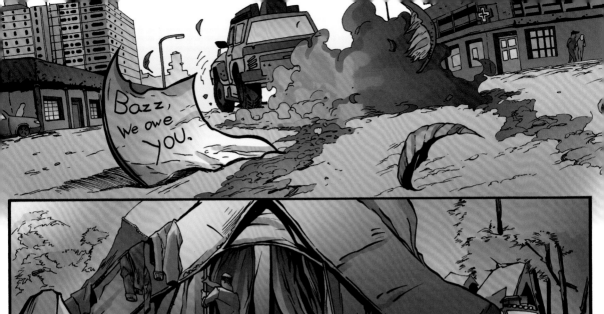

Bazz, we owe you.

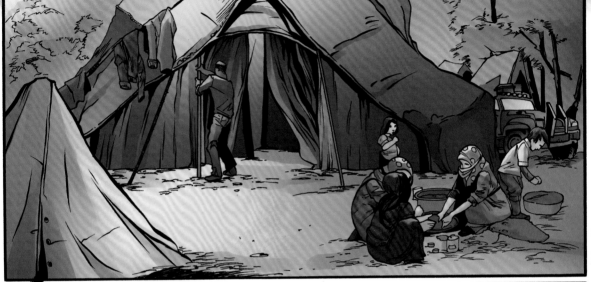

G'DAY.

I'M BACK, SO YOU DON'T HAVE TO CUT OFF MY LEG FOR REAL, DOC.

MISTER. I TOLD YOU I NEVER FINISHED SCHOOL.

AND IT WAS *VETERINARY SCHOOL* BESIDES.

OH... OKAY.

I HAVE YOUR AMOXICILLIN. I'LL JUST BE A MOMENT.

YOU LEAVING?

YUP.

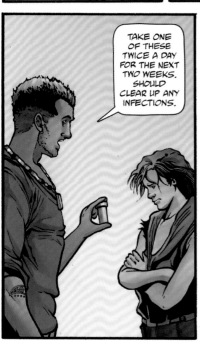

TAKE ONE OF THESE TWICE A DAY FOR THE NEXT TWO WEEKS. SHOULD CLEAR UP ANY INFECTIONS.

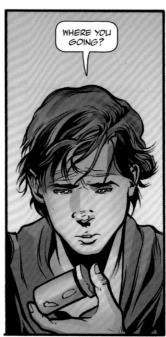

WHERE YOU GOING?

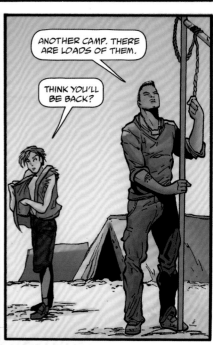

ANOTHER CAMP. THERE ARE LOADS OF THEM.

THINK YOU'LL BE BACK?

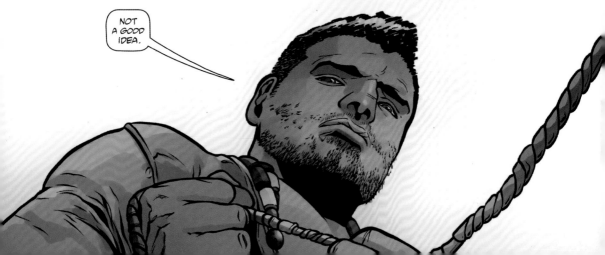

NOT A GOOD IDEA.

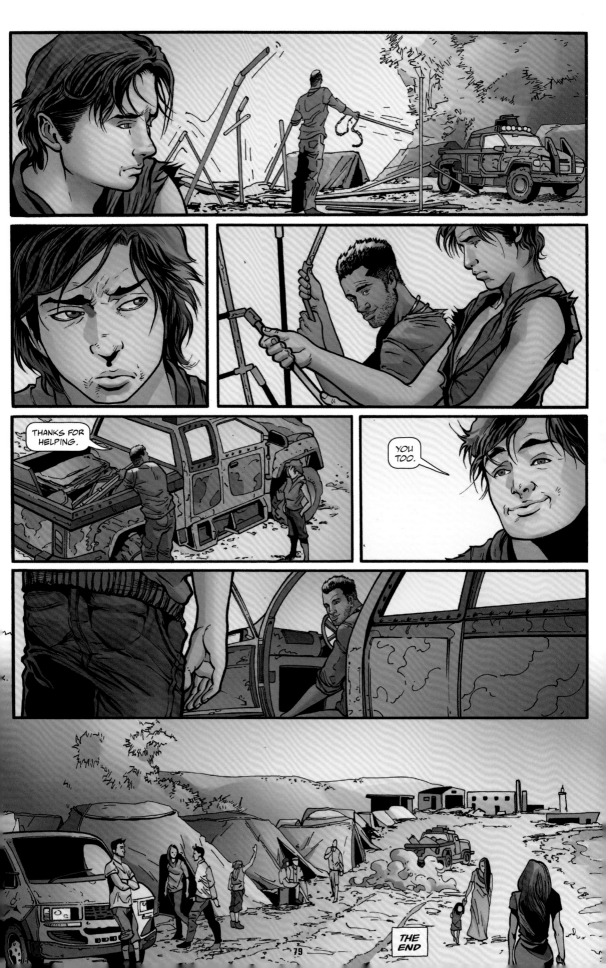

THANKS FOR HELPING.

YOU TOO.

THE END

# T O R Q U E

Writer: **Aaron Duran** / Penciler: **Jack Jadson** / Inkers: **Mário Loerzer** and **Jack Jadson**
Colorist: **Thiago Dal Bello**
Cover Artist: **Kirbi Fagan**

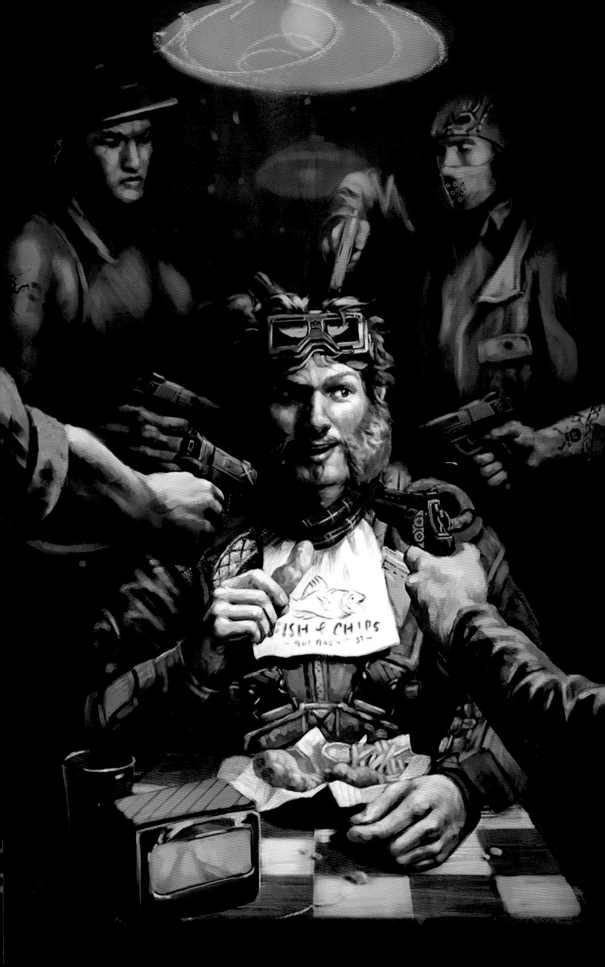

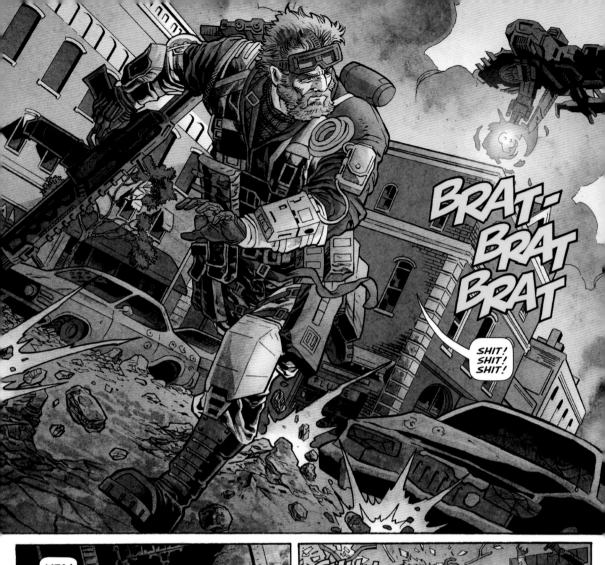

BRAT-
BRAT
BRAT

SHIT!
SHIT!
SHIT!

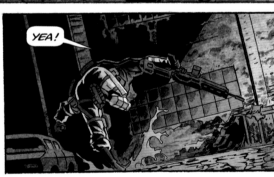

YEA!

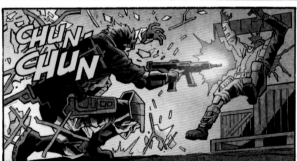

CHUN-
CHUN

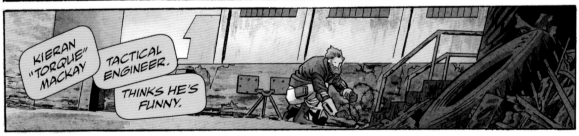

KIERAN
"TORQUE"
MACKAY

TACTICAL
ENGINEER.

THINKS HE'S
FUNNY.

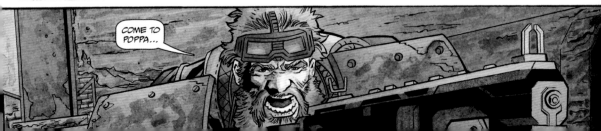

COME TO
POPPA...

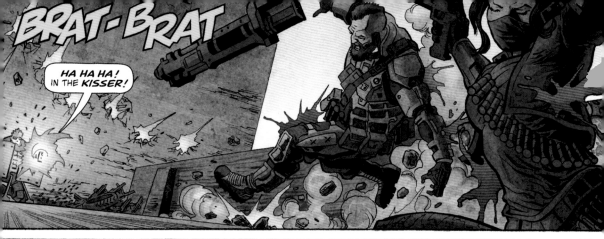

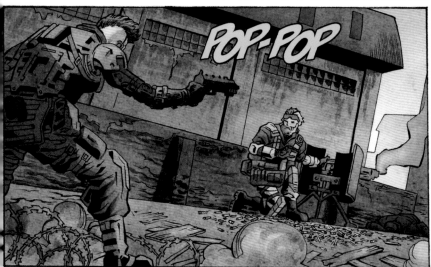

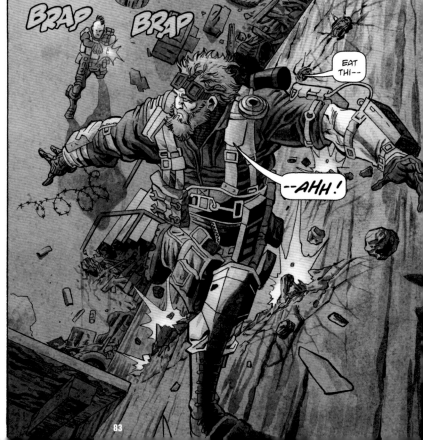

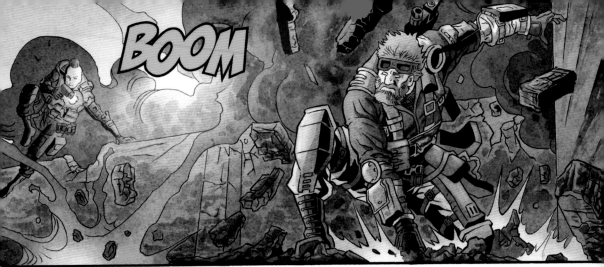

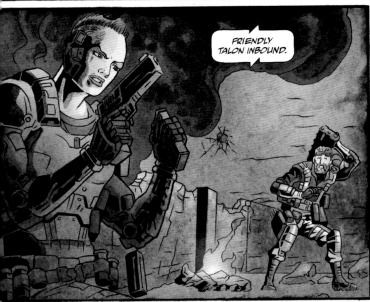

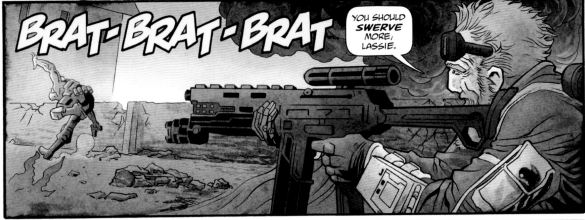

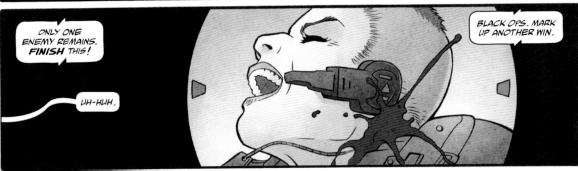

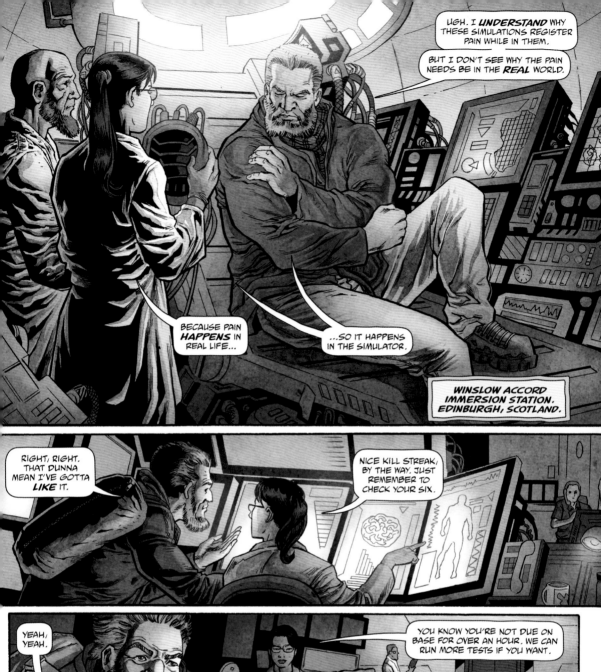

UGH. I **UNDERSTAND** WHY THESE SIMULATIONS REGISTER PAIN WHILE IN THEM.

BUT I DON'T SEE WHY THE PAIN NEEDS BE IN THE **REAL** WORLD.

BECAUSE PAIN **HAPPENS** IN REAL LIFE...

...SO IT HAPPENS IN THE SIMULATOR.

WINSLOW ACCORD IMMERSION STATION. EDINBURGH, SCOTLAND.

RIGHT, RIGHT. THAT DUNNA MEAN I'VE GOTTA **LIKE** IT.

NICE KILL STREAK, BY THE WAY. JUST REMEMBER TO CHECK YOUR SIX.

YEAH, YEAH.

YOU KNOW YOU'RE NOT DUE ON BASE FOR OVER AN HOUR. WE CAN RUN MORE TESTS IF YOU WANT.

NAH, I NEED TO GET MOVING SO I'M NOT LATE FOR MY MEETING WITH THE CAPTAIN.

BELIEVE ME, IN THE REAL WORLD, I **NEVER** MAKE THAT MISTAKE.

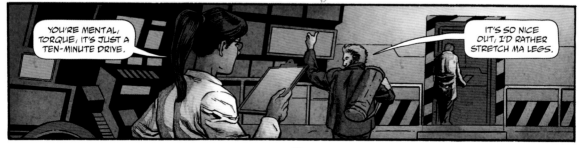

YOU'RE MENTAL, TORQUE, IT'S JUST A TEN-MINUTE DRIVE.

IT'S SO NICE OUT, I'D RATHER STRETCH MA LEGS.

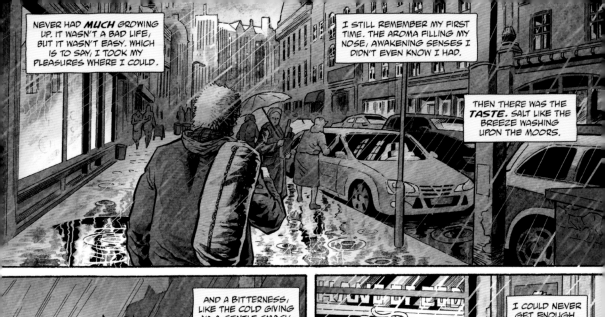

NEVER HAD *MUCH* GROWING UP. IT WASN'T A BAD LIFE, BUT IT WASN'T EASY. WHICH IS TO SAY, I TOOK MY PLEASURES WHERE I COULD.

I STILL REMEMBER MY FIRST TIME. THE AROMA FILLING MY NOSE, AWAKENING SENSES I DIDN'T EVEN KNOW I HAD.

THEN THERE WAS THE *TASTE.* SALT LIKE THE BREEZE WASHING UPON THE MOORS.

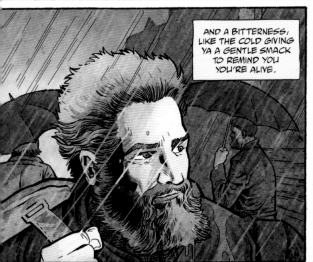

AND A BITTERNESS, LIKE THE COLD GIVING YA A GENTLE SMACK TO REMIND YOU YOU'RE ALIVE.

I COULD NEVER GET ENOUGH. EVEN NOW, ALL THESE YEARS GONE, I CAN REMEMBER MY FIRST TIME.

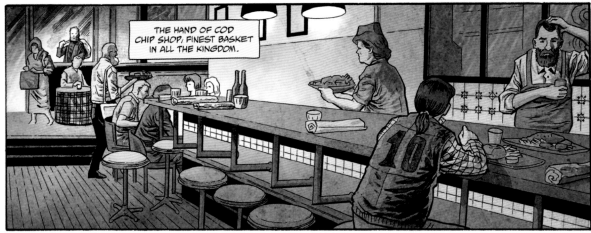

THE HAND OF COD CHIP SHOP, FINEST BASKET IN ALL THE KINGDOM.

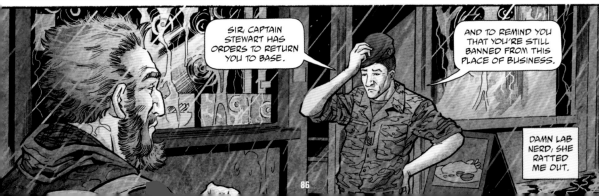

SIR, CAPTAIN STEWART HAS ORDERS TO RETURN YOU TO BASE.

AND TO REMIND YOU THAT YOU'RE STILL BANNED FROM THIS PLACE OF BUSINESS.

DAMN LAB NERD, SHE RATTED ME OUT.

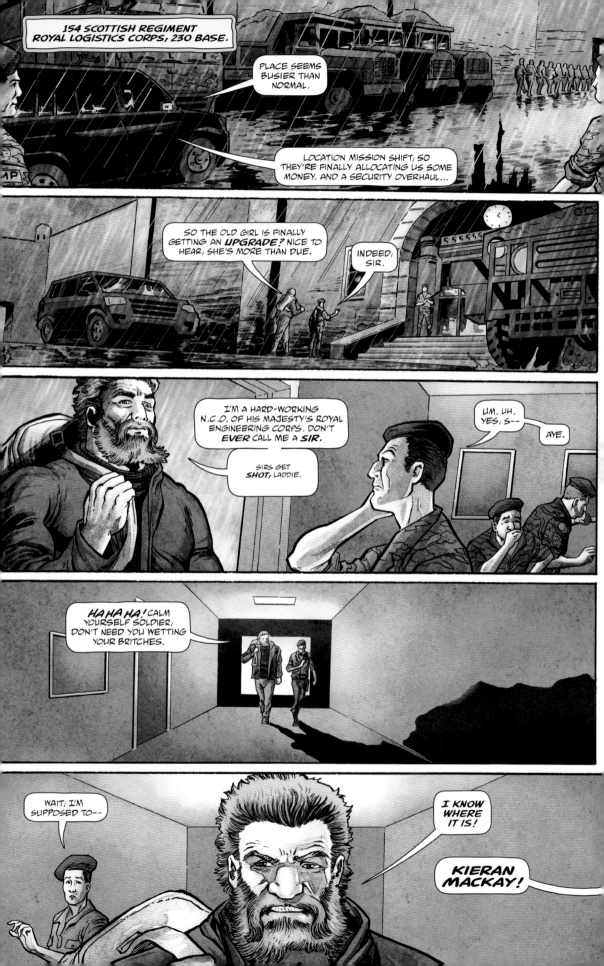

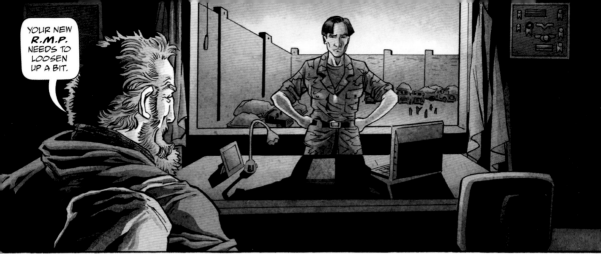

YOUR NEW *R.M.P.* NEEDS TO LOOSEN UP A BIT.

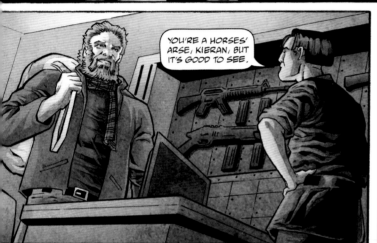

YOU'RE A HORSES' ARSE, KIERAN, BUT IT'S GOOD TO SEE.

*HAHAHA*--ON BASE, IT'S *TORQUE.* AND SAME.

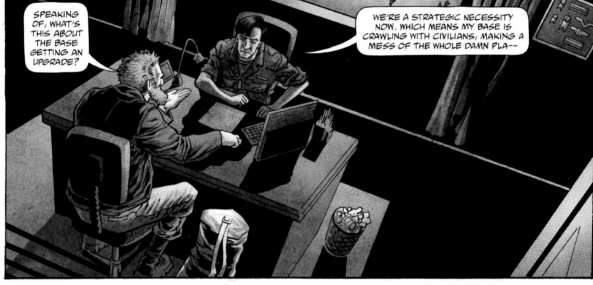

SPEAKING OF, WHAT'S THIS ABOUT THE BASE GETTING AN UPGRADE?

WE'RE A STRATEGIC NECESSITY NOW. WHICH MEANS MY BASE IS CRAWLING WITH CIVILIANS, MAKING A MESS OF THE WHOLE DAMN PLA--

KRA-BOOM

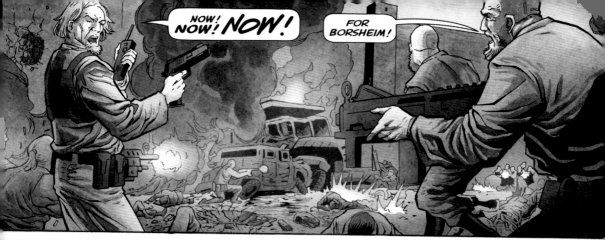

NOW! NOW! **NOW!**

FOR BORSHEIM!

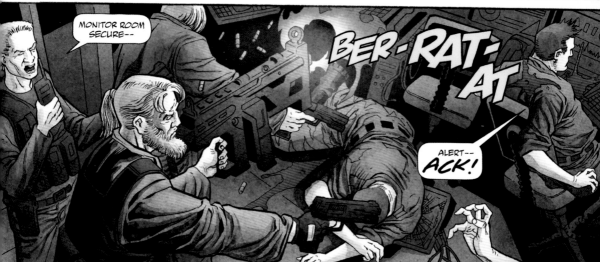

MONITOR ROOM SECURE--

**BER-RAT-AT**

ALERT-- **ACK!**

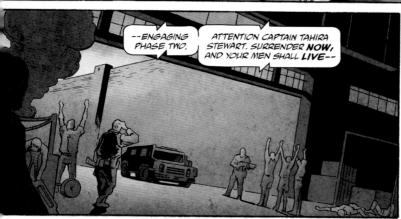

--ENGAGING PHASE TWO.

ATTENTION CAPTAIN TAHIRA STEWART. SURRENDER **NOW,** AND YOUR MEN SHALL **LIVE**--

--WHAT'S **LEFT** OF THEM.

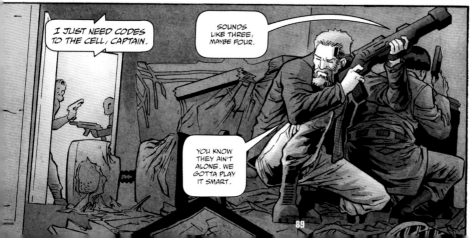

I JUST NEED CODES TO THE CELL, CAPTAIN.

SOUNDS LIKE THREE, MAYBE FOUR.

YOU KNOW THEY AIN'T ALONE. WE GOTTA PLAY IT SMART.

COME ON.

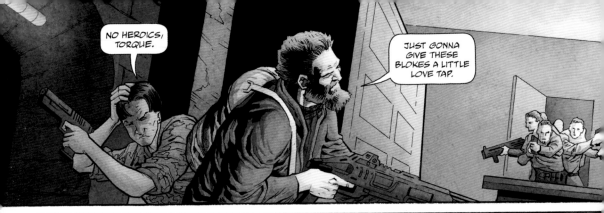

NO HEROICS, TORQUE.

JUST GONNA GIVE THESE BLOKES A LITTLE LOVE TAP.

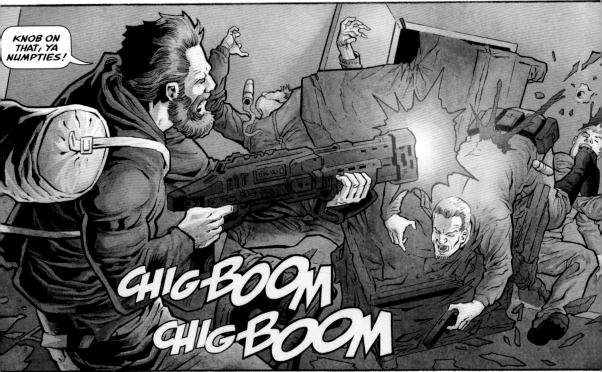

KNOB ON THAT, YA NUMPTIES!

CHIG-BOOM
CHIG-BOOM

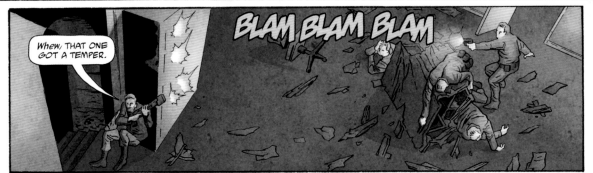

BLAM BLAM BLAM

WHEW, THAT ONE GOT A TEMPER.

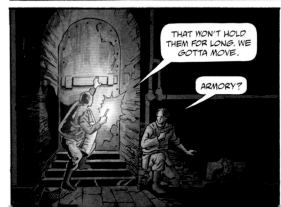

THAT WON'T HOLD THEM FOR LONG. WE GOTTA MOVE.

ARMORY?

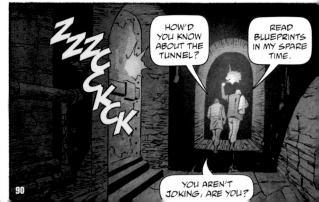

ZZZCKCK

HOW'D YOU KNOW ABOUT THE TUNNEL?

READ BLUEPRINTS IN MY SPARE TIME.

YOU AREN'T JOKING, ARE YOU?

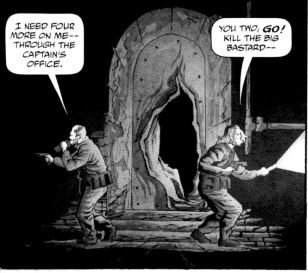

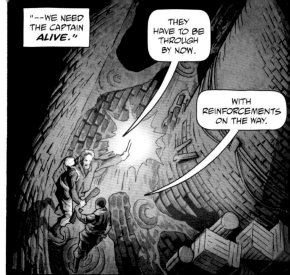

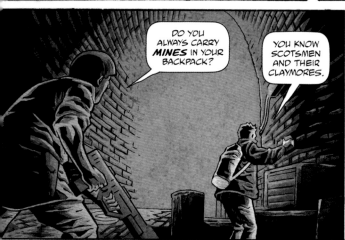

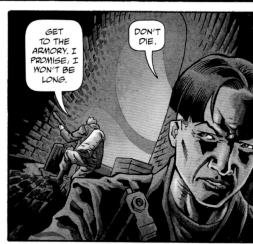

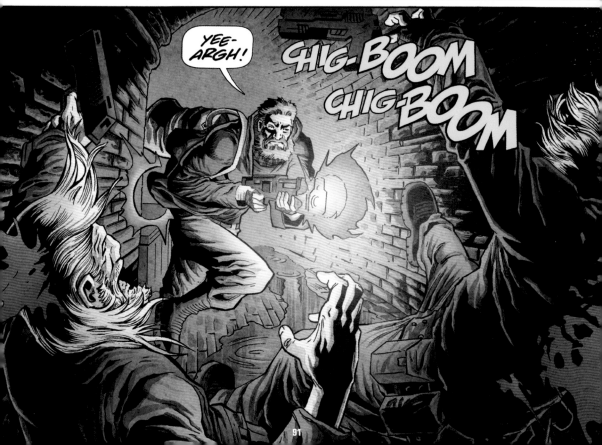

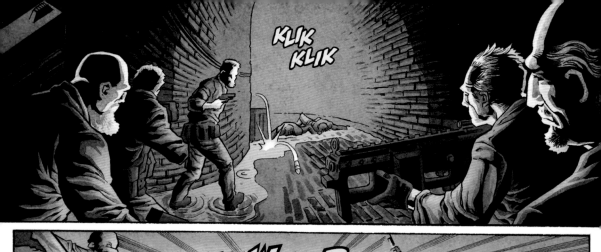

KLIK
KLIK

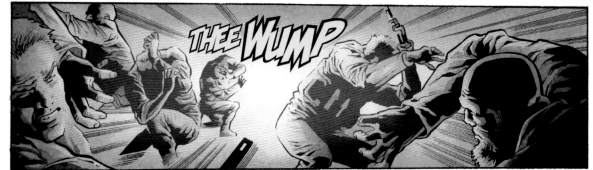

THEE WUMP

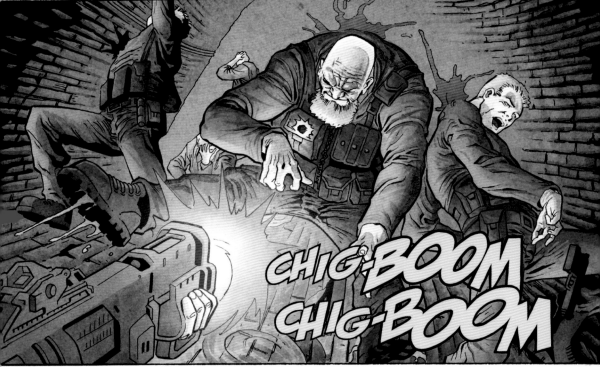

CHIG-BOOM
CHIG-BOOM

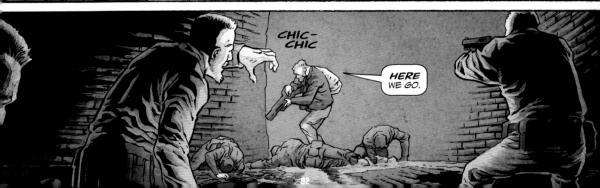

CHIC-CHIC

HERE
WE GO.

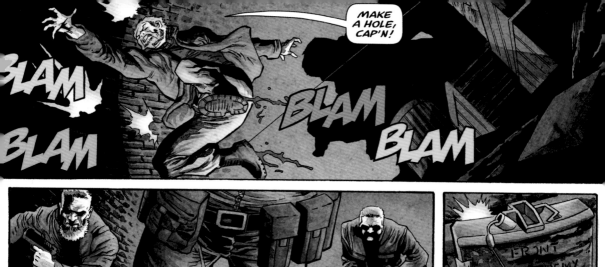

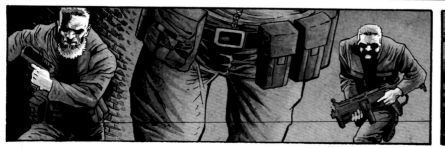

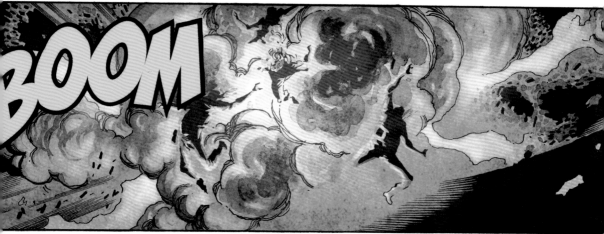

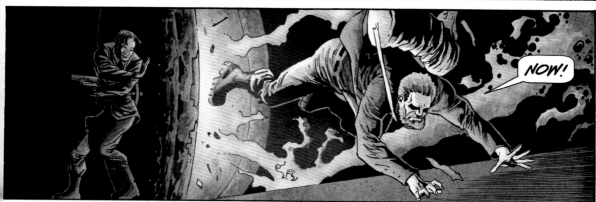

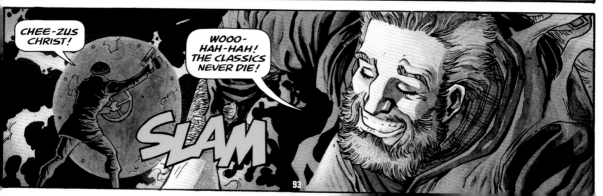

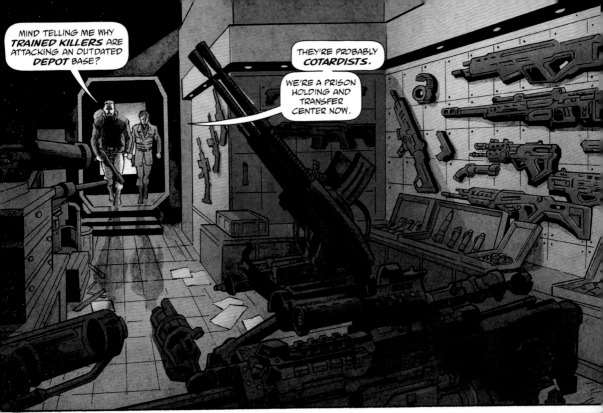

MIND TELLING ME WHY *TRAINED KILLERS* ARE ATTACKING AN OUTDATED *DEPOT* BASE?

THEY'RE PROBABLY *COTARDISTS*.

WE'RE A PRISON HOLDING AND TRANSFER CENTER NOW.

HOW LONG YOU BEEN HIDING THIS BEAUTY DOWN HERE, CAP'N?!

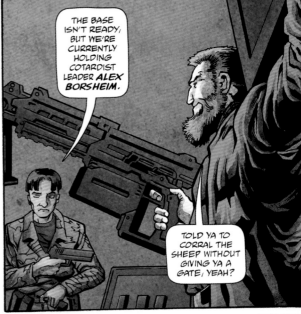

THE BASE ISN'T READY, BUT WE'RE CURRENTLY HOLDING COTARDIST LEADER *ALEX BORSHEIM*.

TOLD YA TO CORRAL THE SHEEP WITHOUT GIVING YA A GATE, YEAH?

HOW'D THOSE FUCKERS PULL THIS OFF? THE WHOLE OPERATION IS *OFF BOOKS!*

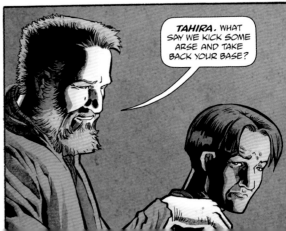

*TAHIRA*. WHAT SAY WE KICK SOME ARSE AND TAKE BACK YOUR BASE?

THIS DON'T MEAN WE'RE SQUARE ON THE *DRONE PRANK* YA PULLED.

I WAS PULLING BITS OF BLUE PAINT FROM MY BEARD FOR *WEEKS.*

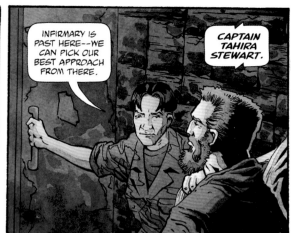

INFIRMARY IS PAST HERE--WE CAN PICK OUR BEST APPROACH FROM THERE.

*CAPTAIN TAHIRA STEWART.*

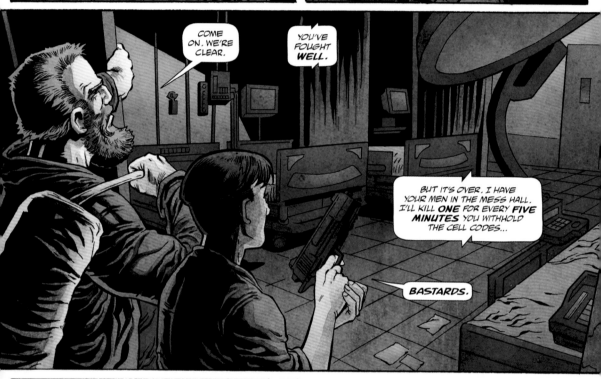

COME ON. WE'RE CLEAR.

YOU'VE FOUGHT *WELL.*

BUT IT'S OVER. I HAVE YOUR MEN IN THE MESS HALL. I'LL KILL *ONE* FOR EVERY *FIVE MINUTES* YOU WITHHOLD THE CELL CODES...

*BASTARDS.*

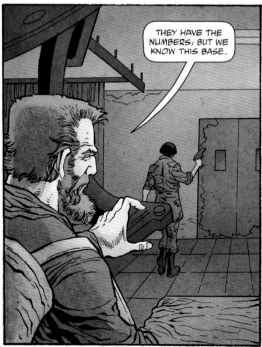

THEY HAVE THE NUMBERS, BUT WE KNOW THIS BASE.

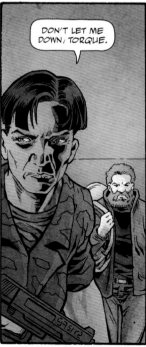

DON'T LET ME DOWN, TORQUE.

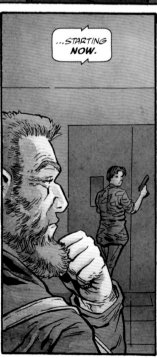

...STARTING *NOW.*

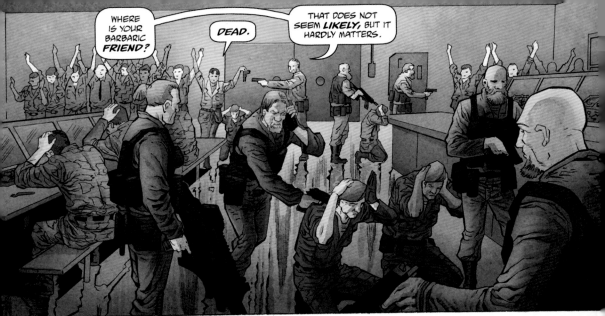

WHERE IS YOUR BARBARIC **FRIEND?**

**DEAD.**

THAT DOES NOT SEEM **LIKELY,** BUT IT HARDLY MATTERS.

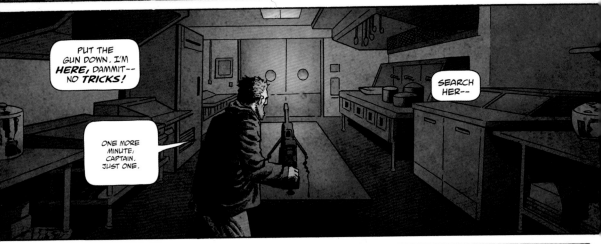

PUT THE GUN DOWN. I'M **HERE,** DAMMIT-- NO **TRICKS!**

ONE MORE MINUTE, CAPTAIN. JUST ONE.

SEARCH HER--

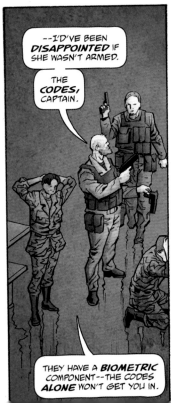

--I'D'VE BEEN **DISAPPOINTED** IF SHE WASN'T ARMED.

THE **CODES,** CAPTAIN.

THEY HAVE A **BIOMETRIC** COMPONENT--THE CODES **ALONE** WON'T GET YOU IN.

WHICH IS WHY MY MEN HAVE ORDERS TO **KILL** EVERYONE IF I DON'T RETURN WITH BORSHEIM WITHIN TEN MINUTES.

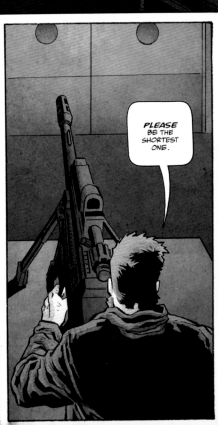

**PLEASE** BE THE SHORTEST ONE.

96

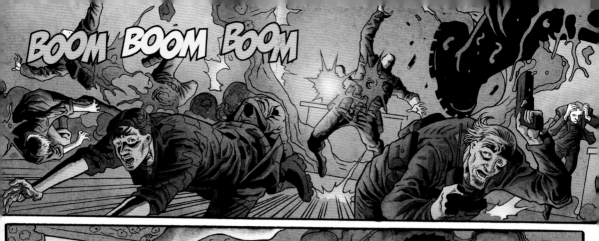

BOOM BOOM BOOM

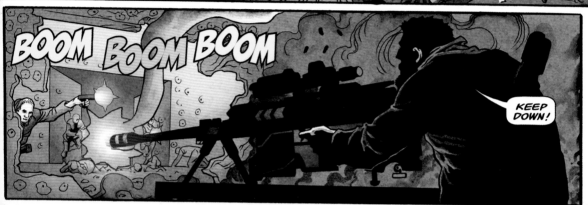

BOOM BOOM BOOM

KEEP DOWN!

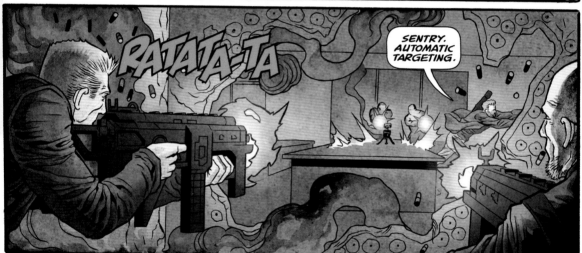

RATAT-TA

SENTRY. AUTOMATIC TARGETING.

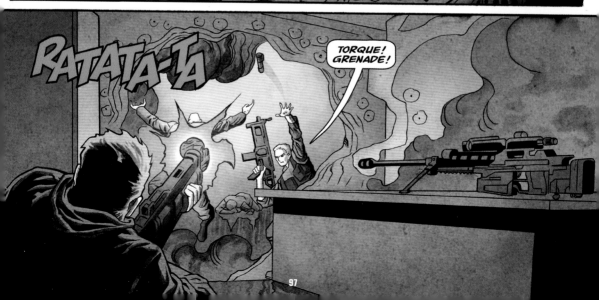

RATATA-TA

TORQUE! GRENADE!

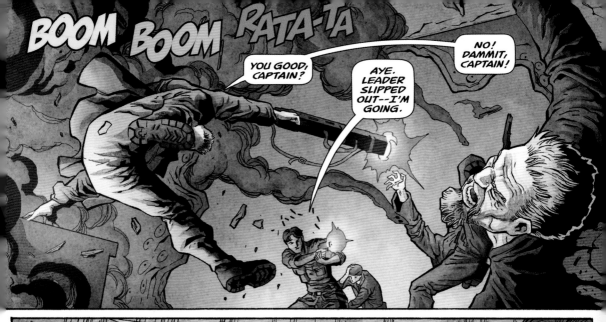

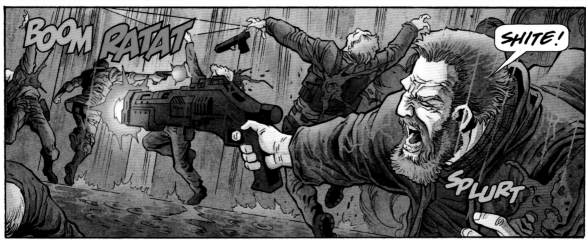

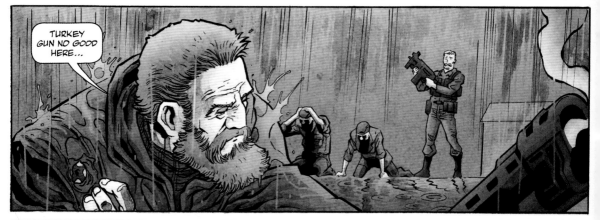

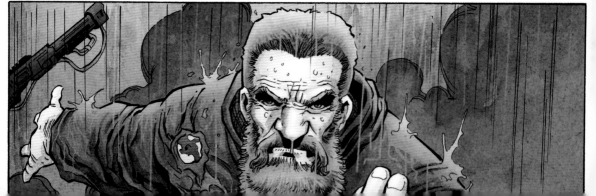

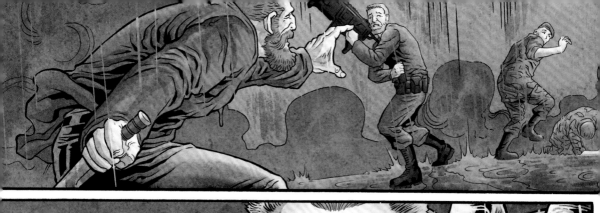

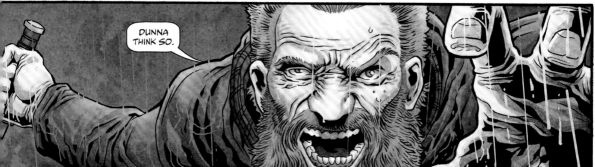

DUNNA THINK SO.

CLICK

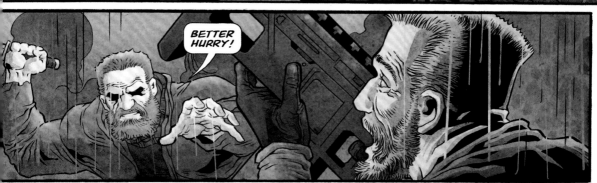

BETTER HURRY!

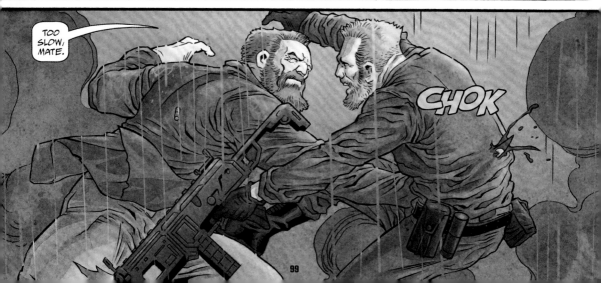

TOO SLOW, MATE.

CHOK

99

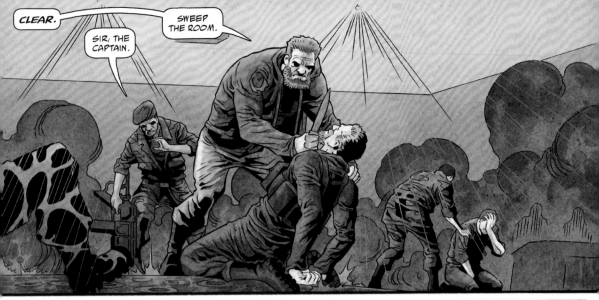

CLEAR.

SWEEP THE ROOM.

SIR, THE CAPTAIN.

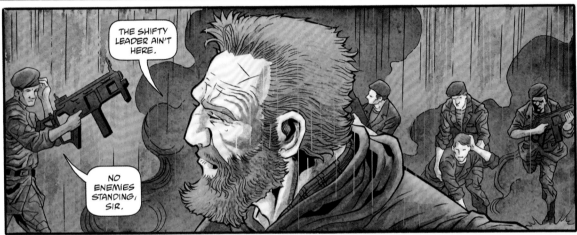

THE SHIFTY LEADER AIN'T HERE.

NO ENEMIES STANDING, SIR.

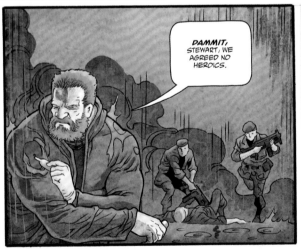

DAMMIT, STEWART, WE AGREED NO HEROICS.

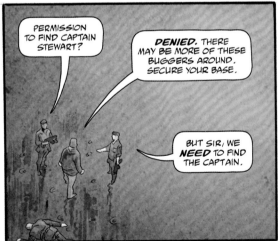

PERMISSION TO FIND CAPTAIN STEWART?

DENIED. THERE MAY BE MORE OF THESE BUGGERS AROUND. SECURE YOUR BASE.

BUT SIR, WE NEED TO FIND THE CAPTAIN.

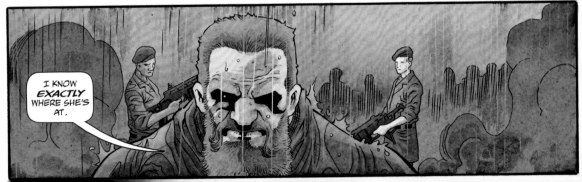

I KNOW EXACTLY WHERE SHE'S AT.

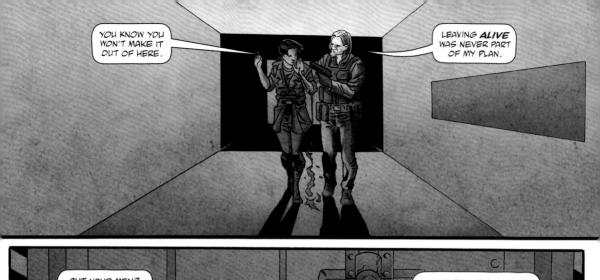

YOU KNOW YOU WON'T MAKE IT OUT OF HERE.

LEAVING *ALIVE* WAS NEVER PART OF MY PLAN.

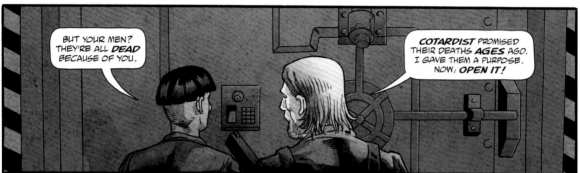

BUT YOUR MEN? THEY'RE ALL *DEAD* BECAUSE OF YOU.

*COTARDIST* PROMISED THEIR DEATHS *AGES* AGO. I GAVE THEM A PURPOSE. NOW, *OPEN IT!*

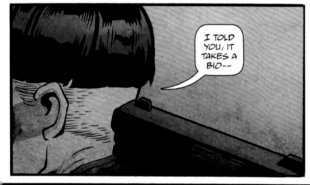

I TOLD YOU, IT TAKES A BIO--

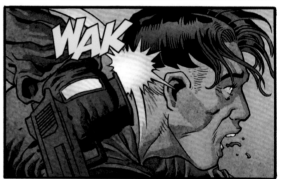

WAK

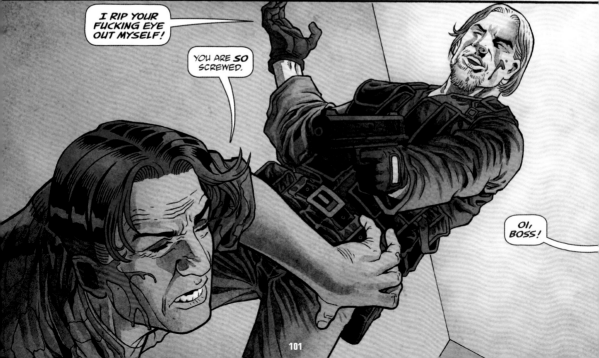

I RIP YOUR *FUCKING* EYE OUT MYSELF!

YOU ARE *SO* SCREWED.

OI, BOSS!

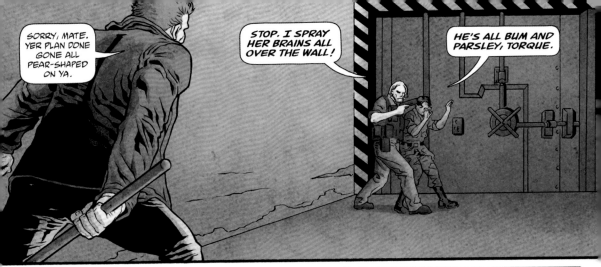

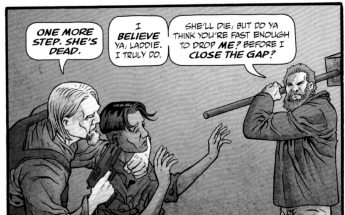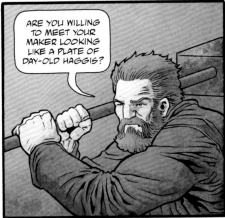

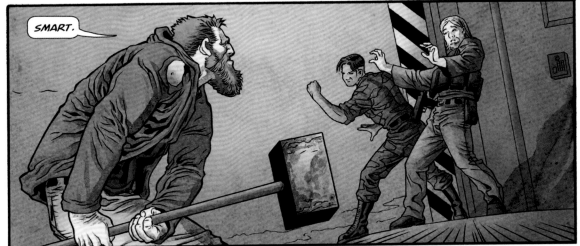

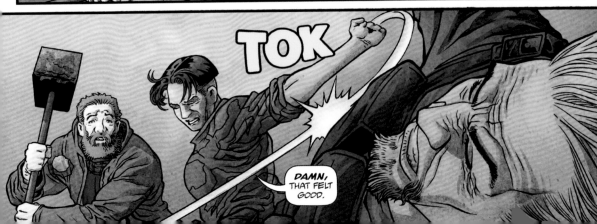

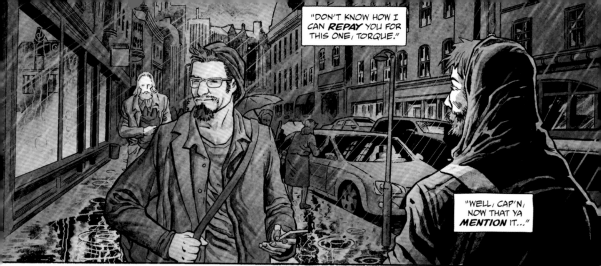

"DON'T KNOW HOW I CAN **REPAY** YOU FOR THIS ONE, TORQUE."

"WELL, CAP'N, NOW THAT YA **MENTION** IT..."

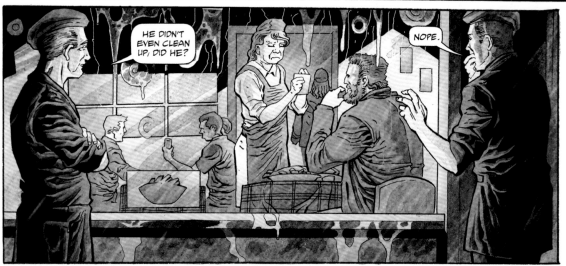

HE DIDN'T EVEN CLEAN UP, DID HE?

NOPE.

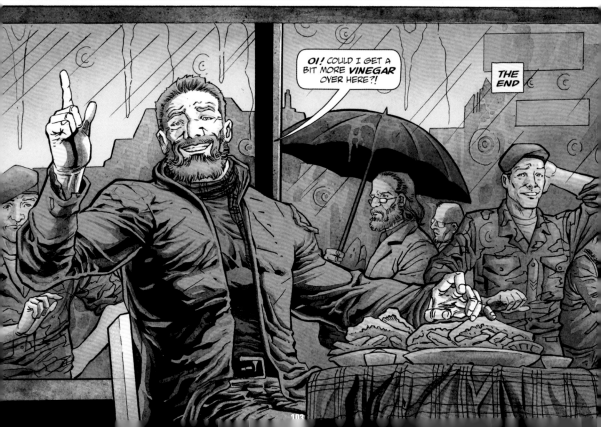

OI! COULD I GET A BIT MORE **VINEGAR** OVER HERE?!

THE END

# FIREBREAK

Writer: **Jeremy Barlow** / Penciler: **Dheeraj Verma**
Inkers: **Bill Anderson, Belardino Brabo, Ronilson Freire** and **Dheeraj Verma**
Colorist: **Sebastian Cheng**
Cover Artist: **Eric Wilkerson**

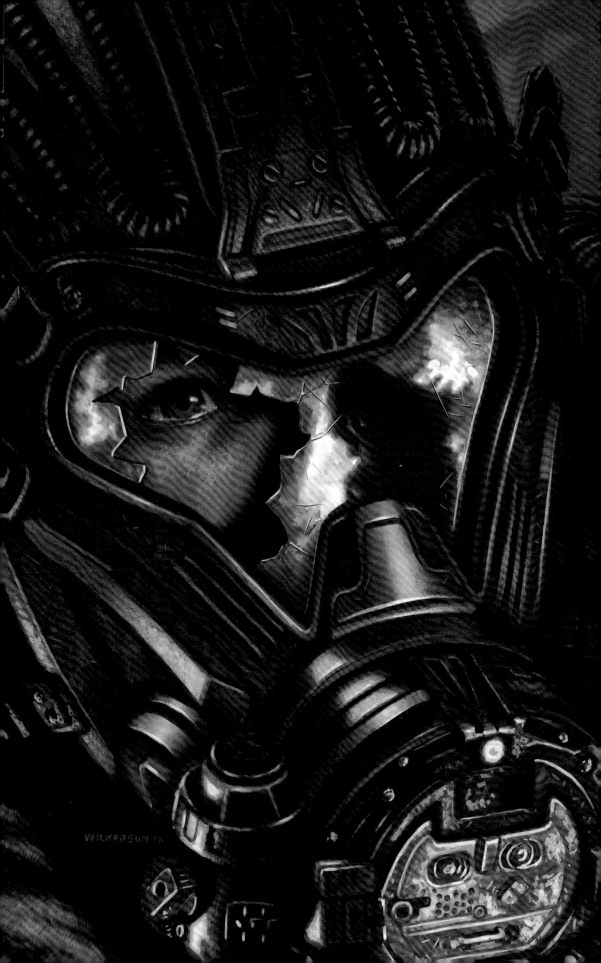

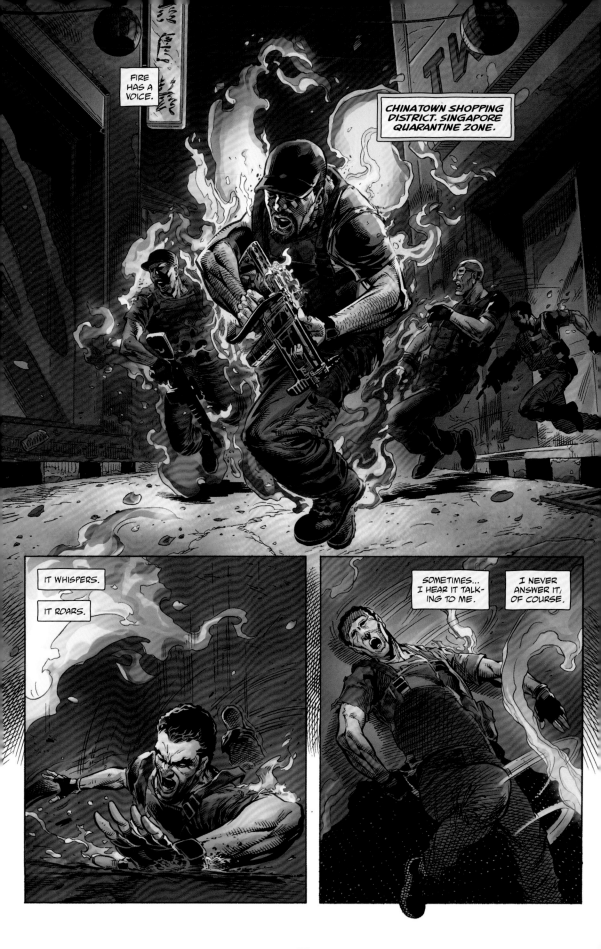

FIRE HAS A VOICE.

CHINATOWN SHOPPING DISTRICT. SINGAPORE QUARANTINE ZONE.

IT WHISPERS.

IT ROARS.

SOMETIMES... I HEAR IT TALKING TO ME.

I NEVER ANSWER IT, OF COURSE.

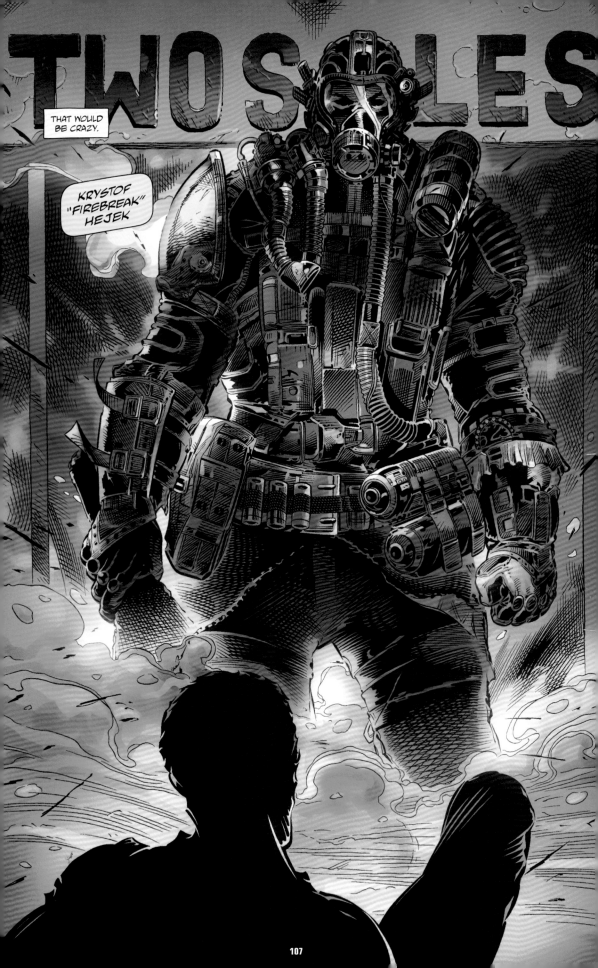

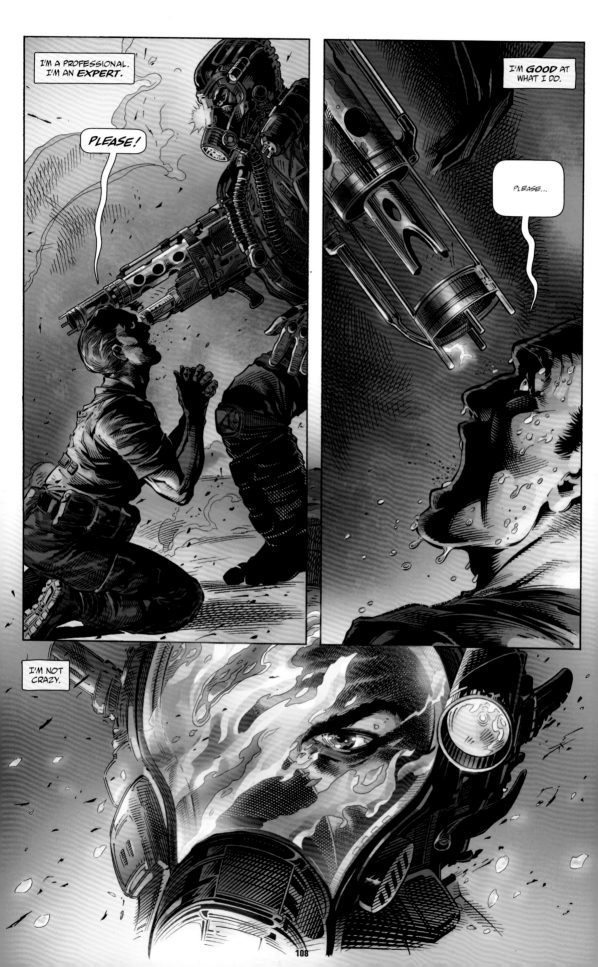

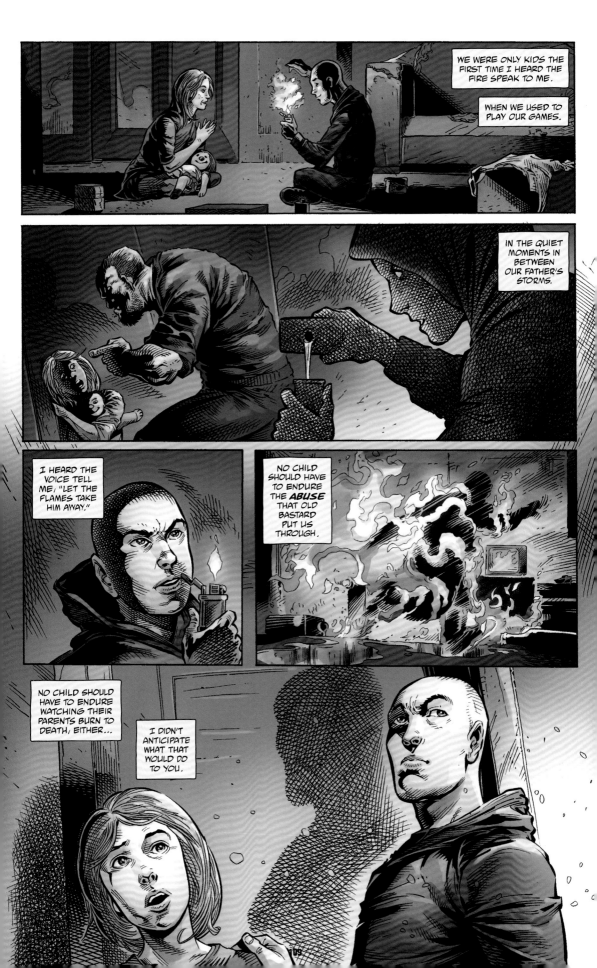

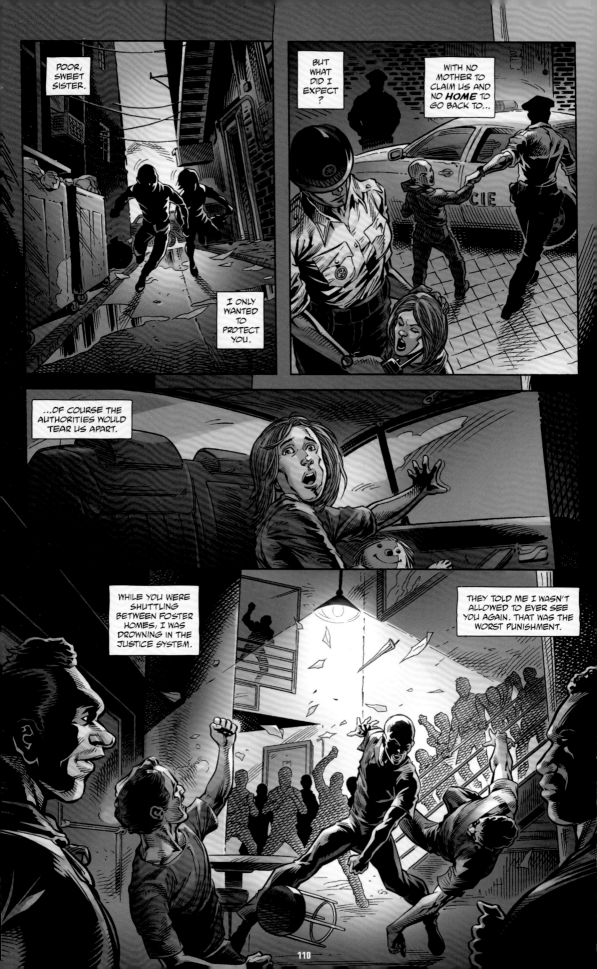

POOR, SWEET SISTER.

I ONLY WANTED TO PROTECT YOU.

BUT WHAT DID I EXPECT?

WITH NO MOTHER TO CLAIM US AND NO **HOME** TO GO BACK TO...

...OF COURSE THE AUTHORITIES WOULD TEAR US APART.

WHILE YOU WERE SHUTTLING BETWEEN FOSTER HOMES, I WAS DROWNING IN THE JUSTICE SYSTEM.

THEY TOLD ME I WASN'T ALLOWED TO EVER SEE YOU AGAIN. THAT WAS THE WORST PUNISHMENT.

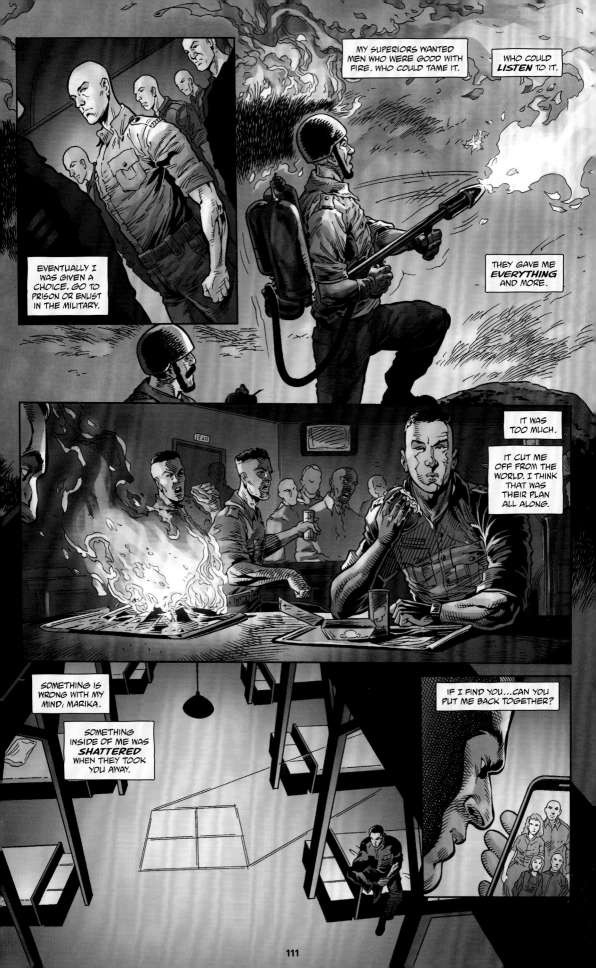

MY SUPERIORS WANTED MEN WHO WERE GOOD WITH FIRE. WHO COULD TAME IT.

WHO COULD *LISTEN* TO IT.

EVENTUALLY I WAS GIVEN A CHOICE. GO TO PRISON OR ENLIST IN THE MILITARY.

THEY GAVE ME *EVERYTHING* AND MORE.

IT WAS TOO MUCH.

IT CUT ME OFF FROM THE WORLD. I THINK THAT WAS THEIR PLAN ALL ALONG.

SOMETHING IS WRONG WITH MY MIND, MARIKA.

SOMETHING INSIDE OF ME WAS *SHATTERED* WHEN THEY TOOK YOU AWAY.

IF I FIND YOU...CAN YOU PUT ME BACK TOGETHER?

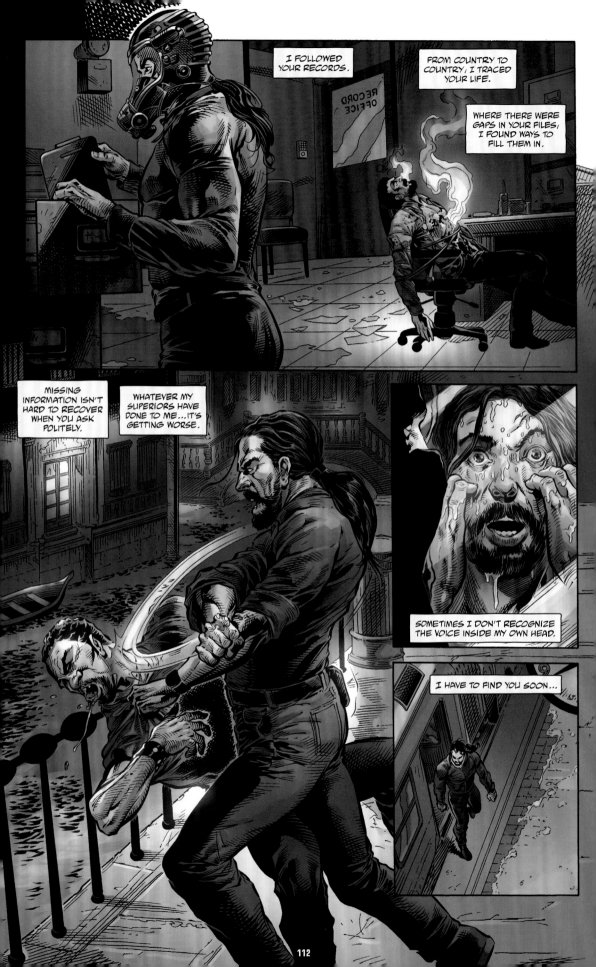

I FOLLOWED YOUR RECORDS.

FROM COUNTRY TO COUNTRY, I TRACED YOUR LIFE.

WHERE THERE WERE GAPS IN YOUR FILES, I FOUND WAYS TO FILL THEM IN.

MISSING INFORMATION ISN'T HARD TO RECOVER WHEN YOU ASK POLITELY.

WHATEVER MY SUPERIORS HAVE DONE TO ME...IT'S GETTING WORSE.

SOMETIMES I DON'T RECOGNIZE THE VOICE INSIDE MY OWN HEAD.

I HAVE TO FIND YOU SOON...

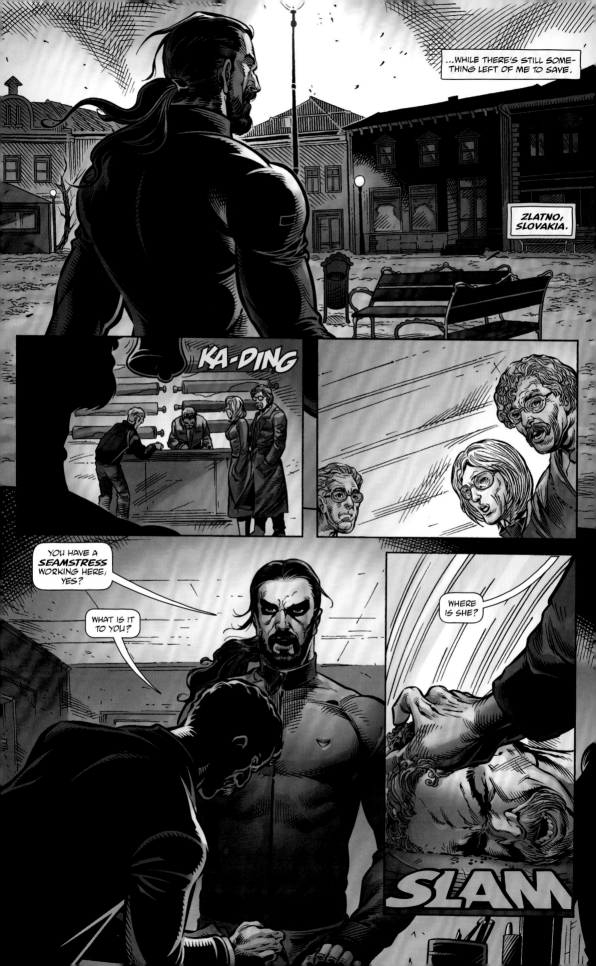

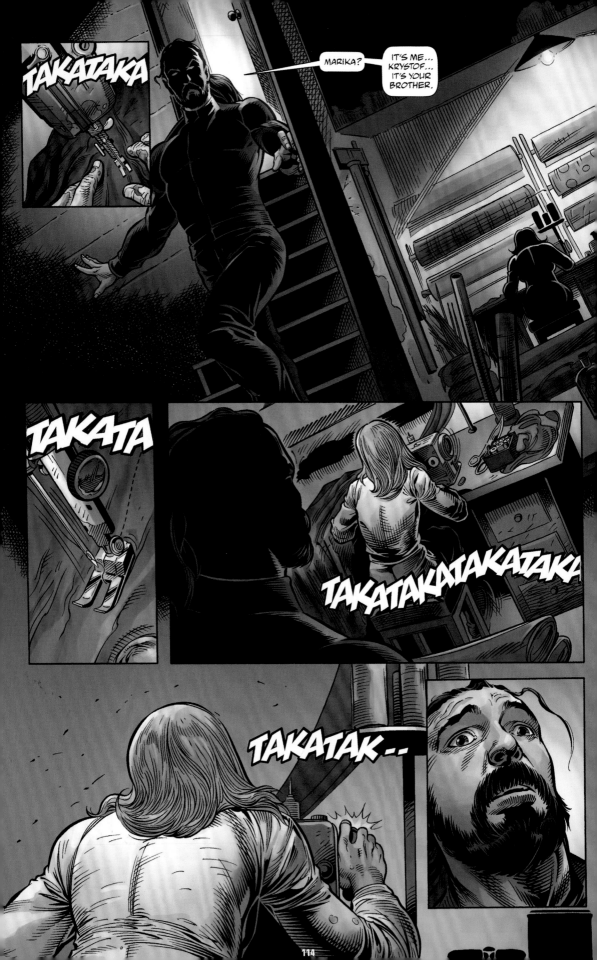

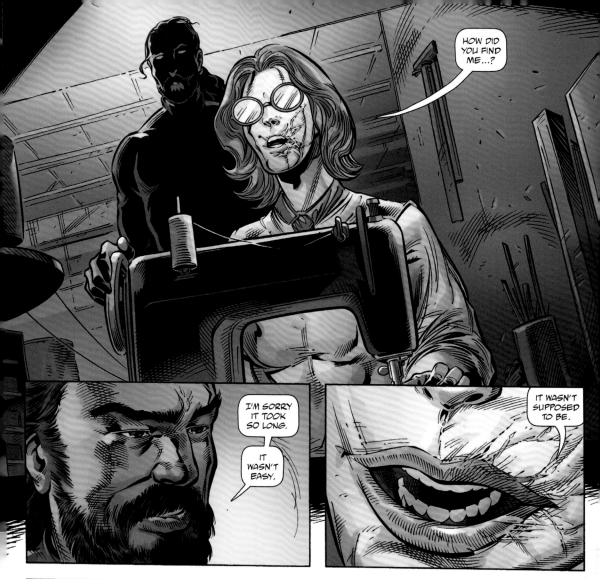

HOW DID YOU FIND ME...?

I'M SORRY IT TOOK SO LONG.

IT WASN'T EASY.

IT WASN'T SUPPOSED TO BE.

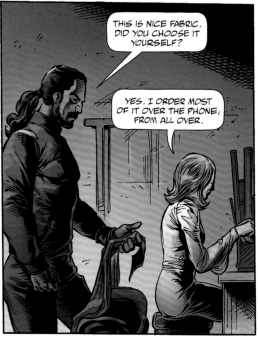

THIS IS NICE FABRIC. DID YOU CHOOSE IT YOURSELF?

YES, I ORDER MOST OF IT OVER THE PHONE, FROM ALL OVER.

WE SAVE A LITTLE MONEY IF WE PURCHASE IT BEFORE IT'S TREATED.

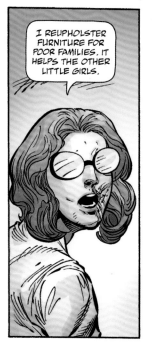

I REUPHOLSTER FURNITURE FOR POOR FAMILIES. IT HELPS THE OTHER LITTLE GIRLS.

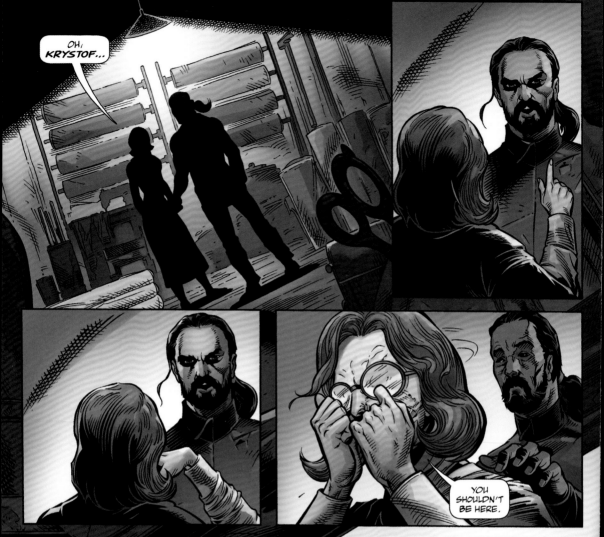

OH, *KRYSTOF*...

YOU SHOULDN'T BE HERE.

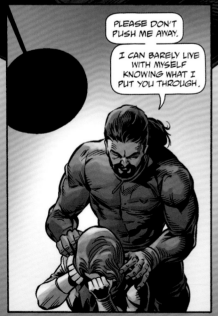

PLEASE DON'T PUSH ME AWAY.

I CAN BARELY LIVE WITH MYSELF KNOWING WHAT I PUT YOU THROUGH.

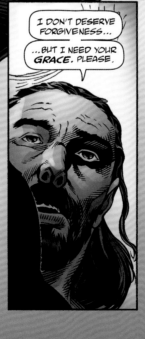

I DON'T DESERVE FORGIVENESS...

...BUT I NEED YOUR *GRACE*. PLEASE.

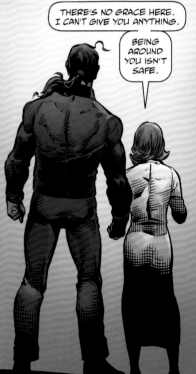

THERE'S NO GRACE HERE. I CAN'T GIVE YOU ANYTHING.

BEING AROUND YOU ISN'T SAFE.

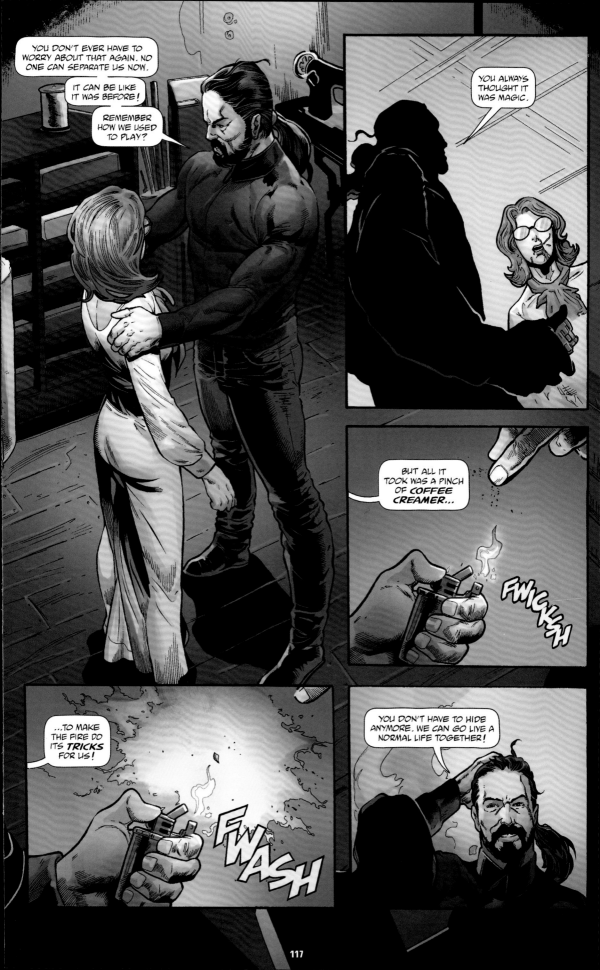

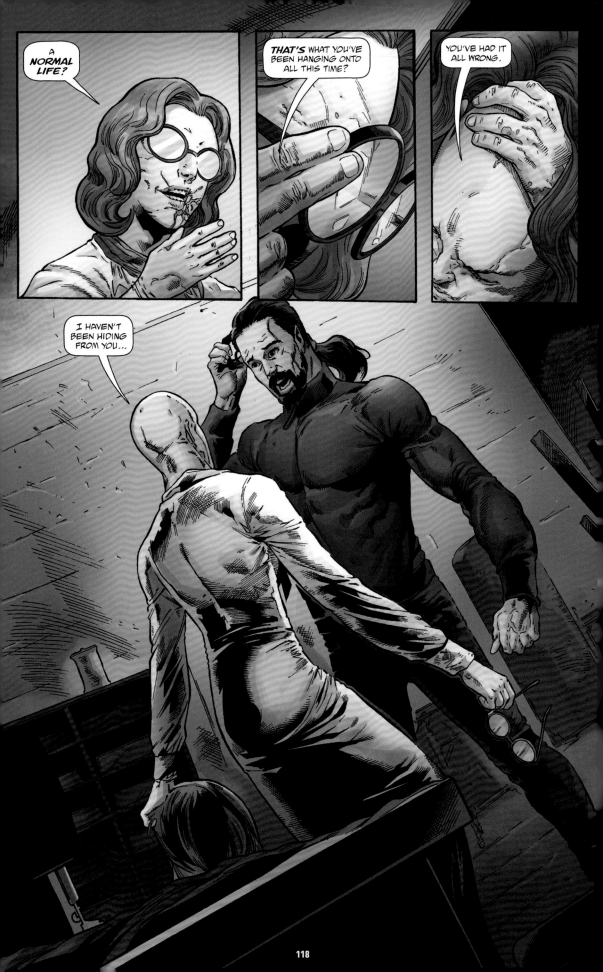

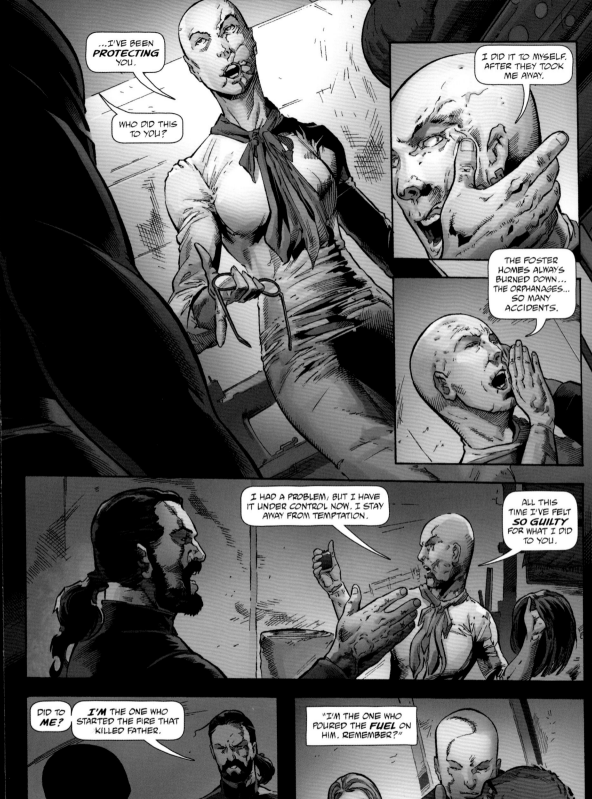

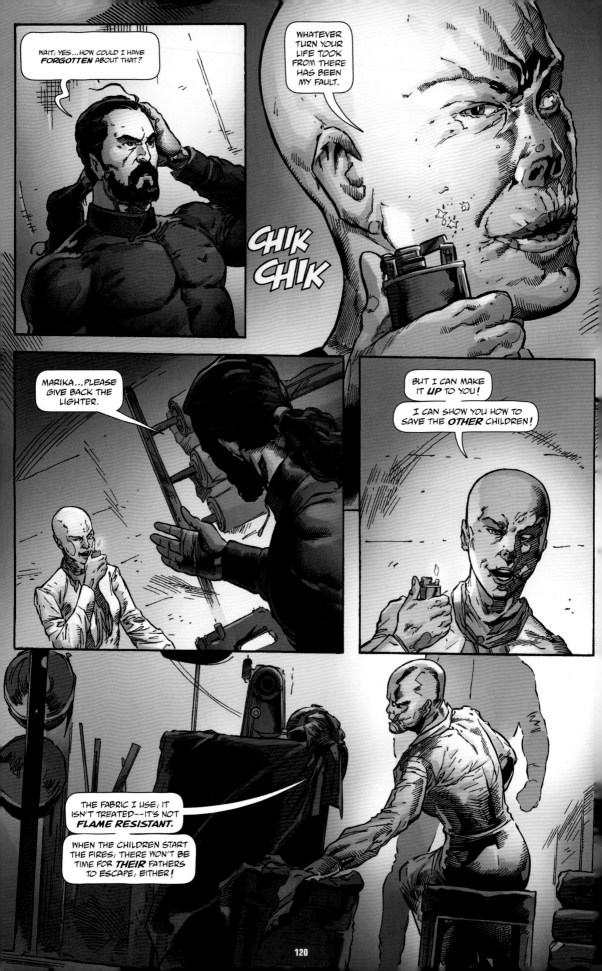

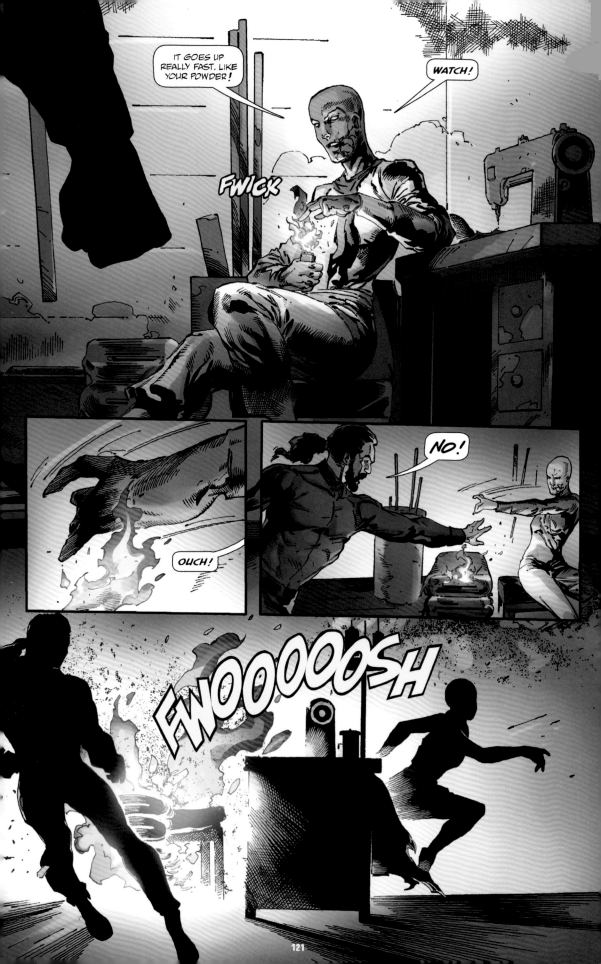

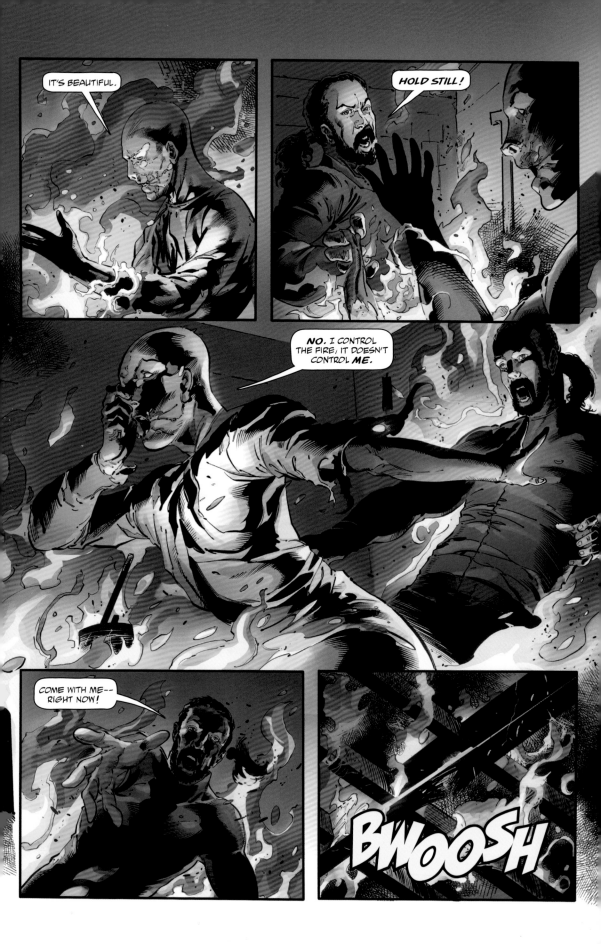

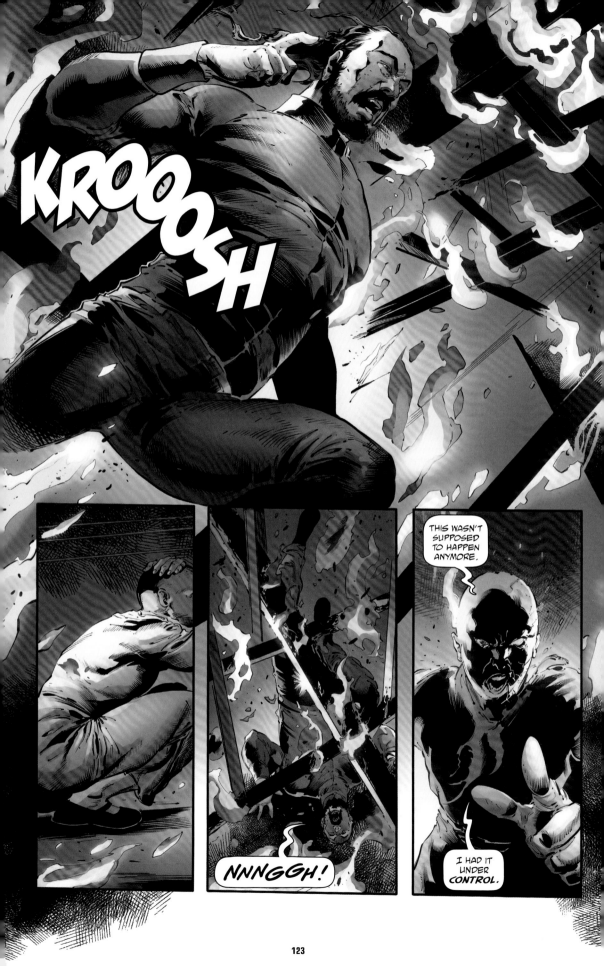

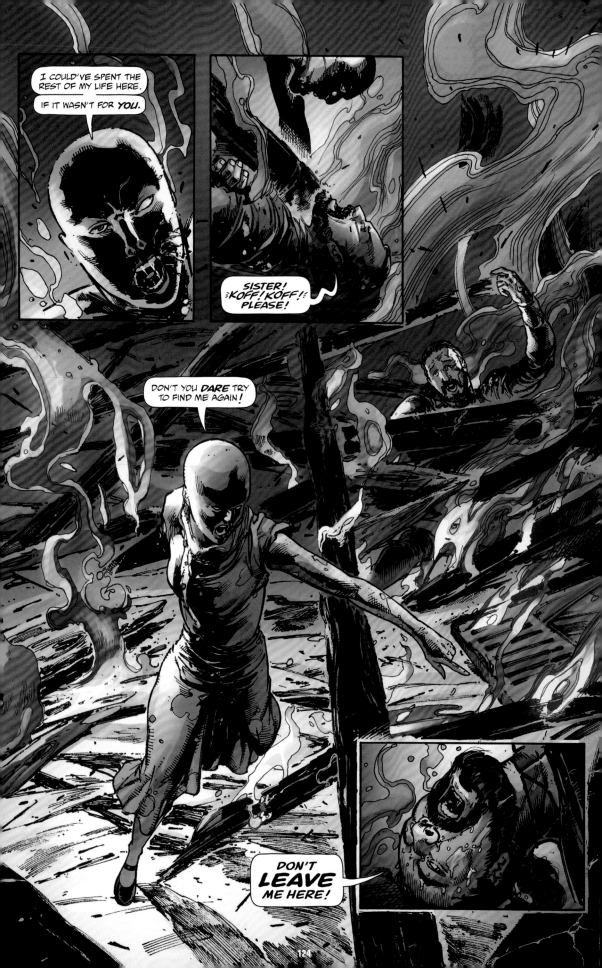

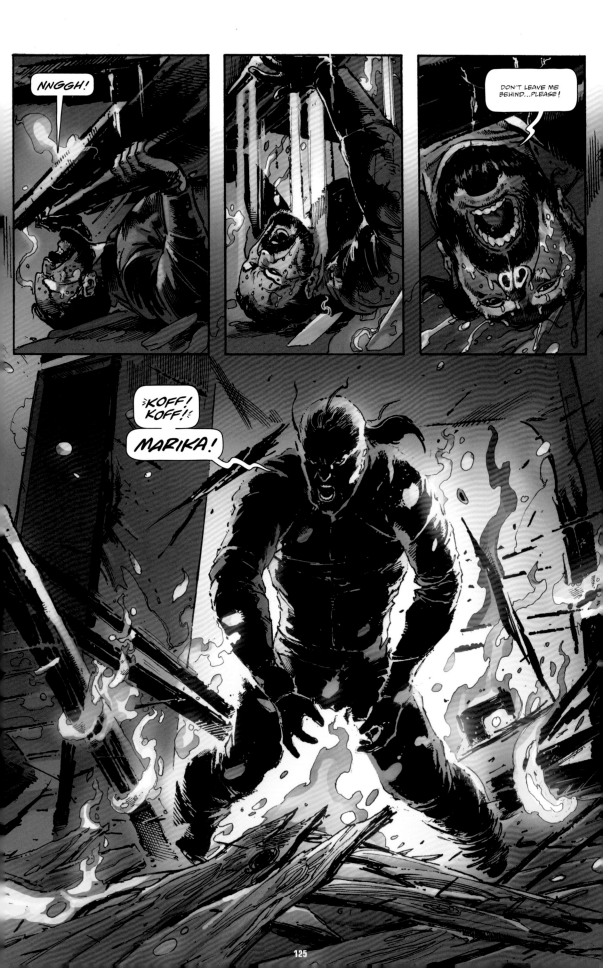

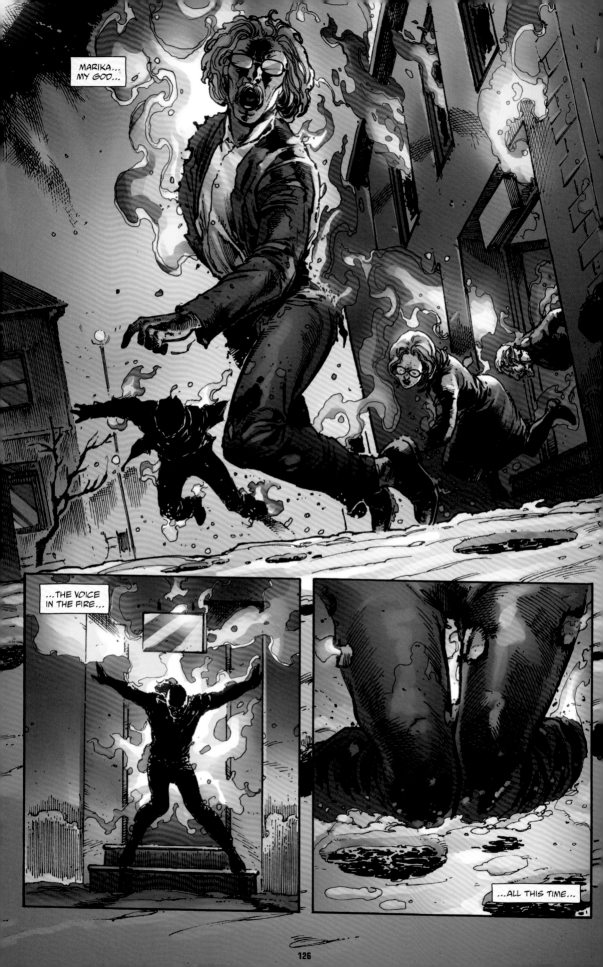

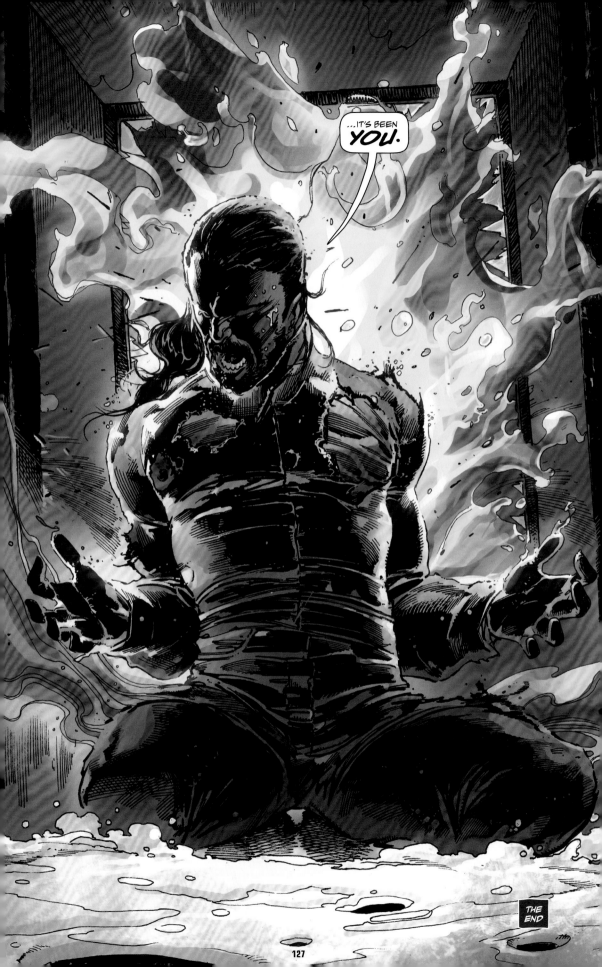

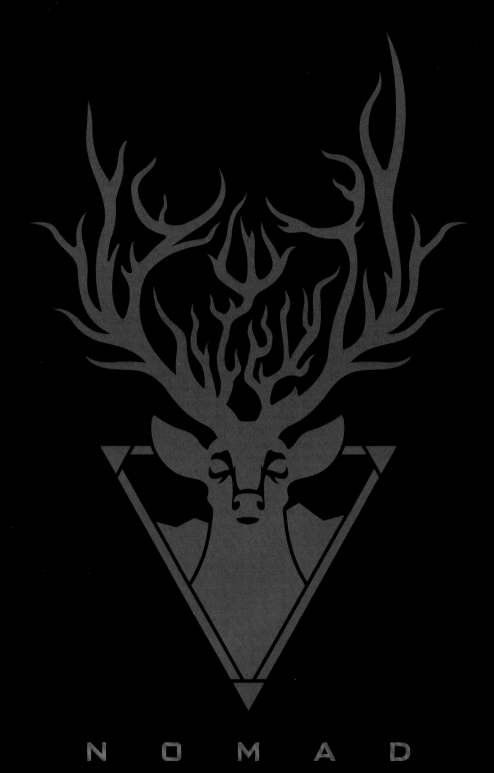

# N O M A D

Writer: **K.A. McDonald** / Artist: **Cliff Richards** / Colorist: **Jay David Ramos**
Cover Artist: **Eric Wilkerson**

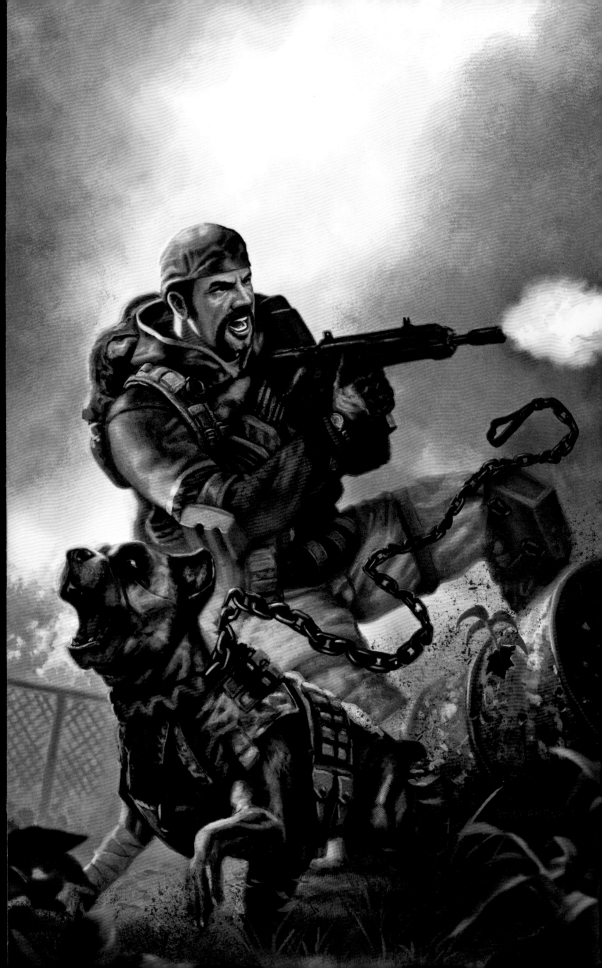

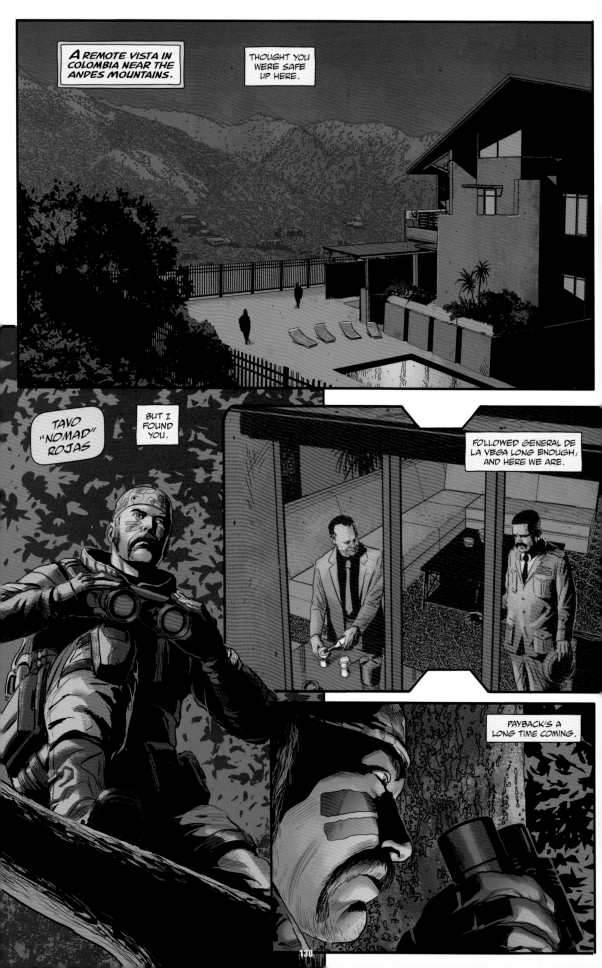

A REMOTE VISTA IN COLOMBIA NEAR THE ANDES MOUNTAINS.

THOUGHT YOU WERE SAFE UP HERE.

TAVO "NOMAD" ROJAS

BUT I FOUND YOU.

FOLLOWED GENERAL DE LA VEGA LONG ENOUGH, AND HERE WE ARE.

PAYBACK'S A LONG TIME COMING.

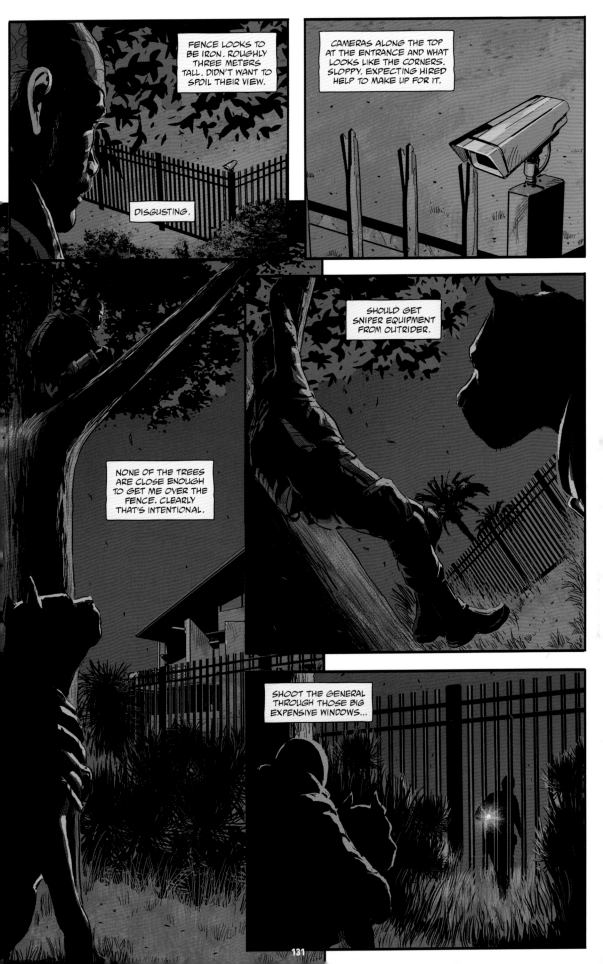

FENCE LOOKS TO BE IRON. ROUGHLY THREE METERS TALL. DIDN'T WANT TO SPOIL THEIR VIEW.

DISGUSTING.

CAMERAS ALONG THE TOP AT THE ENTRANCE AND WHAT LOOKS LIKE THE CORNERS. SLOPPY. EXPECTING HIRED HELP TO MAKE UP FOR IT.

SHOULD GET SNIPER EQUIPMENT FROM OUTRIDER.

NONE OF THE TREES ARE CLOSE ENOUGH TO GET ME OVER THE FENCE. CLEARLY THAT'S INTENTIONAL.

SHOOT THE GENERAL THROUGH THOSE BIG EXPENSIVE WINDOWS...

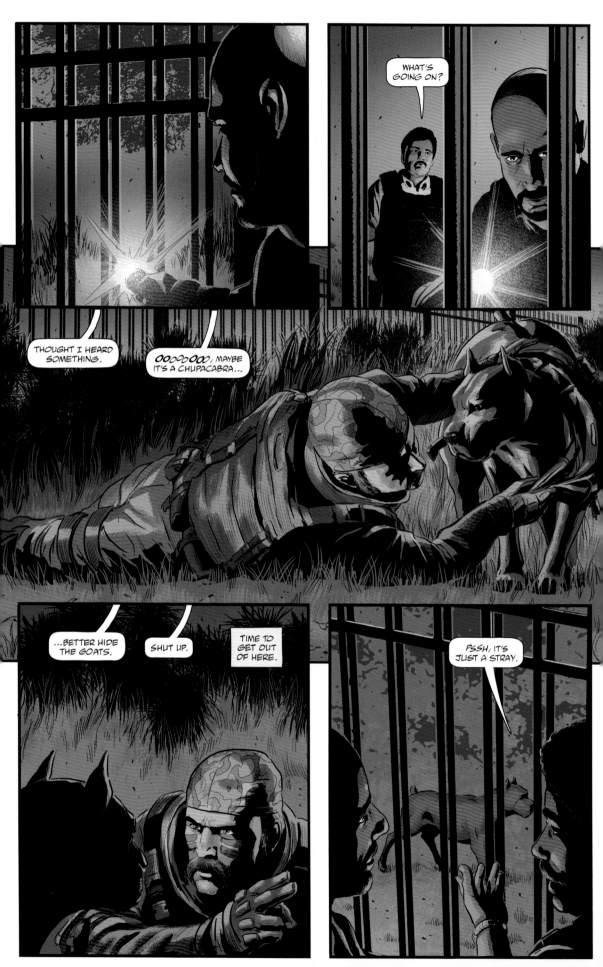

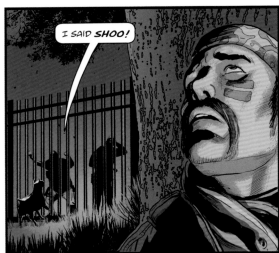

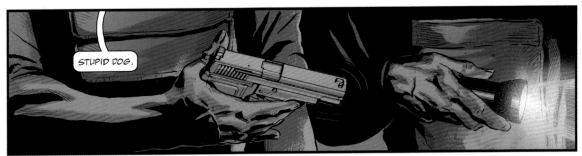

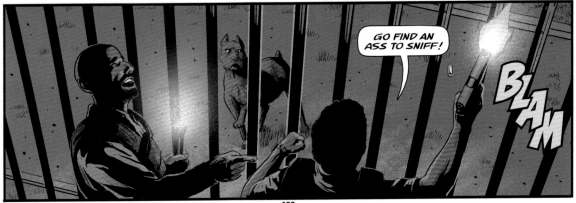

133

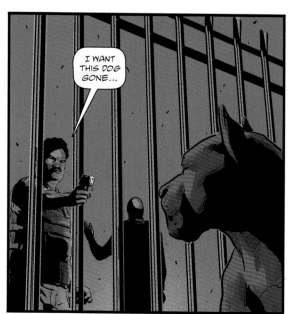

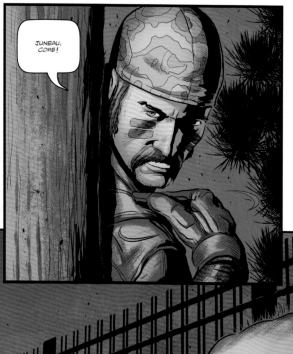

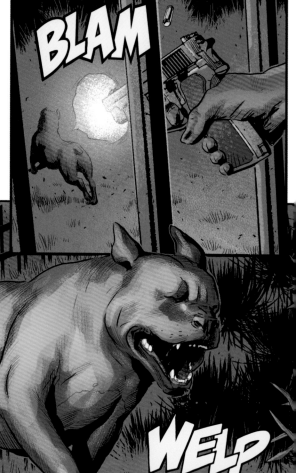

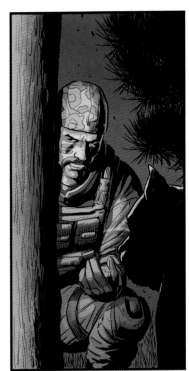

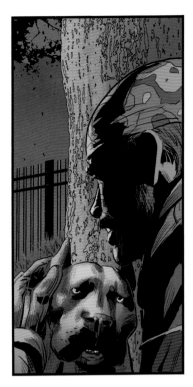

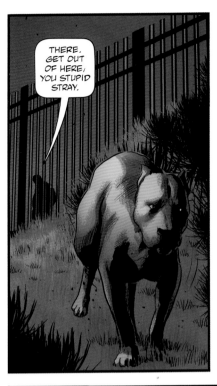

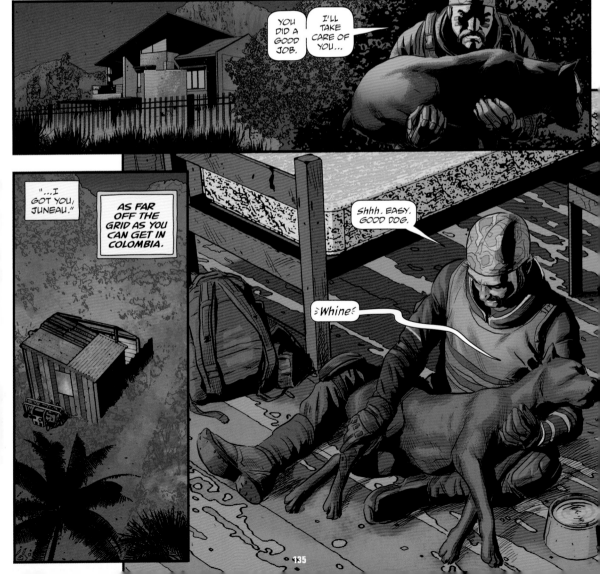

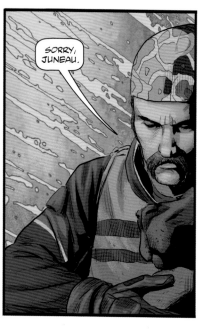

SORRY, JUNEAU.

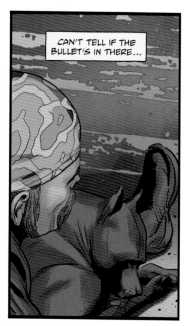

CAN'T TELL IF THE BULLET'S IN THERE...

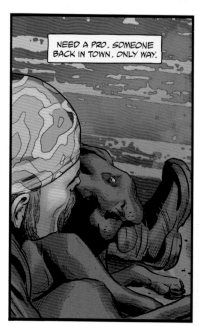

NEED A PRO. SOMEONE BACK IN TOWN. ONLY WAY.

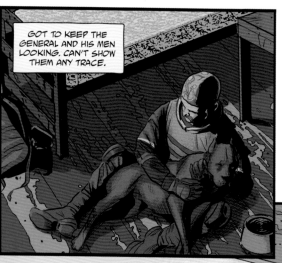

GOT TO KEEP THE GENERAL AND HIS MEN LOOKING. CAN'T SHOW THEM ANY TRACE.

I GOT YOU, JUNEAU.

SALUD ANIMAL CLINICA VETERINARIA.

OKAY...SEÑOR ANDRES RODRIGUEZ. I CAN SEE YOUR DOG, AH, **NOODLE,** NOW.

COALESCENCE
ENHANCE YOURSELF FOR A BETTER TOMORROW

WHERE DO I PUT HER?

Uh...

PUT HER ON THE TABLE.

SO, SHE WAS HURT WHILE YOU WERE HUNTING?

YES. ANOTHER HUNTER MUST HAVE THOUGHT SHE WAS A *CHIGÜIRO*.

GRRRRR

GRRRRR

THEY GRAZED HER PAW.

OH, POOR THING.

GRRRRRR

DID YOU GET THE OTHER HUNTER'S NAME AND ADDRESS?

TOO WORRIED ABOUT MY DOG.

THAT'S UNDERSTANDABLE, BUT YOU REALLY SHOULD'VE GOTTEN THEIR INFORMATION TO REPORT THE INCIDENT TO THE POLICE.

NO NEED FOR THAT.

ALL RIGHT...

WOOF

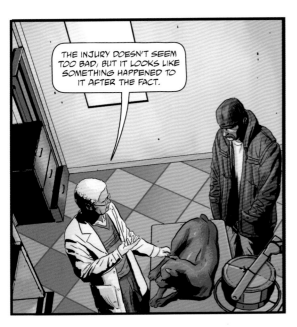

THE INJURY DOESN'T SEEM TOO BAD, BUT IT LOOKS LIKE SOMETHING HAPPENED TO IT AFTER THE FACT.

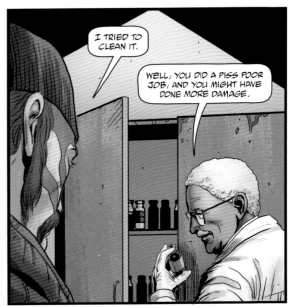

I TRIED TO CLEAN IT.

WELL, YOU DID A PISS POOR JOB, AND YOU MIGHT HAVE DONE MORE DAMAGE.

≶Whine≶

AND YOU SHOULD HAVE BROUGHT HER IN IMMEDIATELY--

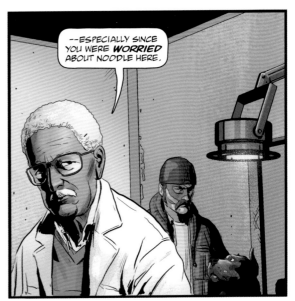

--ESPECIALLY SINCE YOU WERE *WORRIED* ABOUT NOODLE HERE.

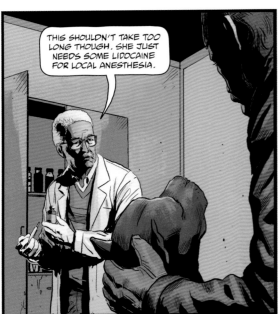

THIS SHOULDN'T TAKE TOO LONG THOUGH. SHE JUST NEEDS SOME LIDOCAINE FOR LOCAL ANESTHESIA.

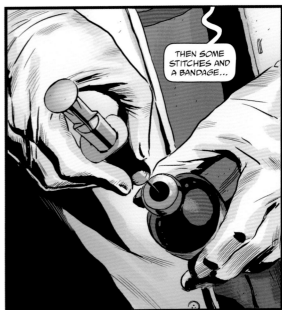

THEN SOME STITCHES AND A BANDAGE...

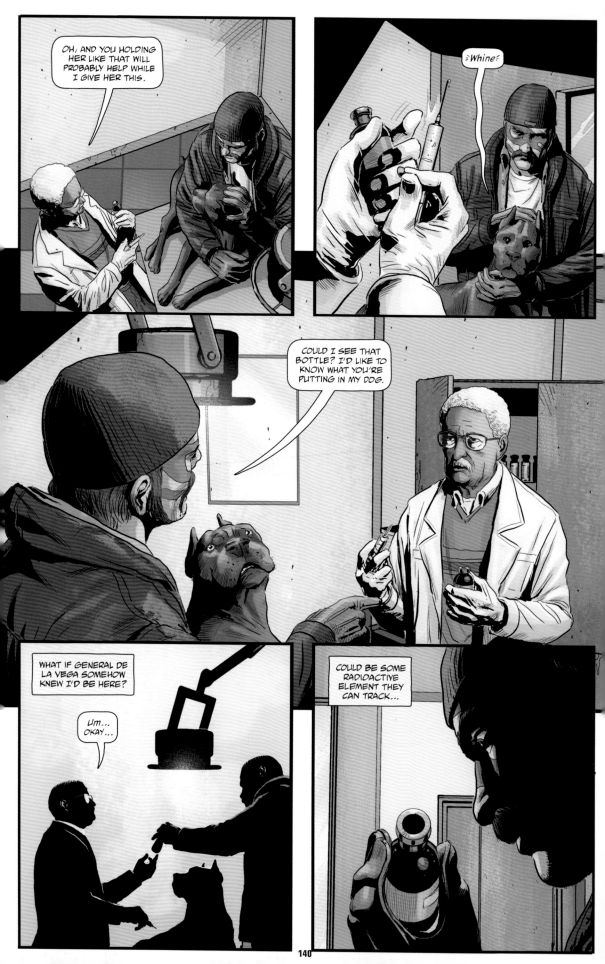

OH, AND YOU HOLDING HER LIKE THAT WILL PROBABLY HELP WHILE I GIVE HER THIS.

≤Whine≥

COULD I SEE THAT BOTTLE? I'D LIKE TO KNOW WHAT YOU'RE PUTTING IN MY DOG.

WHAT IF GENERAL DE LA VEGA SOMEHOW KNEW I'D BE HERE?

Um... OKAY...

COULD BE SOME RADIOACTIVE ELEMENT THEY CAN TRACK...

REFUSING THE SHOT IS TOO RISKY.

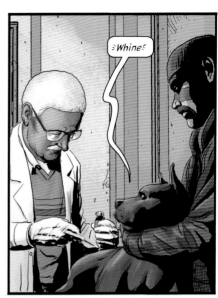

⸗Whine⸗

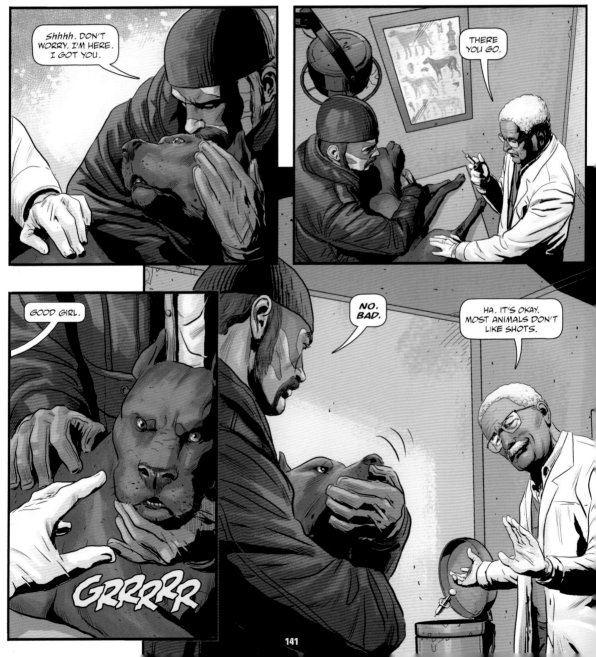

SHHHH. DON'T WORRY. I'M HERE. I GOT YOU.

THERE YOU GO.

GOOD GIRL.

NO. BAD.

HA. IT'S OKAY. MOST ANIMALS DON'T LIKE SHOTS.

GRRRRR

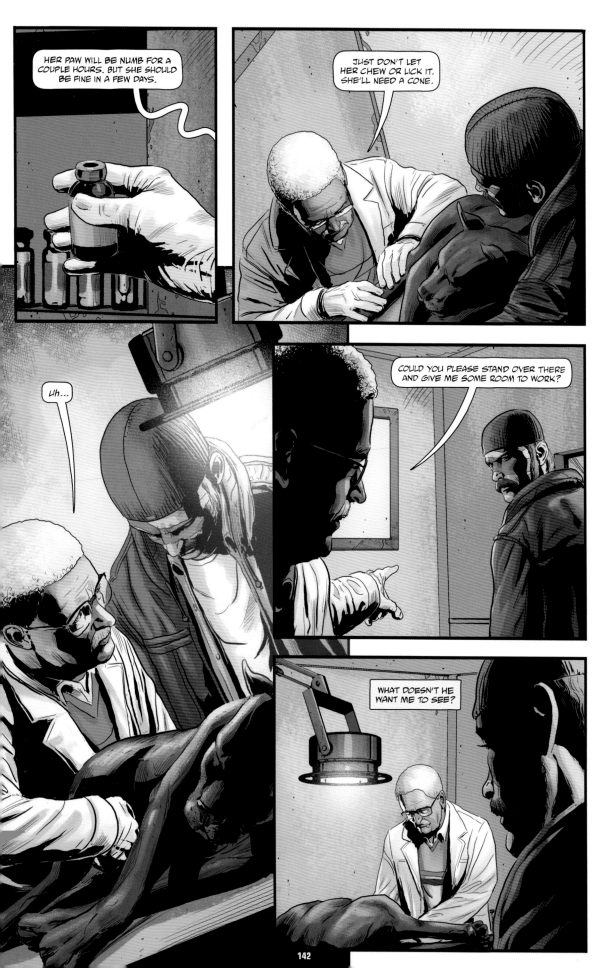

HER PAW WILL BE NUMB FOR A COUPLE HOURS, BUT SHE SHOULD BE FINE IN A FEW DAYS.

JUST DON'T LET HER CHEW OR LICK IT. SHE'LL NEED A CONE.

Uh...

COULD YOU PLEASE STAND OVER THERE AND GIVE ME SOME ROOM TO WORK?

WHAT DOESN'T HE WANT ME TO SEE?

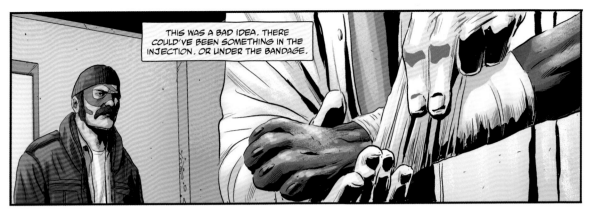

THIS WAS A BAD IDEA. THERE COULD'VE BEEN SOMETHING IN THE INJECTION. OR UNDER THE BANDAGE.

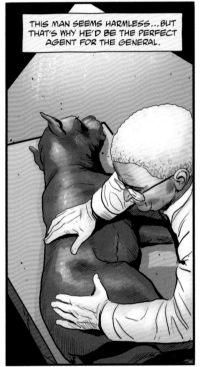

THIS MAN SEEMS HARMLESS...BUT THAT'S WHY HE'D BE THE PERFECT AGENT FOR THE GENERAL.

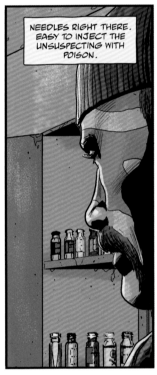

NEEDLES RIGHT THERE. EASY TO INJECT THE UNSUSPECTING WITH POISON.

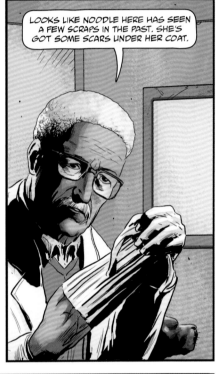

LOOKS LIKE NOODLE HERE HAS SEEN A FEW SCRAPS IN THE PAST. SHE'S GOT SOME SCARS UNDER HER COAT.

SHE WAS A RESCUE.

IS SHE MICROCHIPPED?

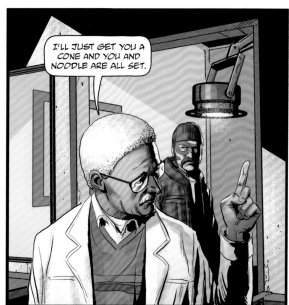

I'LL JUST GET YOU A CONE AND YOU AND NOODLE ARE ALL SET.

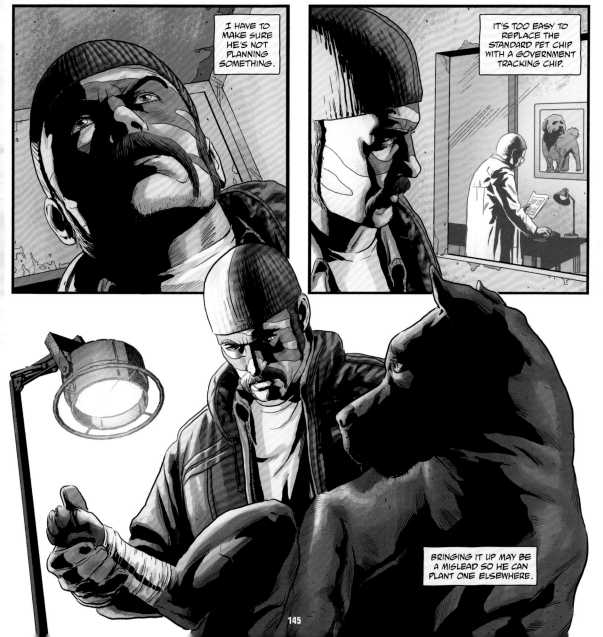

I HAVE TO MAKE SURE HE'S NOT PLANNING SOMETHING.

IT'S TOO EASY TO REPLACE THE STANDARD PET CHIP WITH A GOVERNMENT TRACKING CHIP.

BRINGING IT UP MAY BE A MISLEAD SO HE CAN PLANT ONE ELSEWHERE.

WHO'S HE CALLING...?

GETTING ME TO BACK OFF COULD HAVE LET HIM SLIP IN ANYTHING.

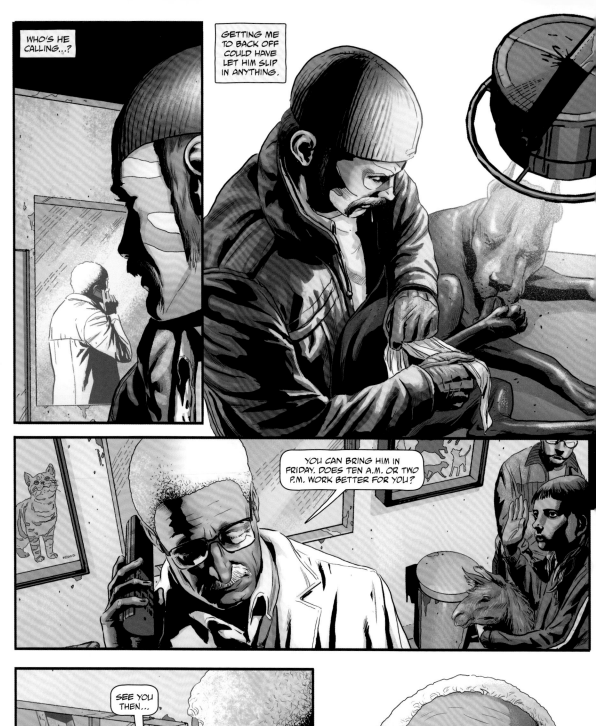

YOU CAN BRING HIM IN FRIDAY. DOES TEN A.M. OR TWO P.M. WORK BETTER FOR YOU?

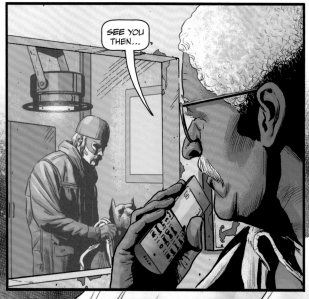

SEE YOU THEN...

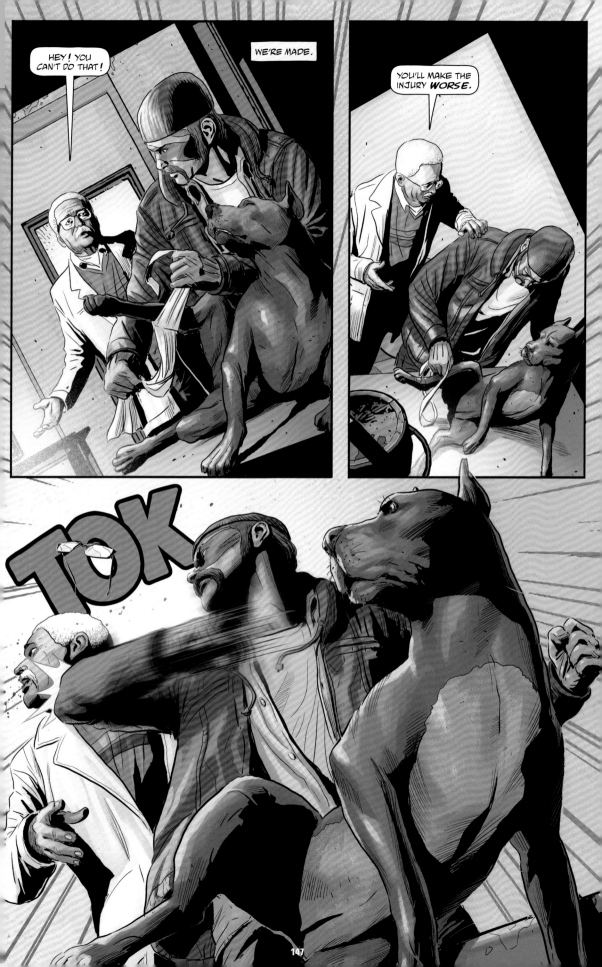

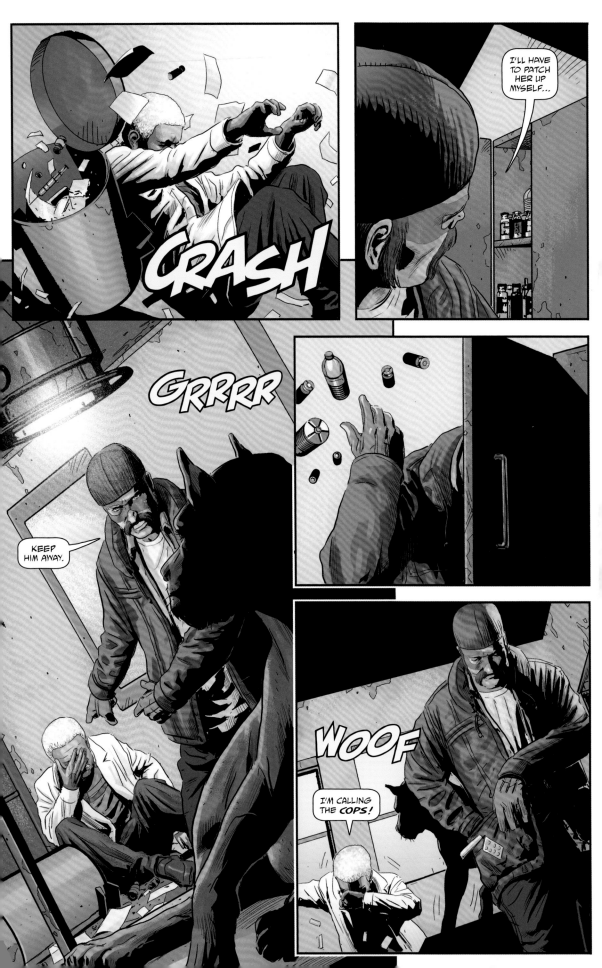

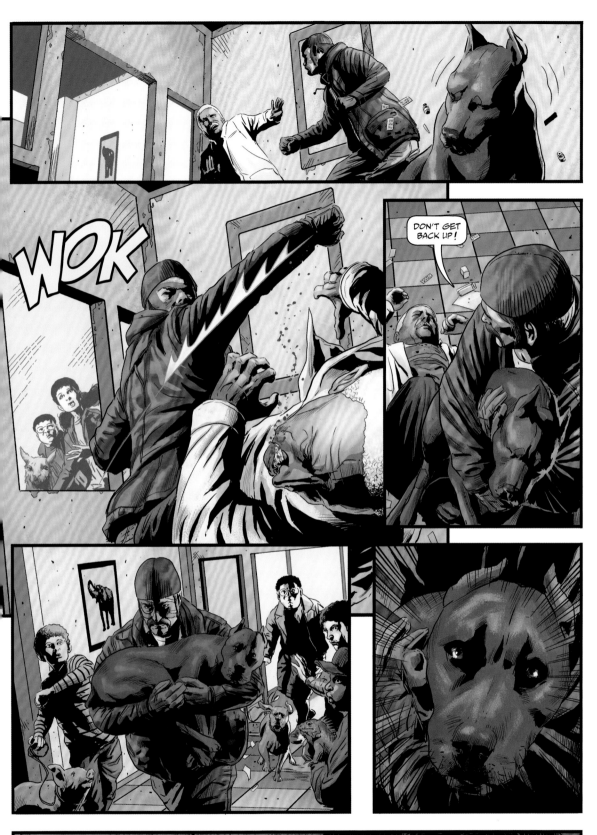

WOK

DON'T GET
BACK UP!

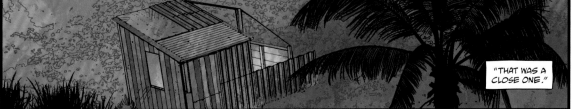

"THAT WAS A
CLOSE ONE."

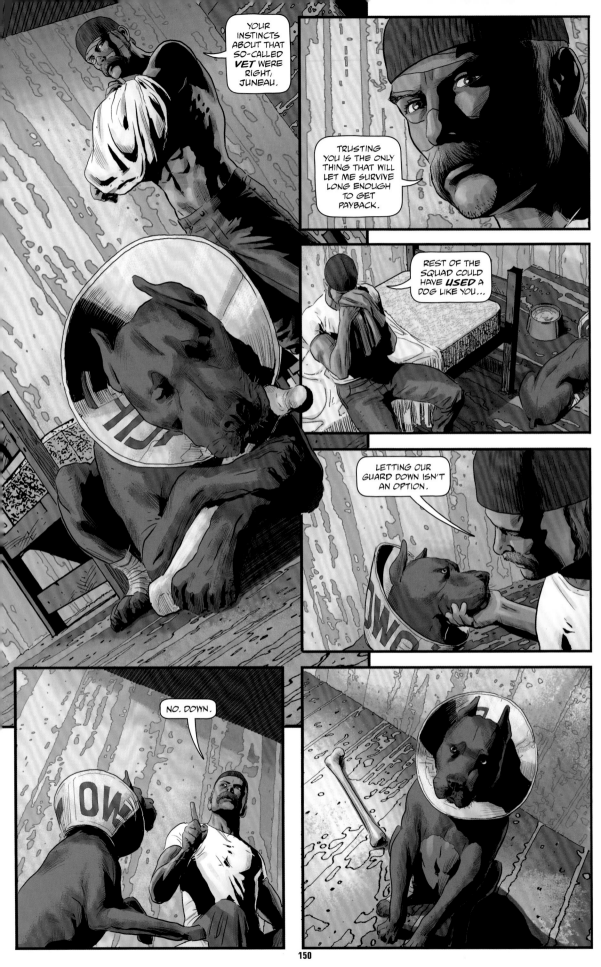

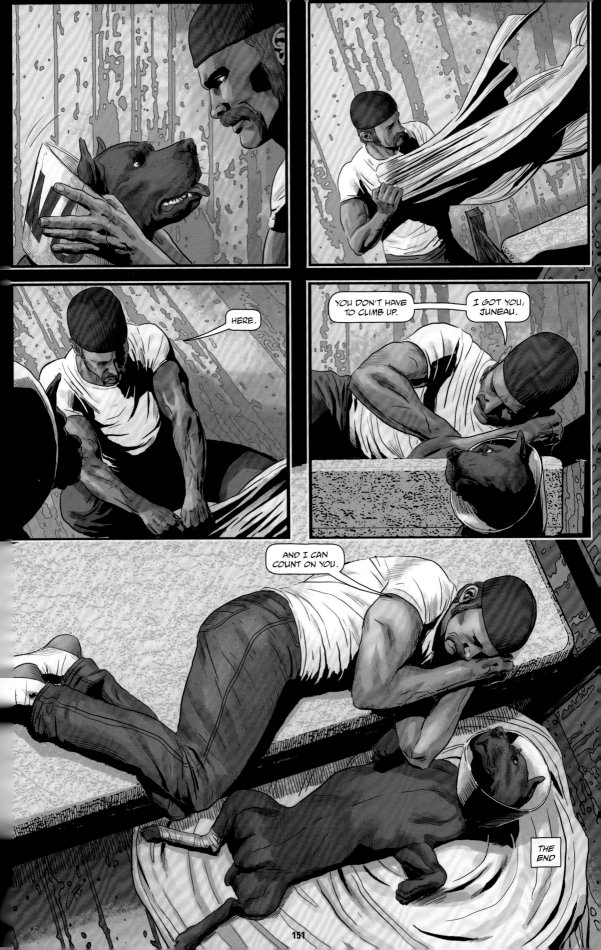

# R E C O N

Writer: **Matthew Robinson** / Layout Artist: **Wilson Tortosa** / Artist: **Mel Joy San Juan**
Colorist: **Katrina Mae Hao**
Cover Artist: **Dan Dos Santos**

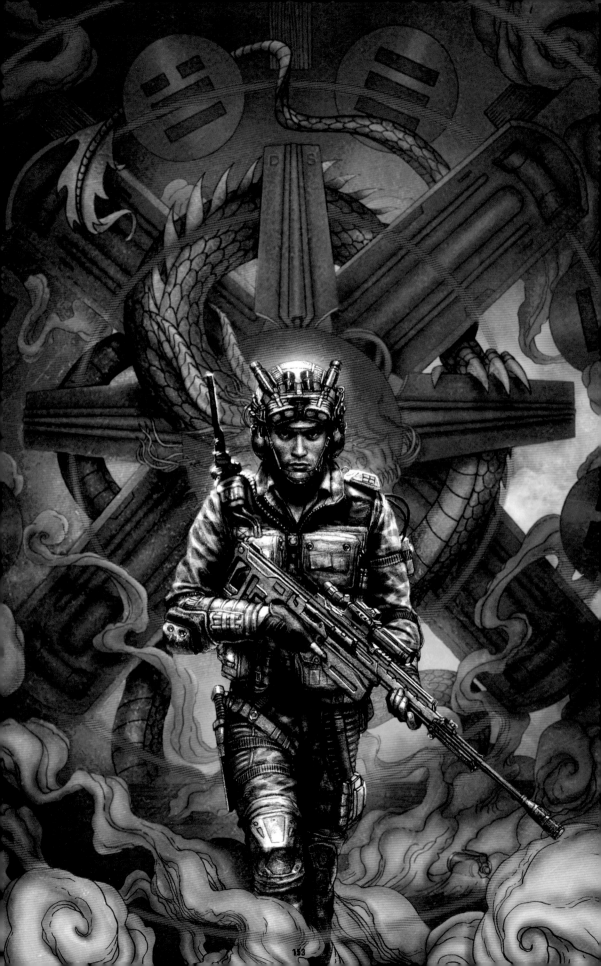

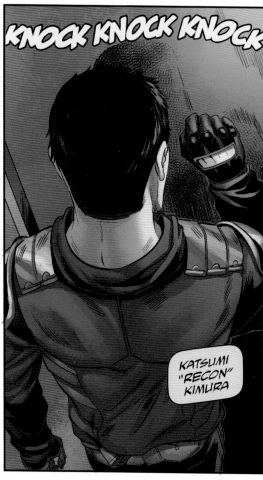

KNOCK KNOCK KNOCK

KATSUMI "RECON" KIMURA

BANG BANG BANG

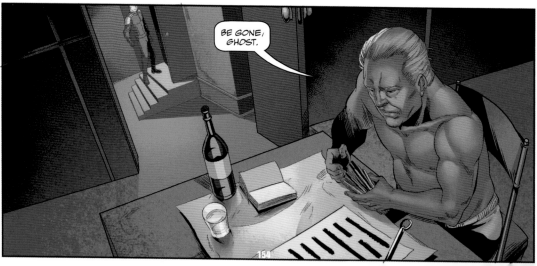

BE GONE, GHOST.

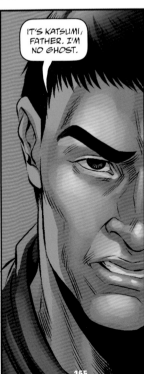
IT'S KATSUMI, FATHER. I'M NO GHOST.

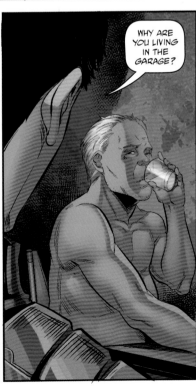
WHY ARE YOU LIVING IN THE GARAGE?

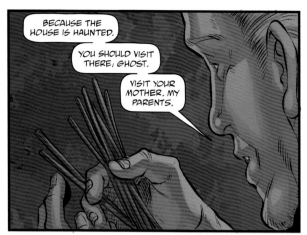

BECAUSE THE HOUSE IS HAUNTED.

YOU SHOULD VISIT THERE, GHOST.

VISIT YOUR MOTHER. MY PARENTS.

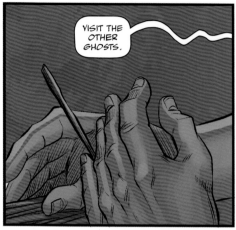

VISIT THE OTHER GHOSTS.

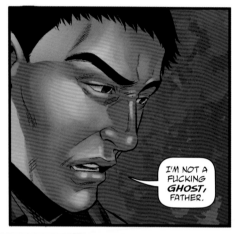

I'M NOT A FUCKING *GHOST,* FATHER.

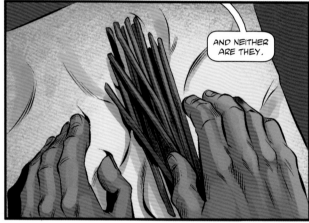

AND NEITHER ARE THEY.

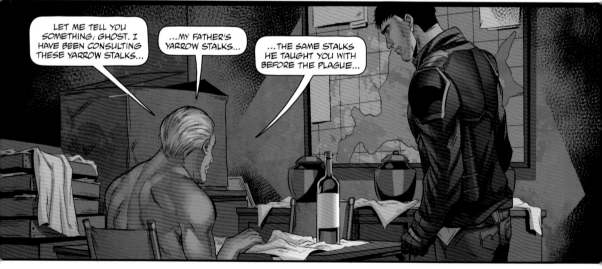

LET ME TELL YOU SOMETHING, GHOST. I HAVE BEEN CONSULTING THESE YARROW STALKS...

...MY FATHER'S YARROW STALKS...

...THE SAME STALKS HE TAUGHT YOU WITH BEFORE THE PLAGUE...

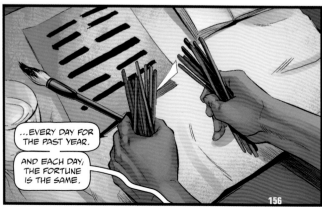

...EVERY DAY FOR THE PAST YEAR.

AND EACH DAY, THE FORTUNE IS THE SAME.

DO YOU KNOW IT?

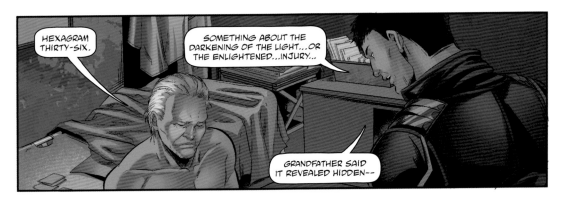

HEXAGRAM THIRTY-SIX.

SOMETHING ABOUT THE DARKENING OF THE LIGHT...OR THE ENLIGHTENED...INJURY...

GRANDFATHER SAID IT REVEALED HIDDEN--

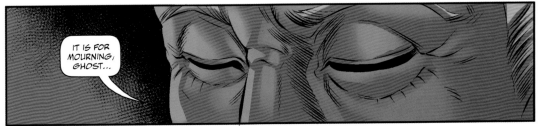

IT IS FOR MOURNING, GHOST...

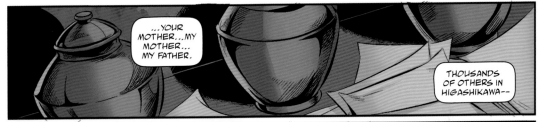

...YOUR MOTHER...MY MOTHER... MY FATHER.

THOUSANDS OF OTHERS IN HIGASHIKAWA--

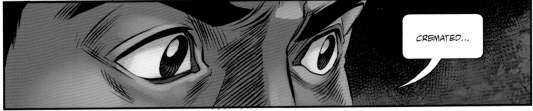

CREMATED...

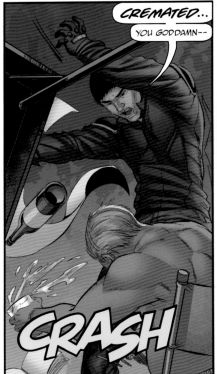

CREMATED...
YOU GODDAMN--

CRASH

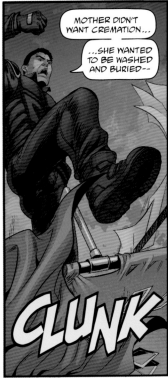

MOTHER DIDN'T WANT CREMATION...

...SHE WANTED TO BE WASHED AND BURIED--

CLUNK

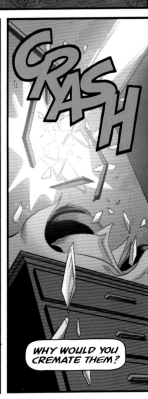

CRASH

WHY WOULD YOU CREMATE THEM?

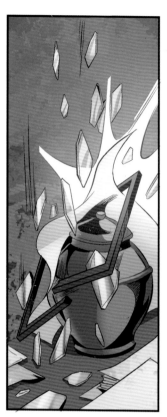

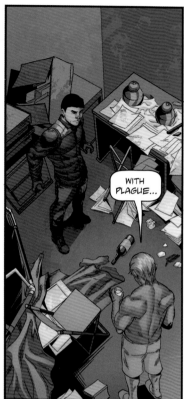

...THERE CAN ONLY BE CREMATION.

WITH PLAGUE...

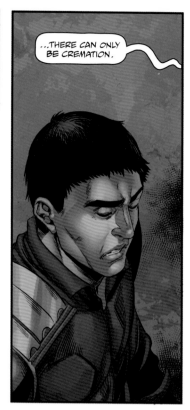

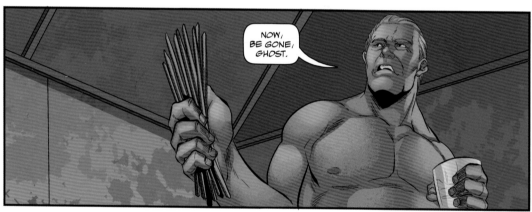

NOW, BE GONE, GHOST.

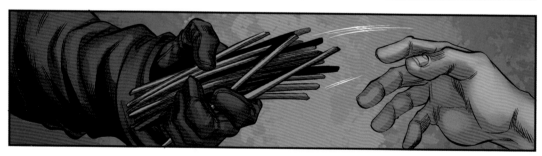

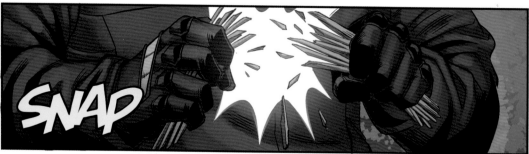

SNAP

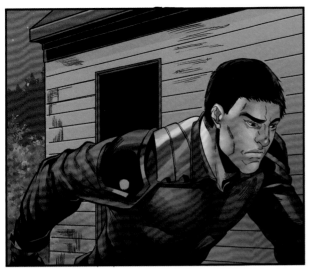
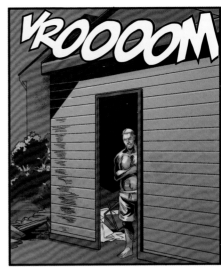
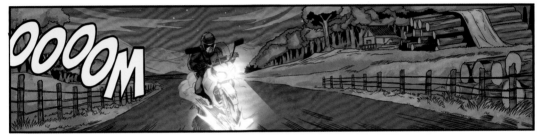
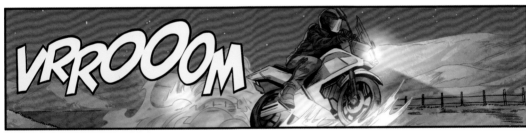

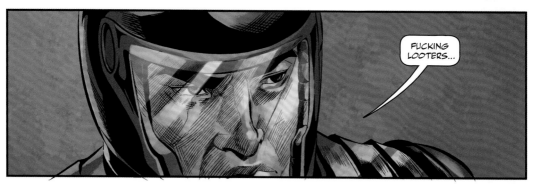
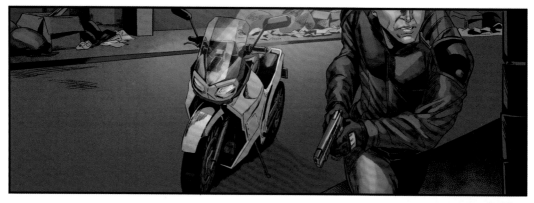
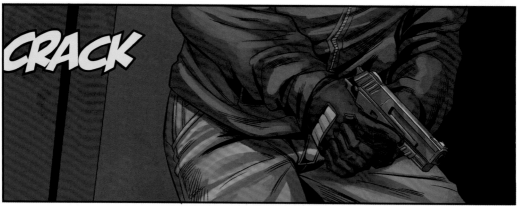

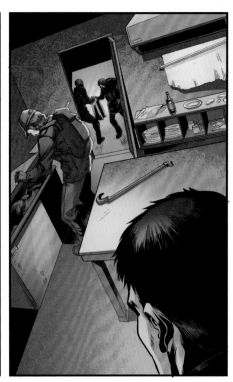

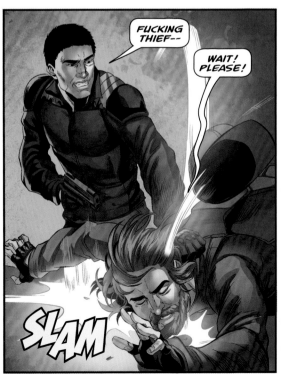

FUCKING THIEF--

WAIT! PLEASE!

SLAM

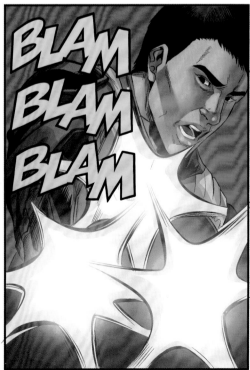

BLAM BLAM BLAM

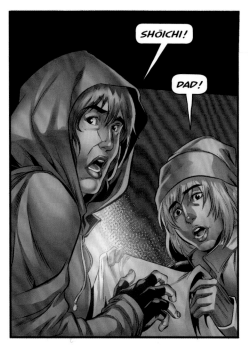

SHŌICHI!

DAD!

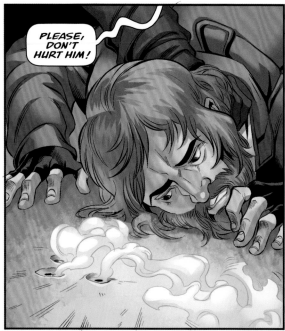

PLEASE, DON'T HURT HIM!

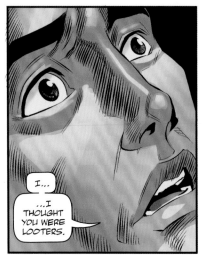

I...

...I THOUGHT YOU WERE LOOTERS.

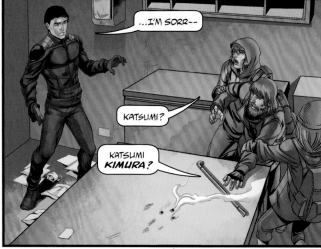

...I'M SORR--

KATSUMI?

KATSUMI KIMURA?

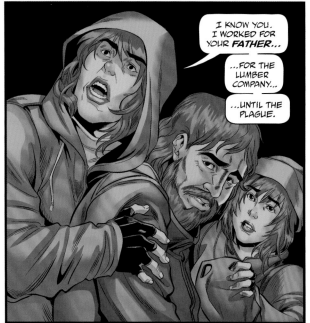

I KNOW YOU. I WORKED FOR YOUR FATHER...

...FOR THE LUMBER COMPANY...

...UNTIL THE PLAGUE.

I'M SORRY... I'M SO SORRY.

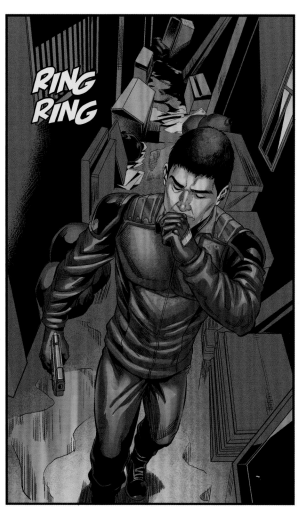

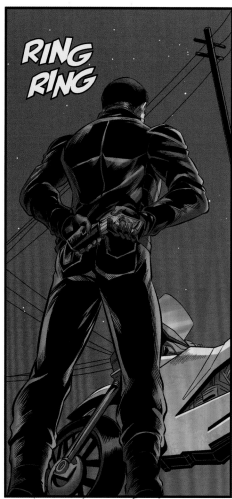

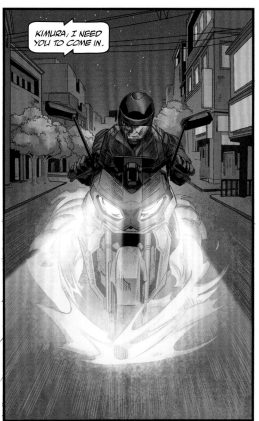

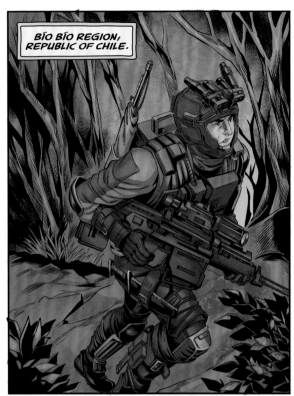

BÍO BÍO REGION, REPUBLIC OF CHILE.

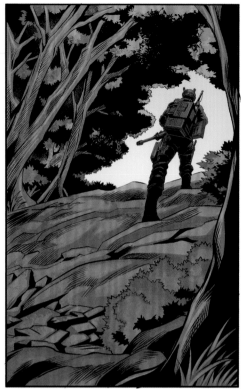

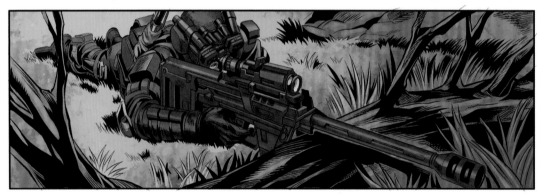

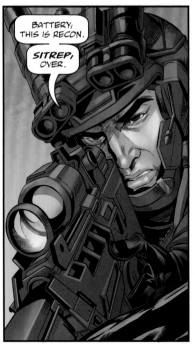

BATTERY, THIS IS RECON.

SITREP, OVER.

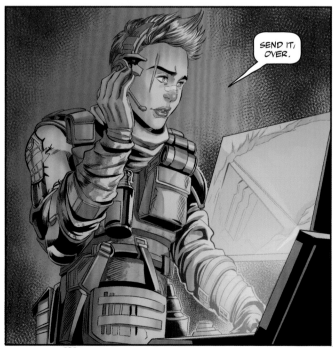

SEND IT, OVER.

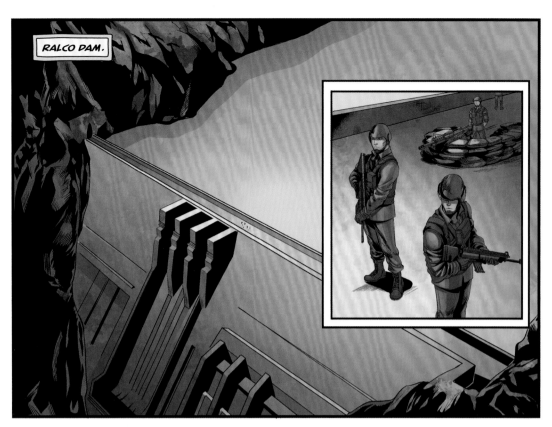

RALCO DAM.

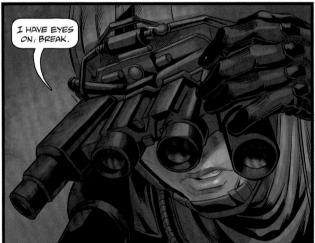

I HAVE EYES ON, BREAK.

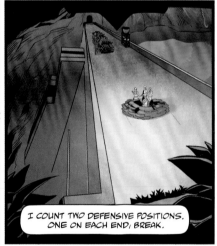

I COUNT TWO DEFENSIVE POSITIONS, ONE ON EACH END, BREAK.

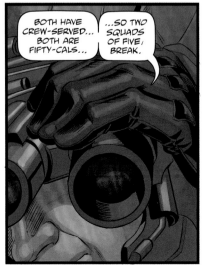

BOTH HAVE CREW-SERVED... BOTH ARE FIFTY-CALS...

...SO TWO SQUADS OF FIVE, BREAK.

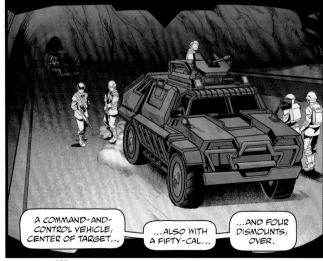

A COMMAND-AND-CONTROL VEHICLE, CENTER OF TARGET...

...ALSO WITH A FIFTY-CAL...

...AND FOUR DISMOUNTS, OVER.

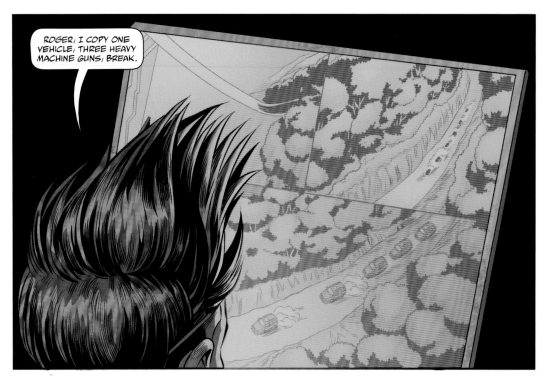

ROGER, I COPY ONE VEHICLE, THREE HEAVY MACHINE GUNS, BREAK.

FIFTEEN LOCAL MILITARY AND...

...FIVE IN-BOUND TRUCKS, CIVILIAN, BY THE LOOK OF THEM.

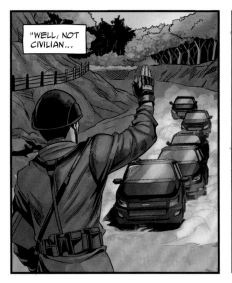

"WELL, NOT CIVILIAN...

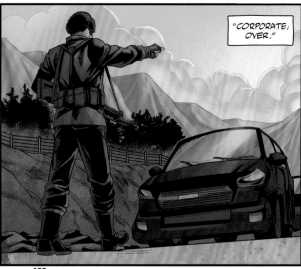

"CORPORATE, OVER."

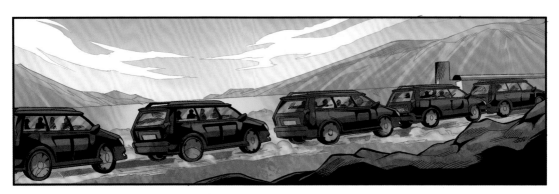

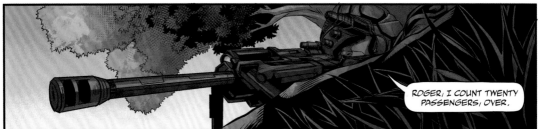

ROGER, I COUNT TWENTY PASSENGERS, OVER.

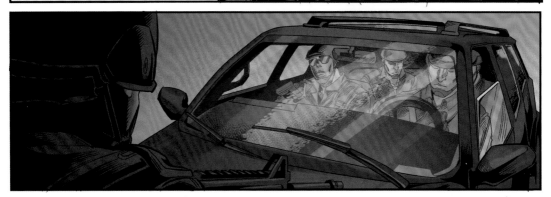

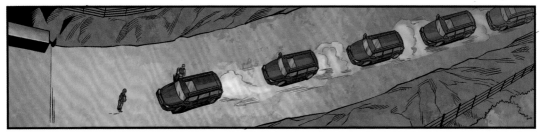

ENGLISH?

SÍ.

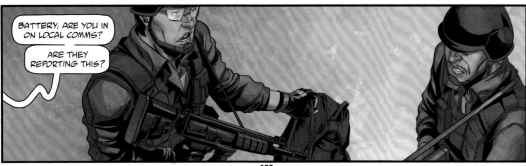

BATTERY, ARE YOU IN ON LOCAL COMMS?

ARE THEY REPORTING THIS?

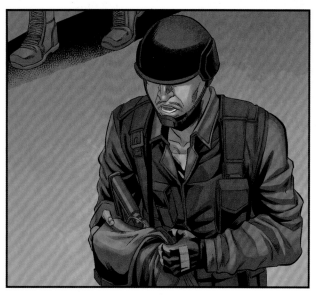

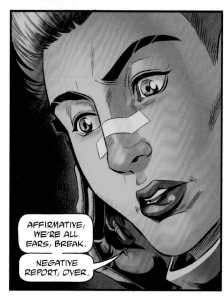

AFFIRMATIVE, WE'RE ALL EARS, BREAK.

NEGATIVE REPORT, OVER.

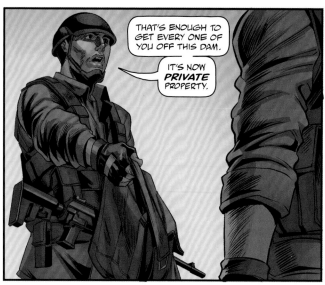

THAT'S ENOUGH TO GET EVERY ONE OF YOU OFF THIS DAM.

IT'S NOW **PRIVATE** PROPERTY.

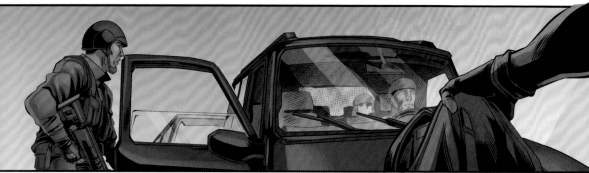

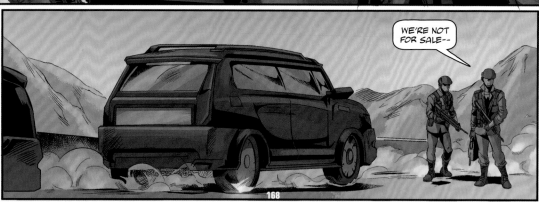

WE'RE NOT FOR SALE--

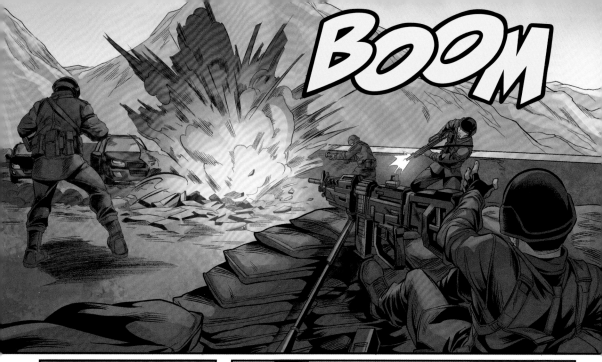

BOOM

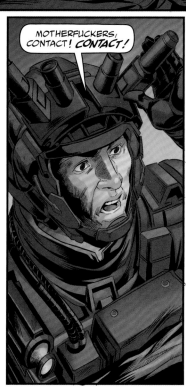

MOTHERFUCKERS, CONTACT! *CONTACT!*

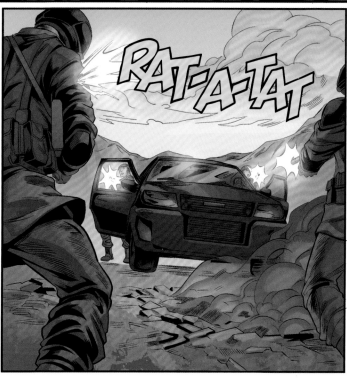

RAT-A-TAT

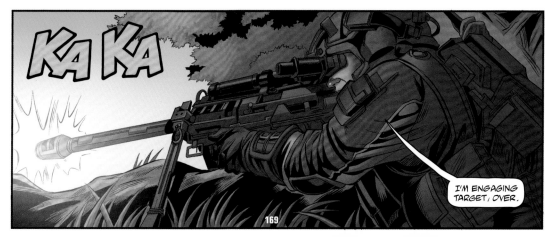

KA KA

I'M ENGAGING TARGET, OVER.

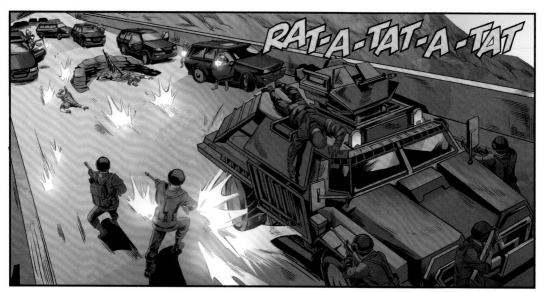

RAT-A-TAT-A-TAT

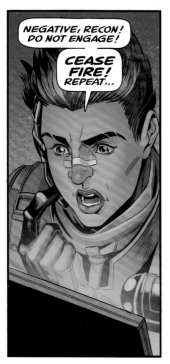

NEGATIVE, RECON! DO NOT ENGAGE!

CEASE FIRE! REPEAT...

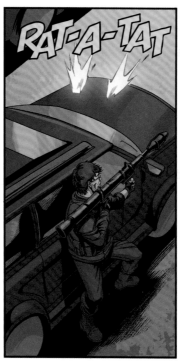

RAT-A-TAT

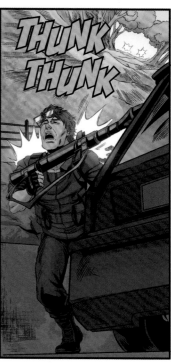

THUNK THUNK

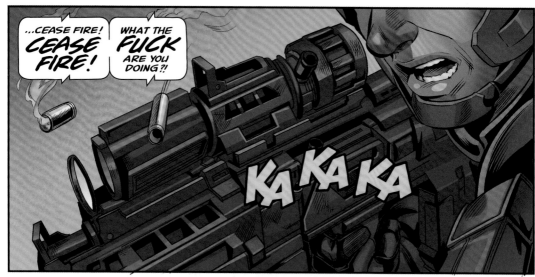

...CEASE FIRE! CEASE FIRE!

WHAT THE FUCK ARE YOU DOING?!

KA KA KA

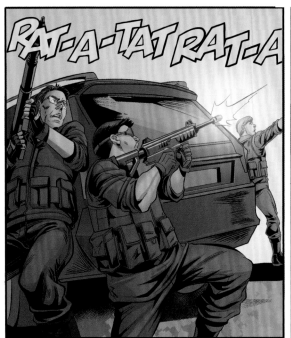

RAT-A-TAT RAT-A-

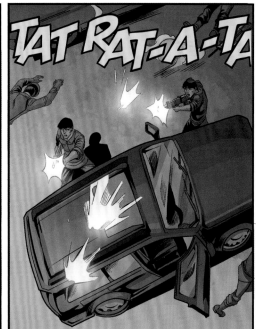

TAT RAT-A-TA

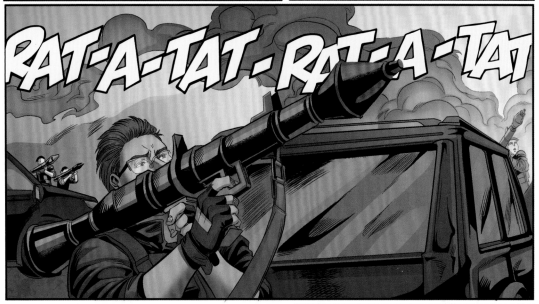

RAT-A-TAT-RAT-A-TAT

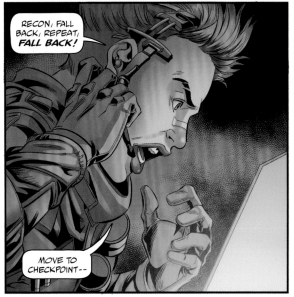

RECON, FALL BACK, REPEAT, **FALL BACK!**

MOVE TO CHECKPOINT--

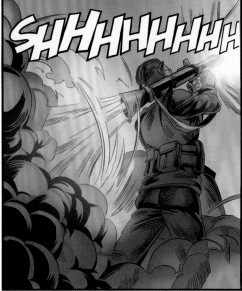

SHHHHHHHH

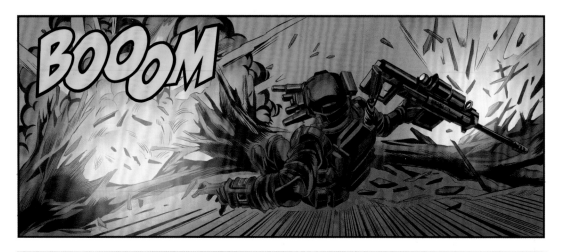

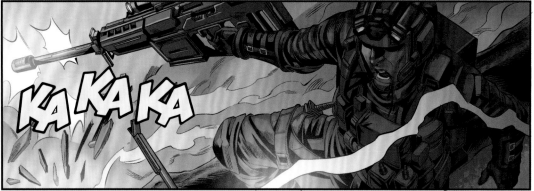

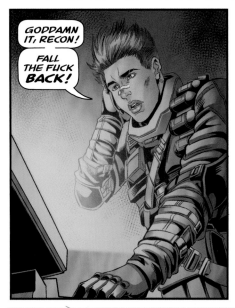

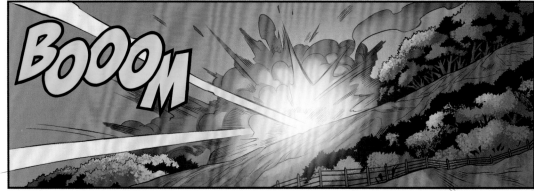

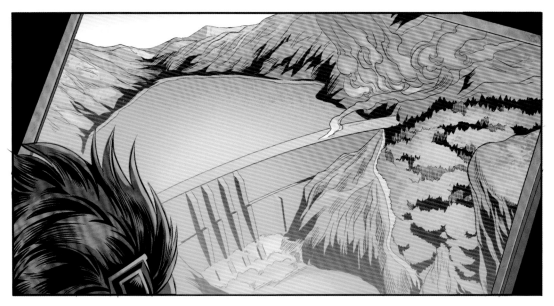

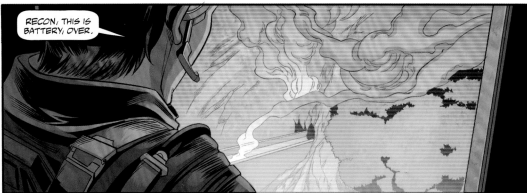

RECON, THIS IS BATTERY, OVER.

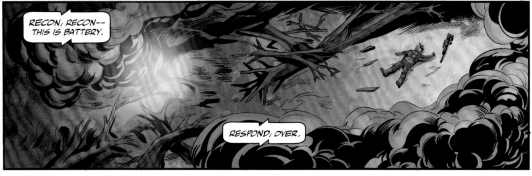

RECON, RECON-- THIS IS BATTERY.

RESPOND, OVER.

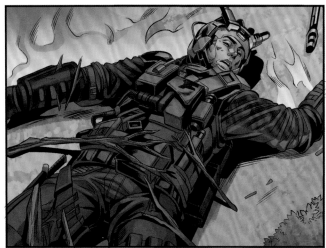

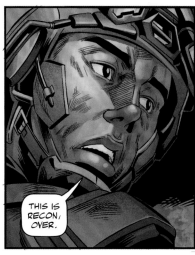

THIS IS RECON, OVER.

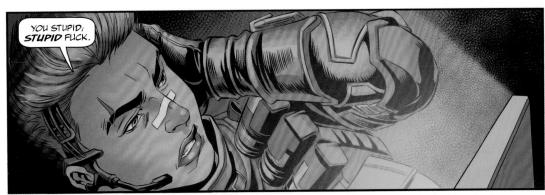

YOU STUPID, **STUPID** FUCK.

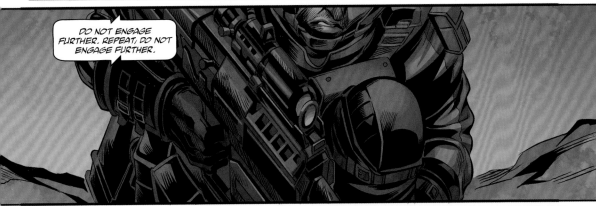

DO NOT ENGAGE FURTHER. REPEAT, DO NOT ENGAGE FURTHER.

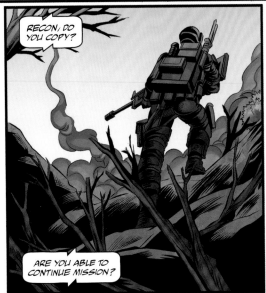

RECON, DO YOU COPY?

ARE YOU ABLE TO CONTINUE MISSION?

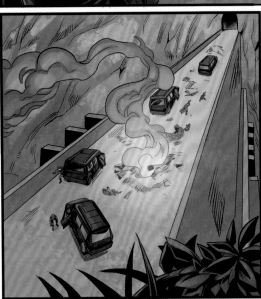

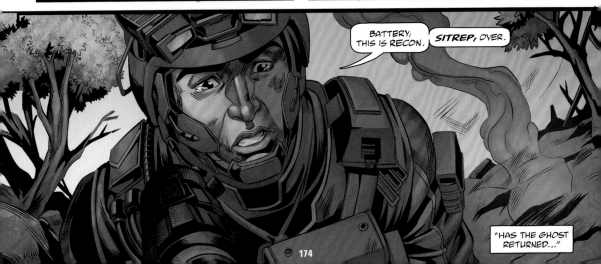

BATTERY, THIS IS RECON. **SITREP**, OVER.

"HAS THE GHOST RETURNED..."

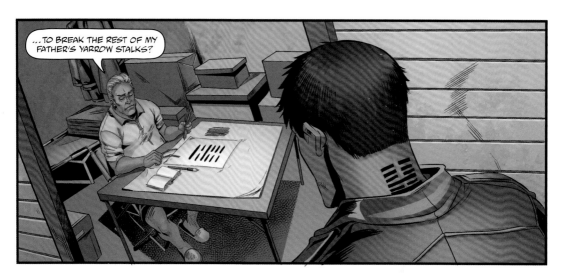

...TO BREAK THE REST OF MY FATHER'S YARROW STALKS?

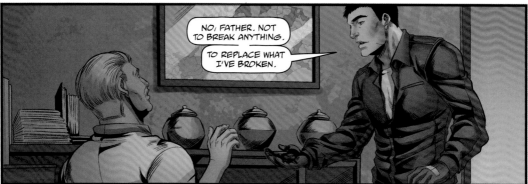

NO, FATHER. NOT TO BREAK ANYTHING.

TO REPLACE WHAT I'VE BROKEN.

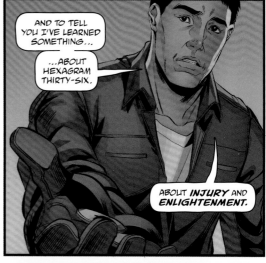

AND TO TELL YOU I'VE LEARNED SOMETHING...

...ABOUT HEXAGRAM THIRTY-SIX.

ABOUT *INJURY* AND *ENLIGHTENMENT*.

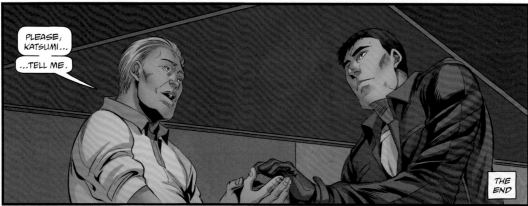

PLEASE, KATSUMI...

...TELL ME.

THE END

# S E R A P H

Writer: **Chris Roberson** / Artist: **Tony Shasteen** / Colorist: **Brian Reber**
Cover Artist: **Eric Wilkerson**

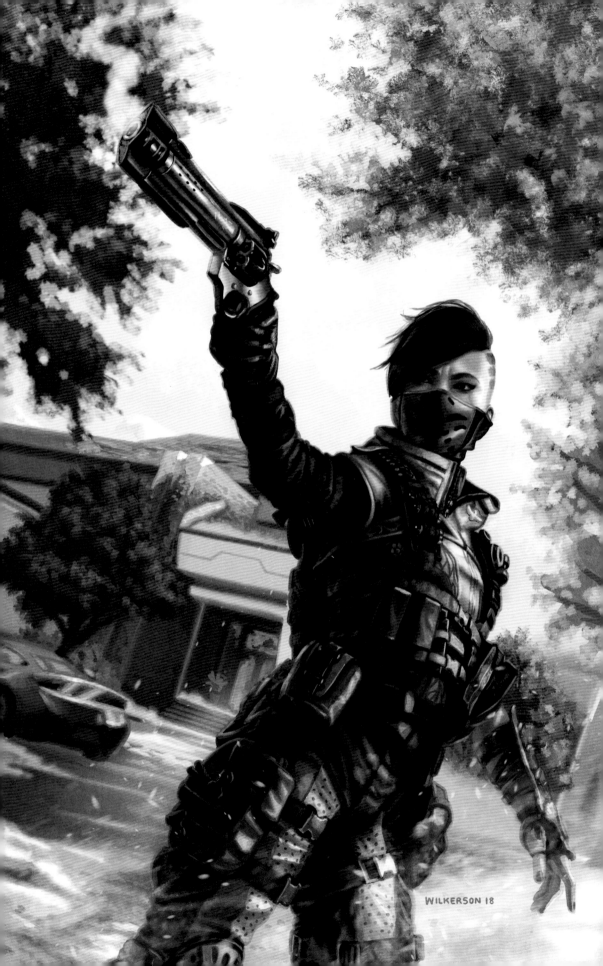

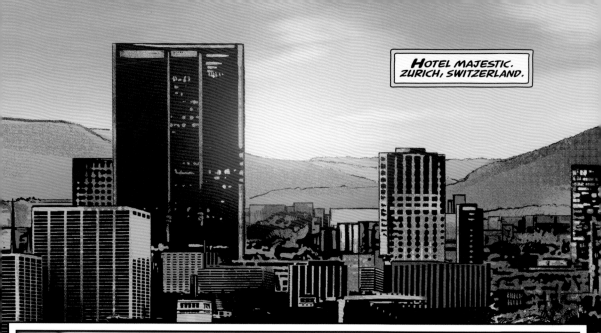

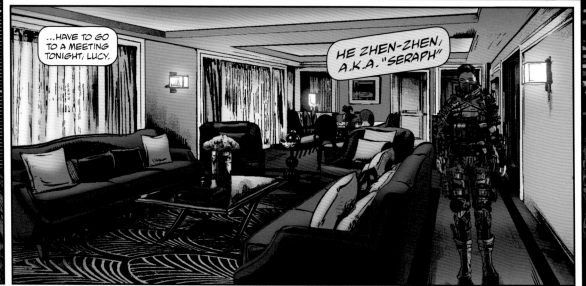

...HAVE TO GO TO A MEETING TONIGHT, LUCY.

HE ZHEN-ZHEN, A.K.A. "SERAPH"

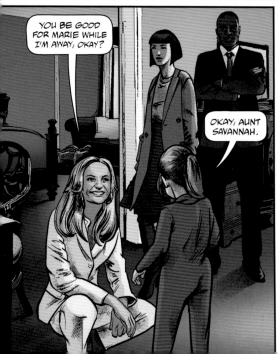

YOU BE GOOD FOR MARIE WHILE I'M AWAY, OKAY?

OKAY, AUNT SAVANNAH.

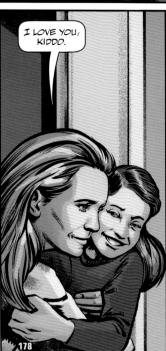

I LOVE YOU, KIDDO.

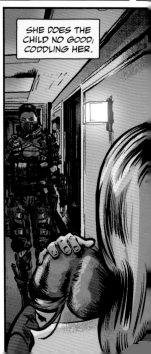

SHE DOES THE CHILD NO GOOD, CODDLING HER.

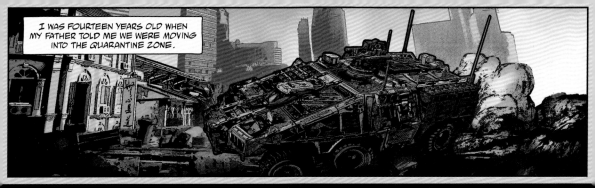

I WAS FOURTEEN YEARS OLD WHEN MY FATHER TOLD ME WE WERE MOVING INTO THE QUARANTINE ZONE.

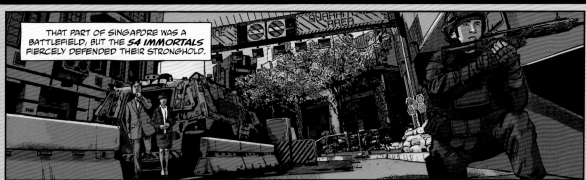

THAT PART OF SINGAPORE WAS A BATTLEFIELD, BUT THE **54 IMMORTALS** FIERCELY DEFENDED THEIR STRONGHOLD.

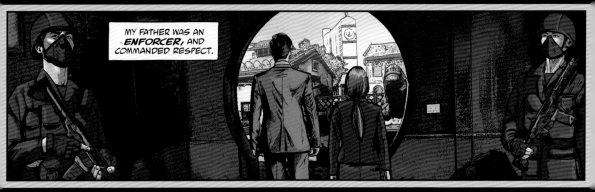

MY FATHER WAS AN **ENFORCER,** AND COMMANDED RESPECT.

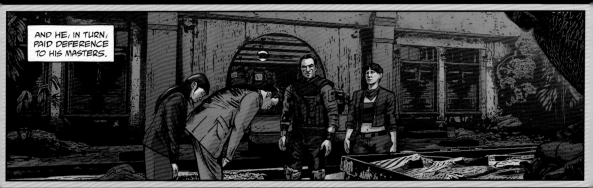

AND HE, IN TURN, PAID DEFERENCE TO HIS MASTERS.

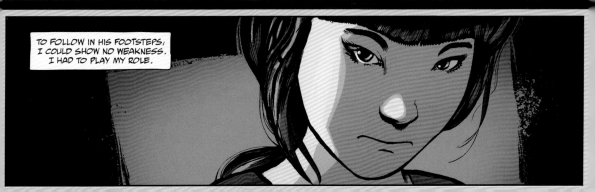

TO FOLLOW IN HIS FOOTSTEPS, I COULD SHOW NO WEAKNESS. I HAD TO PLAY MY ROLE.

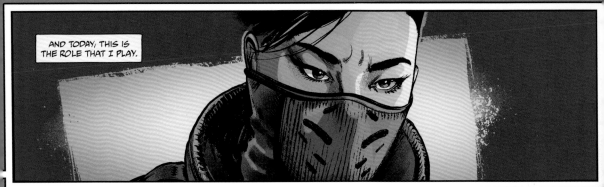

AND TODAY, THIS IS THE ROLE THAT I PLAY.

GOOD NIGHT!

SWEET DREAMS, LUCY. WE CAN HAVE BREAKFAST TOGETHER IN THE MORNING BEFORE YOU AND MARIE HIT THE SLOPES.

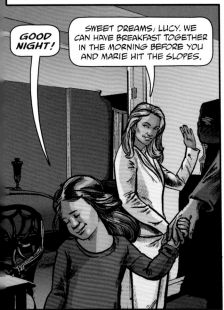

SECURE THE RESIDENCE. NO ONE IS TO ENTER OR LEAVE UNTIL I RETURN.

UNDERSTOOD, MA'AM.

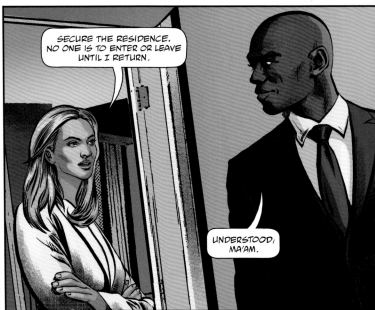

WELL, SHALL WE GO?

THE CHOPPER IS PREPPED AND READY FOR TAKEOFF.

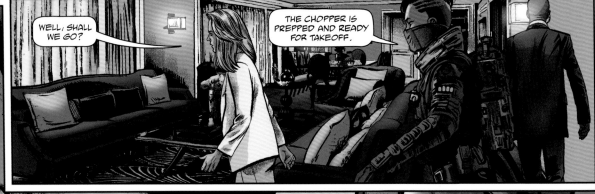

AS AN ENFORCER, I REPRESENT THE WILL OF THE **54 IMMORTALS**. OR, MORE SPECIFICALLY, THE WILL OF ITS LEADERS.

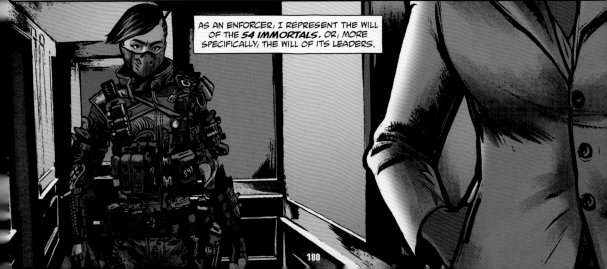

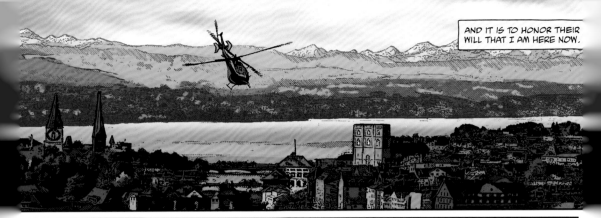

AND IT IS TO HONOR THEIR WILL THAT I AM HERE NOW.

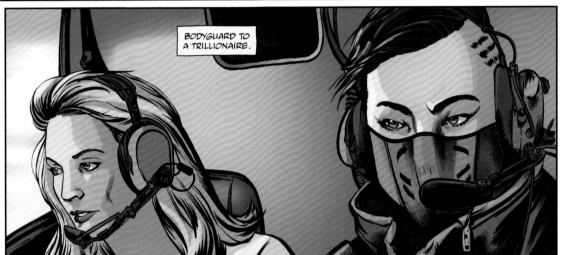

BODYGUARD TO A TRILLIONAIRE.

AND YOU'RE CLEAR ON THE MISSION PARAMETERS?

I KNOW MY DUTY.

JUST BE READY TO KICK ASS, IF THE NEED ARISES.

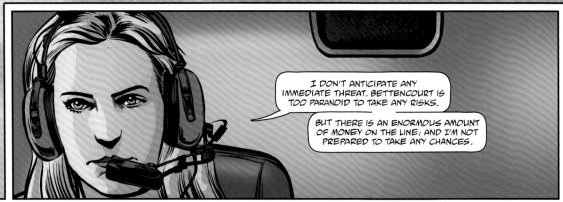

I DON'T ANTICIPATE ANY IMMEDIATE THREAT. BETTENCOURT IS TOO PARANOID TO TAKE ANY RISKS.

BUT THERE IS AN ENORMOUS AMOUNT OF MONEY ON THE LINE, AND I'M NOT PREPARED TO TAKE ANY CHANCES.

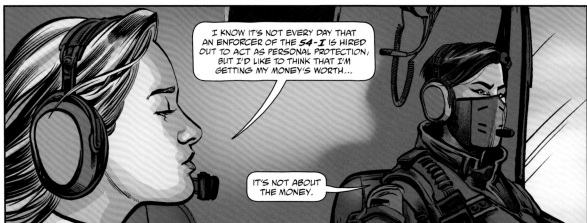

I KNOW IT'S NOT EVERY DAY THAT AN ENFORCER OF THE *54-I* IS HIRED OUT TO ACT AS PERSONAL PROTECTION, BUT I'D LIKE TO THINK THAT I'M GETTING MY MONEY'S WORTH...

IT'S NOT ABOUT THE MONEY.

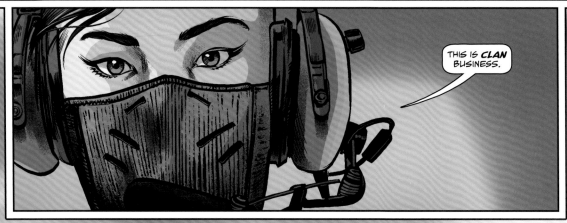

THIS IS *CLAN* BUSINESS.

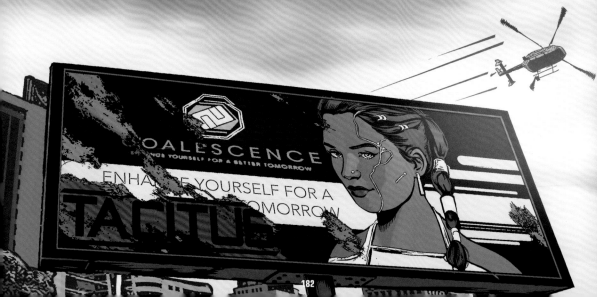

SWISS ALPS.

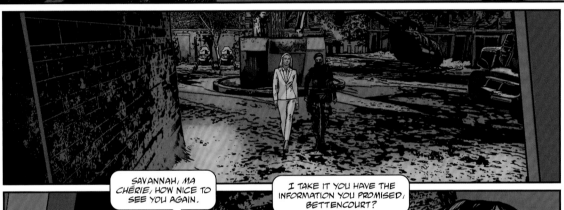

SAVANNAH, MA CHÉRIE, HOW NICE TO SEE YOU AGAIN.

I TAKE IT YOU HAVE THE INFORMATION YOU PROMISED, BETTENCOURT?

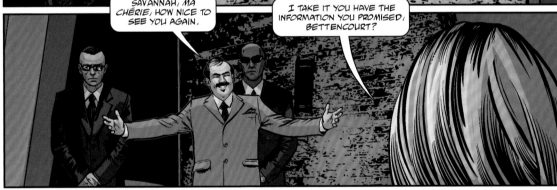

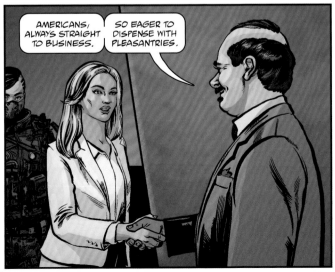

AMERICANS, ALWAYS STRAIGHT TO BUSINESS.

SO EAGER TO DISPENSE WITH PLEASANTRIES.

COME IN, COME IN!

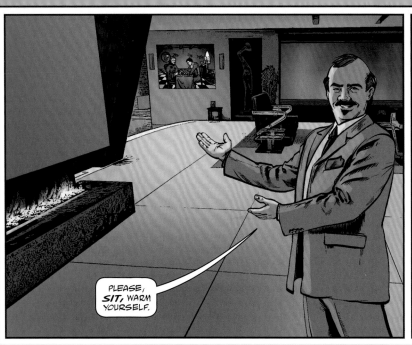

PLEASE, **SIT,** WARM YOURSELF.

IF YOU INSIST.

SHE IS NOT ONE TO SUFFER FOOLS GLADLY.

BUT THIS MAN BETTENCOURT IS NO FOOL.

HE HAS A VIRTUAL ARMY OF PRIVATE SECURITY ON THE PREMISES.

YOU HAVE BEEN WELL, I HOPE.

AND EVEN BETTER IN THE DAYS TO COME, IF FORTUNE SMILES ON ME.

SEEMS MORE A CASUAL DINNER PARTY THAN A HIGH STAKES NEGOTIATION. SO FAR FROM THE WORLD I KNEW AS A CHILD.

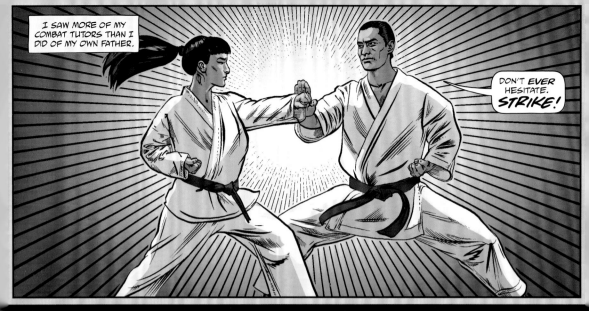

I SAW MORE OF MY COMBAT TUTORS THAN I DID OF MY OWN FATHER.

DON'T *EVER* HESITATE. **STRIKE!**

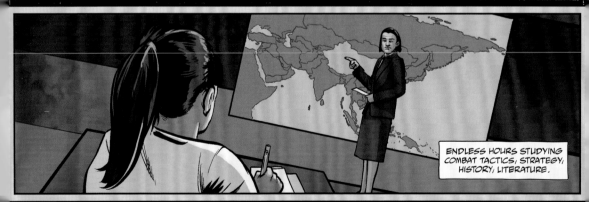

FOR THREE YEARS, EVERY DAY SPENT TRAINING IN HAND-TO-HAND, OR ON THE GUN RANGE.

BLAM BLAM BLAM

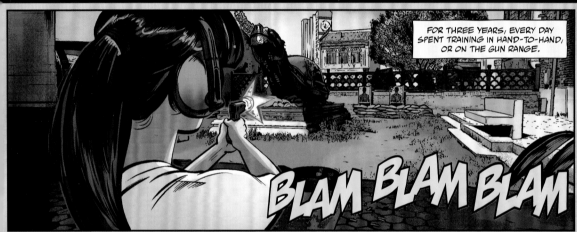

ENDLESS HOURS STUDYING COMBAT TACTICS, STRATEGY, HISTORY, LITERATURE.

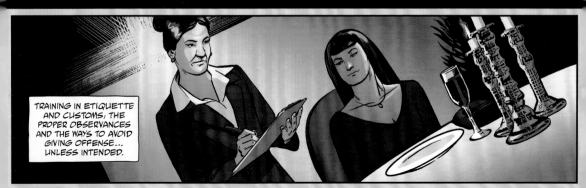

TRAINING IN ETIQUETTE AND CUSTOMS, THE PROPER OBSERVANCES AND THE WAYS TO AVOID GIVING OFFENSE... UNLESS INTENDED.

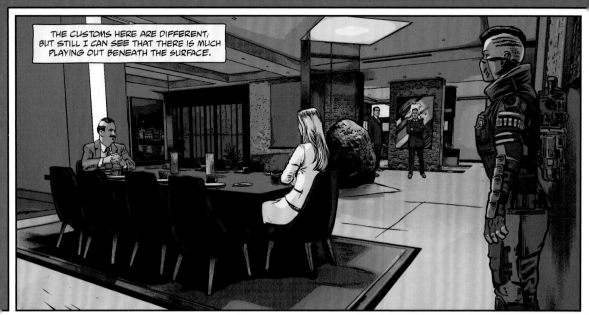

THE CUSTOMS HERE ARE DIFFERENT, BUT STILL I CAN SEE THAT THERE IS MUCH PLAYING OUT BENEATH THE SURFACE.

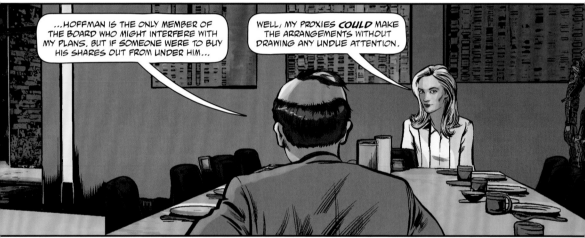

...HOFFMAN IS THE ONLY MEMBER OF THE BOARD WHO MIGHT INTERFERE WITH MY PLANS, BUT IF SOMEONE WERE TO BUY HIS SHARES OUT FROM UNDER HIM...

WELL, MY PROXIES *COULD* MAKE THE ARRANGEMENTS WITHOUT DRAWING ANY UNDUE ATTENTION.

A TOAST, THEN, TO OUR *MUTUAL* BENEFIT.

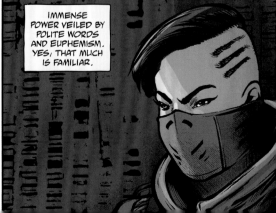

IMMENSE POWER VEILED BY POLITE WORDS AND EUPHEMISM. YES, THAT MUCH IS FAMILIAR.

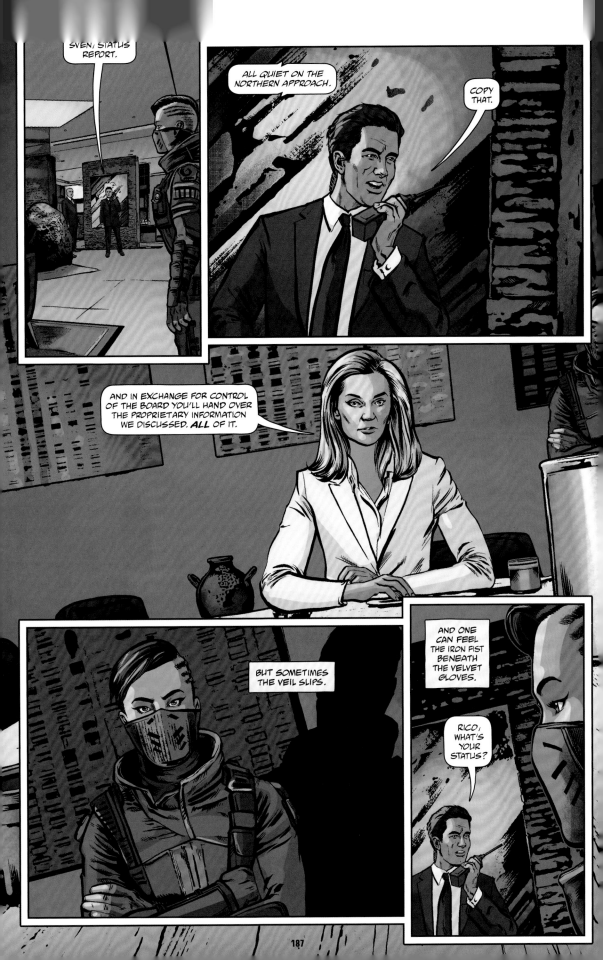

SVEN, STATUS REPORT.

ALL QUIET ON THE NORTHERN APPROACH.

COPY THAT.

AND IN EXCHANGE FOR CONTROL OF THE BOARD YOU'LL HAND OVER THE PROPRIETARY INFORMATION WE DISCUSSED. **ALL** OF IT.

BUT SOMETIMES THE VEIL SLIPS.

AND ONE CAN FEEL THE IRON FIST BENEATH THE VELVET GLOVES.

RICO, WHAT'S YOUR STATUS?

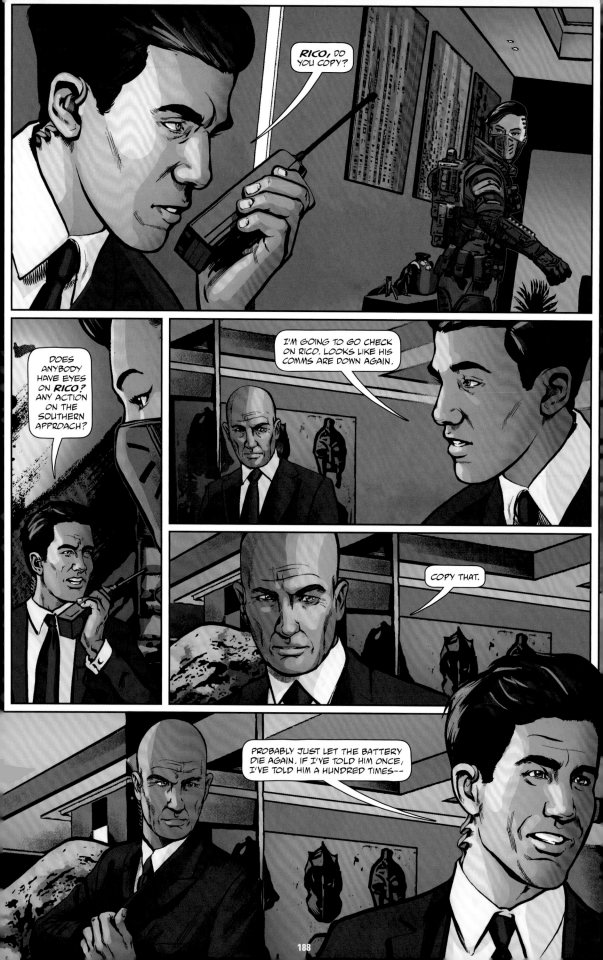

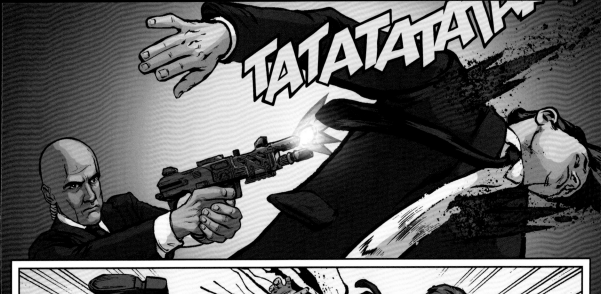

TATATATAT

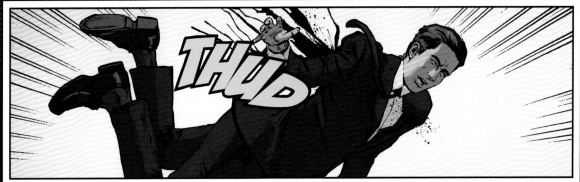

THUD

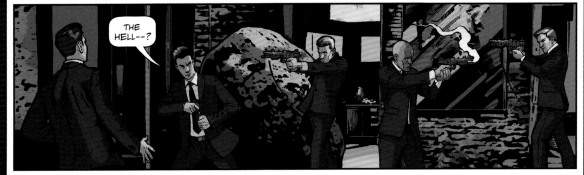

THE HELL--?

TATATA

TA TA TA

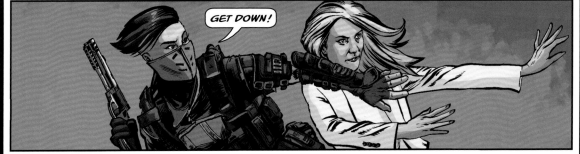

GET DOWN!

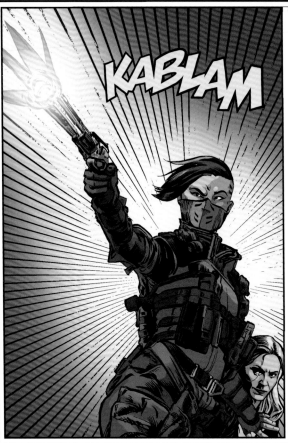

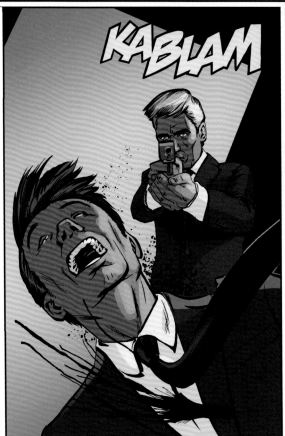

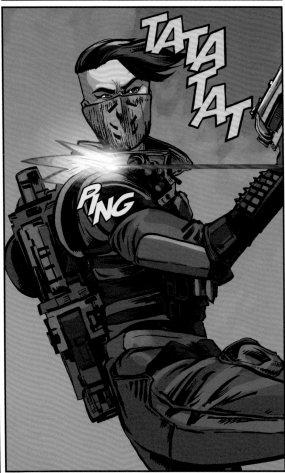

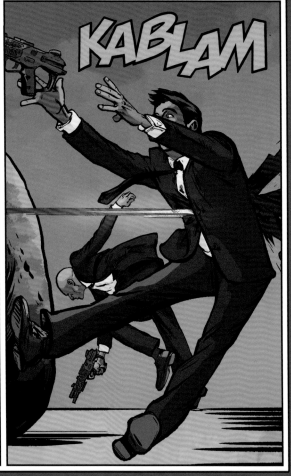

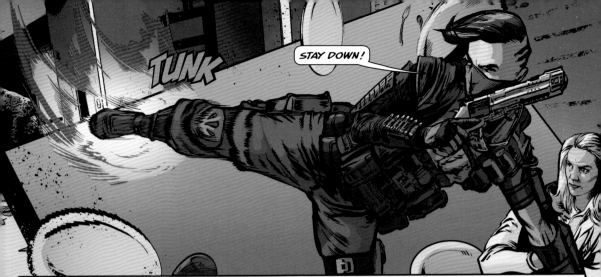

TUNK

STAY DOWN!

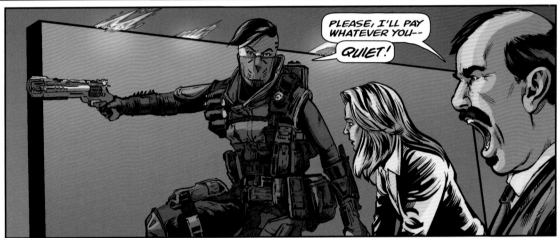

PLEASE, I'LL PAY WHATEVER YOU--

QUIET!

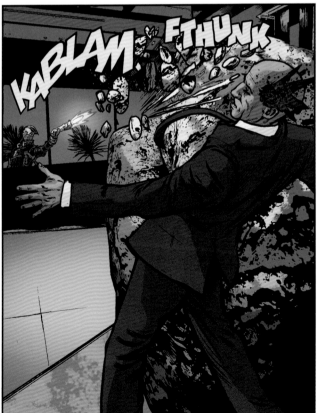

KABLAM FTHUNK

WHAT...WHAT HAPPENED...? MY MEN...?

WERE PAID OFF BY HOFFMAN, I'M GUESSING.

OKAY--WE'RE CLEAR.

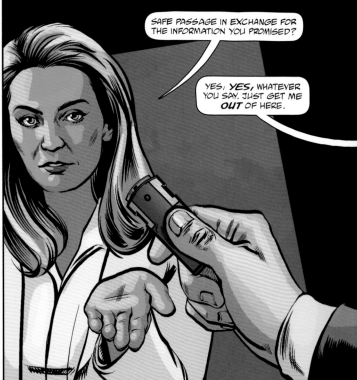

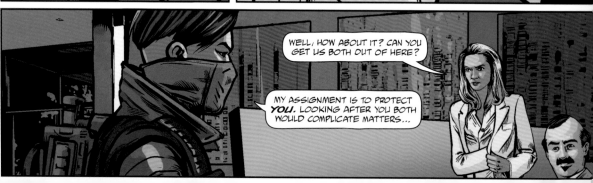

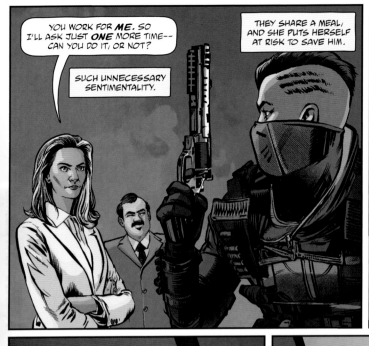

YOU WORK FOR **ME.** SO I'LL ASK JUST **ONE** MORE TIME-- CAN YOU DO IT, OR NOT?

SUCH UNNECESSARY SENTIMENTALITY.

THEY SHARE A MEAL, AND SHE PUTS HERSELF AT RISK TO SAVE HIM.

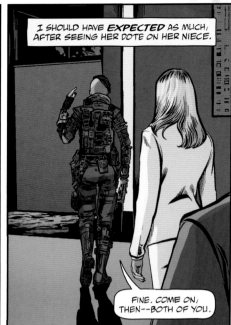

I SHOULD HAVE **EXPECTED** AS MUCH, AFTER SEEING HER DOTE ON HER NIECE.

FINE. COME ON, THEN--BOTH OF YOU.

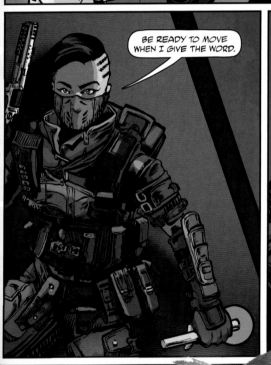

BE READY TO MOVE WHEN I GIVE THE WORD.

KABLAM

TATATATATATATA

KABLAM

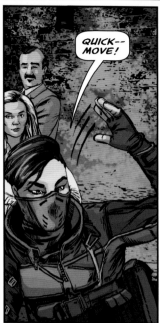

QUICK-- MOVE!

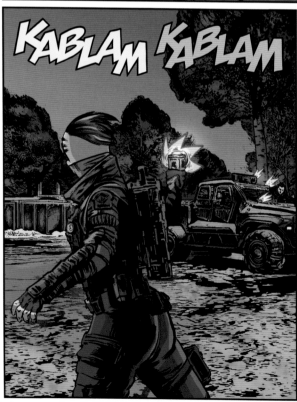

KABLAM KABLAM

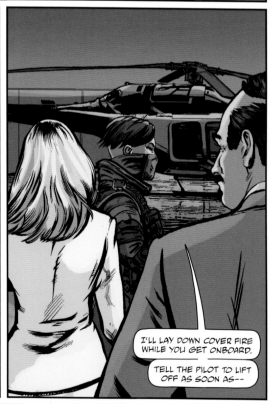

I'LL LAY DOWN COVER FIRE WHILE YOU GET ONBOARD.

TELL THE PILOT TO LIFT OFF AS SOON AS--

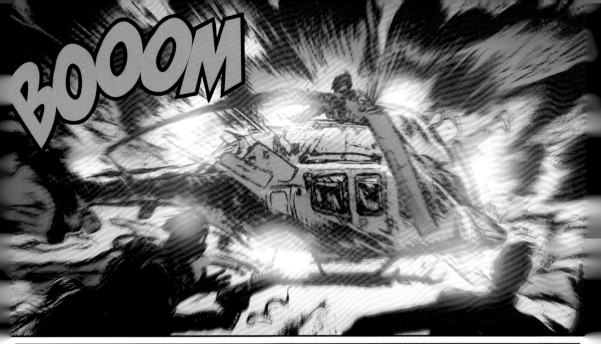

BOOOM

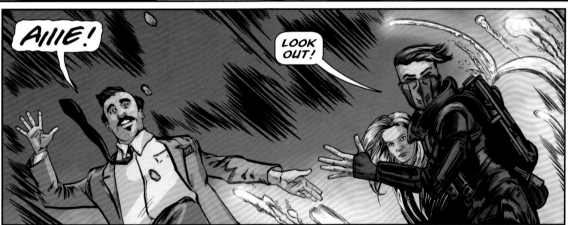

AIIIE!

LOOK OUT!

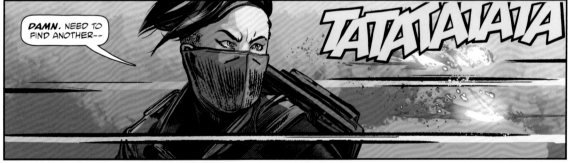

DAMN. NEED TO FIND ANOTHER--

TATATATATA

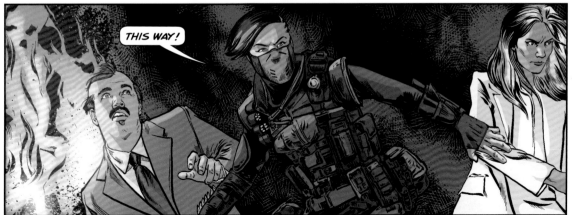

THIS WAY!

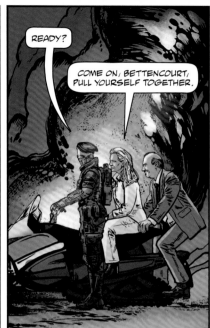

READY?

COME ON, BETTENCOURT, PULL YOURSELF TOGETHER.

HOLD ON!

VROOOM

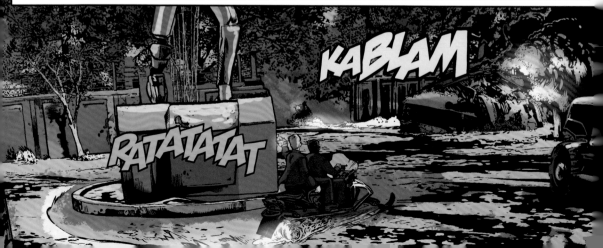

KABLAM

RATATATAT

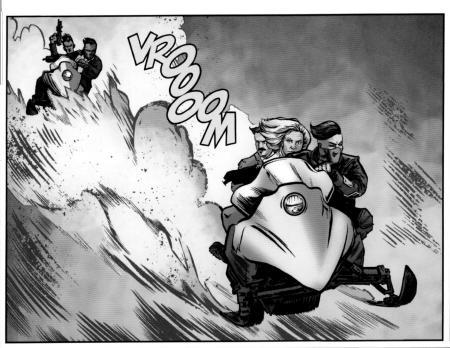

VROOOM

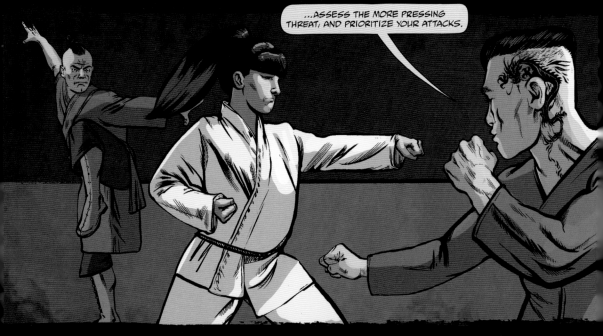

...ASSESS THE MORE PRESSING THREAT, AND PRIORITIZE YOUR ATTACKS.

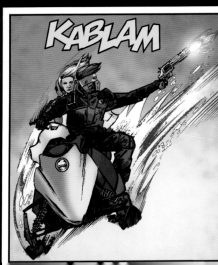

KABLAM

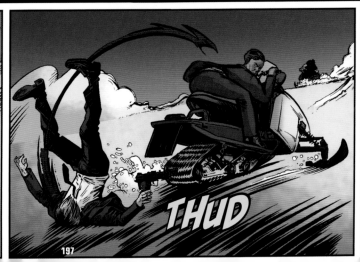

THUD

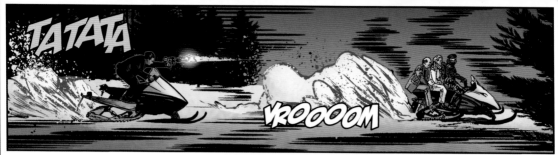

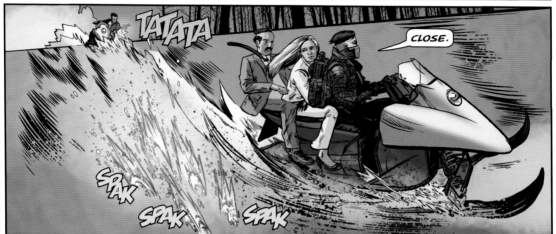

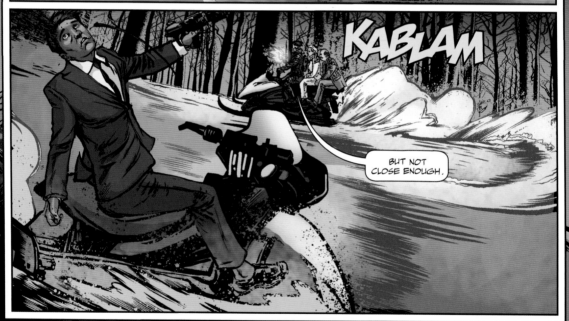

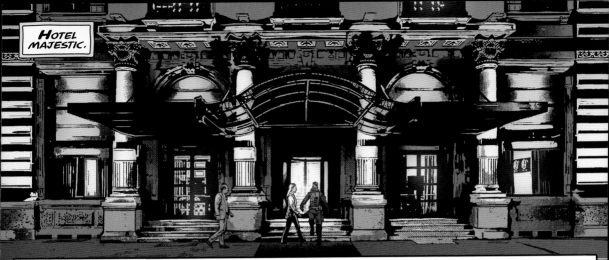

HOTEL MAJESTIC.

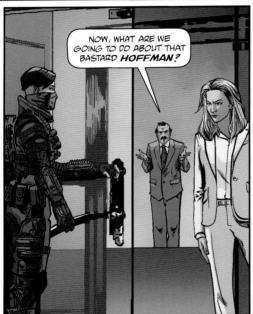

NOW, WHAT ARE WE GOING TO DO ABOUT THAT BASTARD *HOFFMAN?*

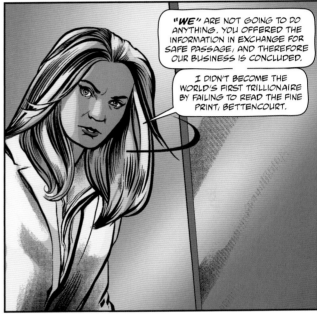

*"WE"* ARE NOT GOING TO DO ANYTHING. YOU OFFERED THE INFORMATION IN EXCHANGE FOR SAFE PASSAGE, AND THEREFORE OUR BUSINESS IS CONCLUDED.

I DIDN'T BECOME THE WORLD'S FIRST TRILLIONAIRE BY FAILING TO READ THE FINE PRINT, BETTENCOURT.

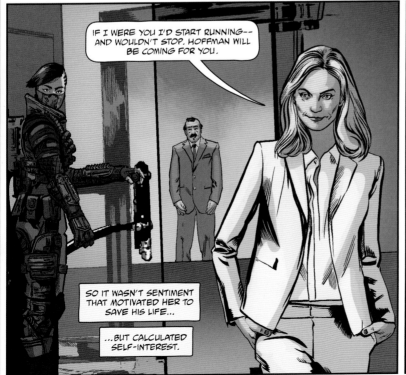

IF I WERE YOU I'D START RUNNING-- AND WOULDN'T STOP. HOFFMAN WILL BE COMING FOR YOU.

SO IT WASN'T SENTIMENT THAT MOTIVATED HER TO SAVE HIS LIFE...

...BUT CALCULATED SELF-INTEREST.

CULTURED WORDS AND REFINED MANNERS WITH SHARP STEEL BEHIND THEM. PERHAPS NOT SO DIFFERENT FROM THE WORLD I KNEW AS A CHILD, AFTER ALL.

THE END

# A J A X

Writer: **Aaron Duran** / Artist: **Emanuele Gizzi** / Colorist: **Mariachristina Federico**
Cover Artist: **Julian Totino Tedesco**

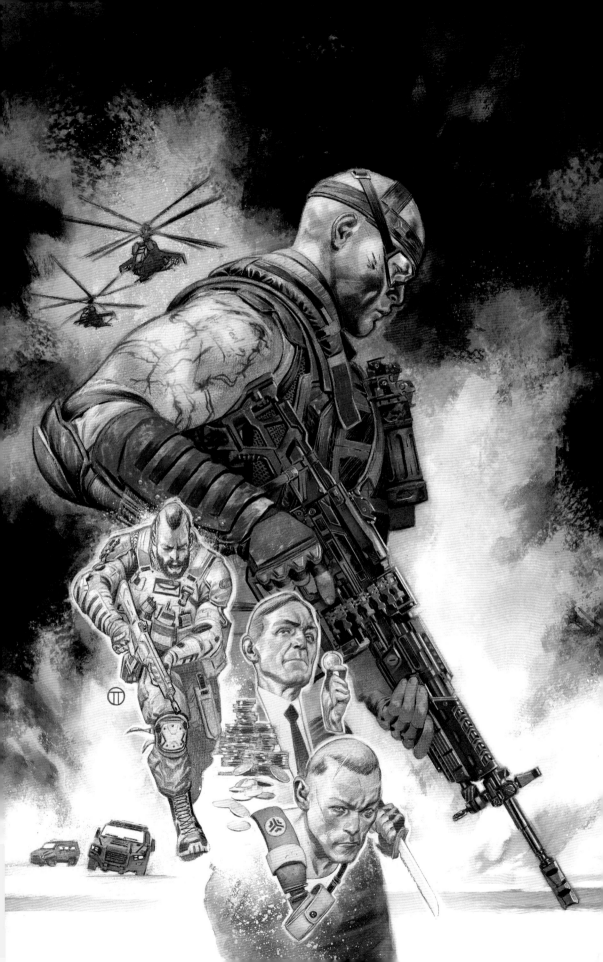

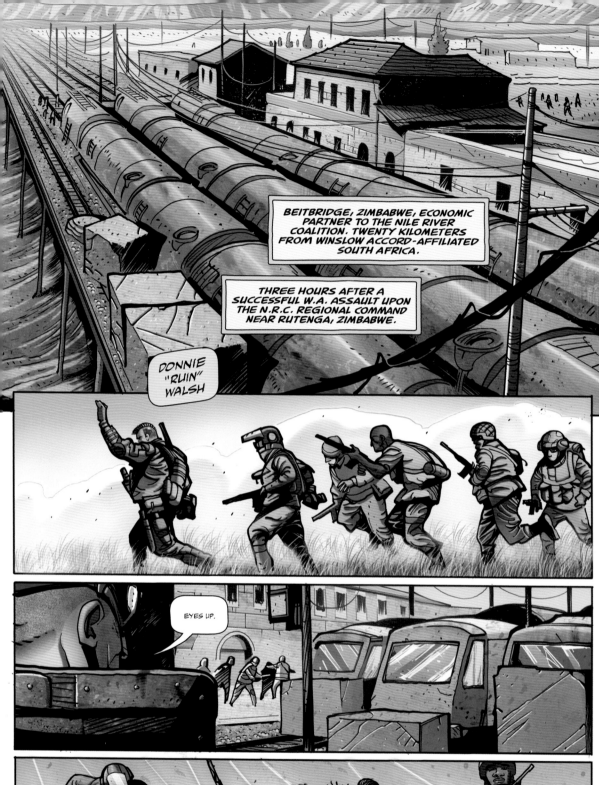

BEITBRIDGE, ZIMBABWE, ECONOMIC PARTNER TO THE NILE RIVER COALITION. TWENTY KILOMETERS FROM WINSLOW ACCORD-AFFILIATED SOUTH AFRICA.

THREE HOURS AFTER A SUCCESSFUL W.A. ASSAULT UPON THE N.R.C. REGIONAL COMMAND NEAR RUTENGA, ZIMBABWE.

DONNIE "RUIN" WALSH

EYES UP.

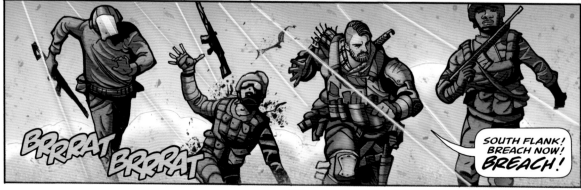

BRRRAT BRRRAT

SOUTH FLANK! BREACH NOW! BREACH!

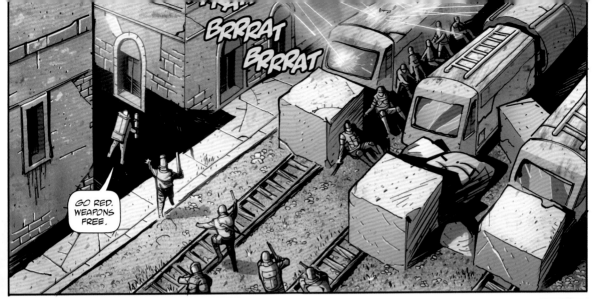

GO RED.
WEAPONS
FREE.

BRRRAT
BRRRAT

KRASH

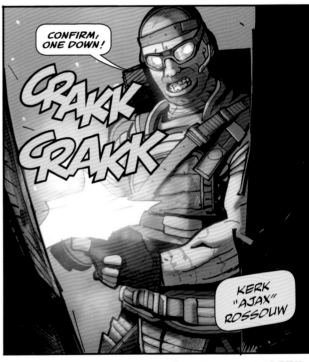

CONFIRM,
ONE DOWN!

CRAKK
CRAKK

KERK
"AJAX"
ROSSOUW

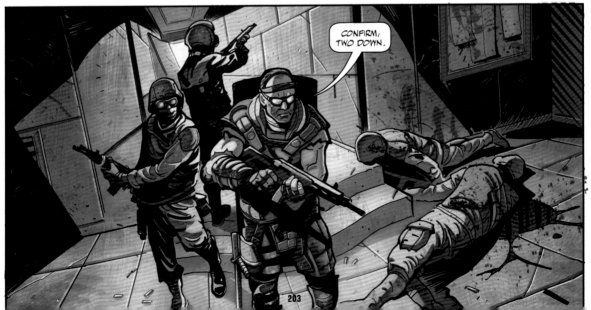

CONFIRM,
TWO DOWN.

203

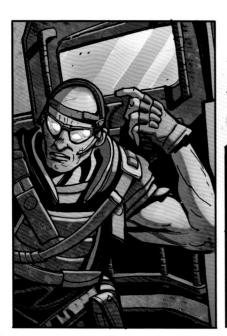
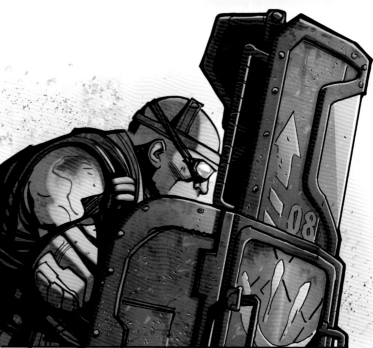
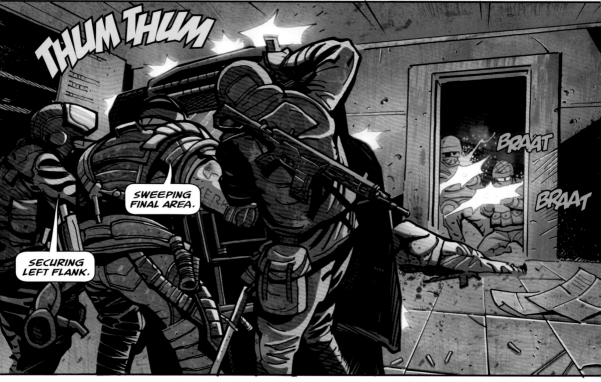
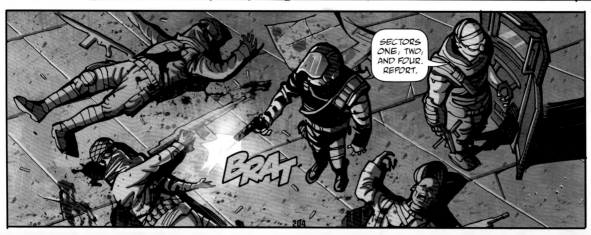

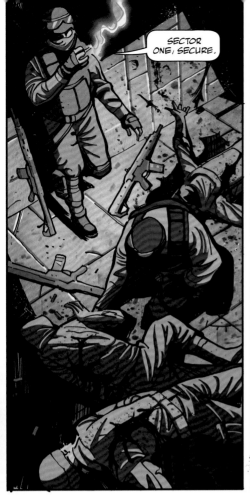

SECTOR ONE, SECURE.

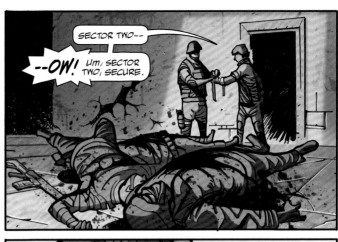

SECTOR TWO--

--OW! *Um,* SECTOR TWO, SECURE.

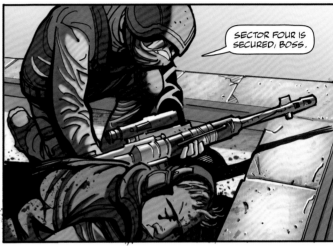

SECTOR FOUR IS SECURED, BOSS.

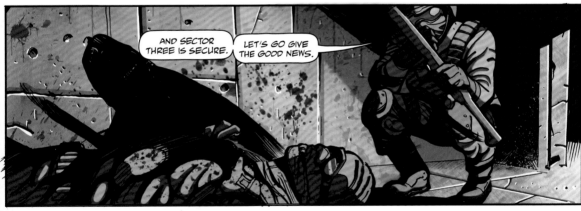

AND SECTOR THREE IS SECURE.

LET'S GO GIVE THE GOOD NEWS.

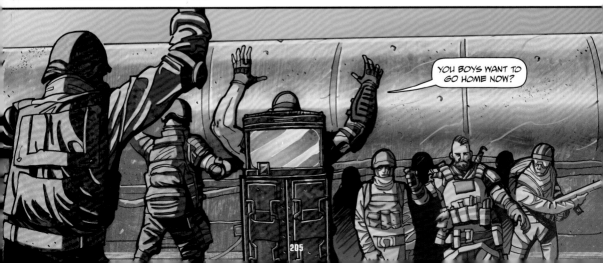

YOU BOYS WANT TO GO HOME NOW?

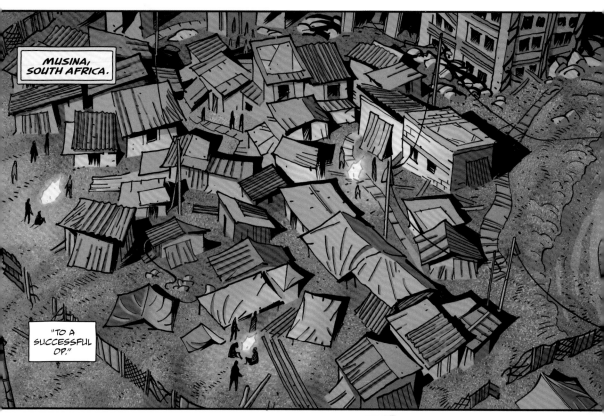

MUSINA, SOUTH AFRICA.

"TO A SUCCESSFUL OP."

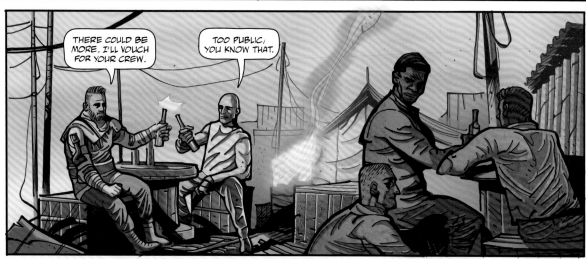

THERE COULD BE MORE. I'LL VOUCH FOR YOUR CREW.

TOO PUBLIC, YOU KNOW THAT.

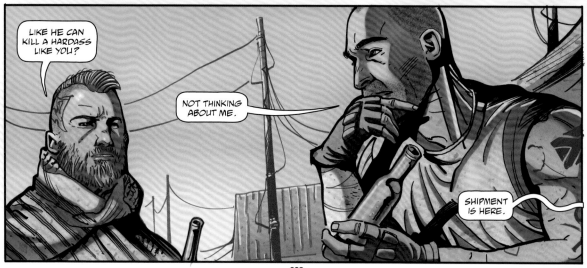

LIKE HE CAN KILL A HARDASS LIKE YOU?

NOT THINKING ABOUT ME.

SHIPMENT IS HERE.

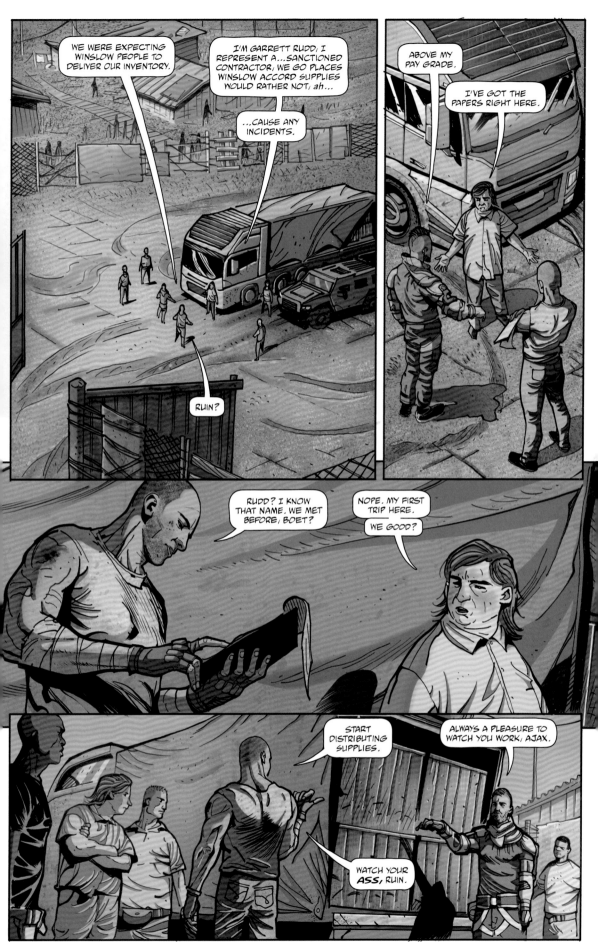

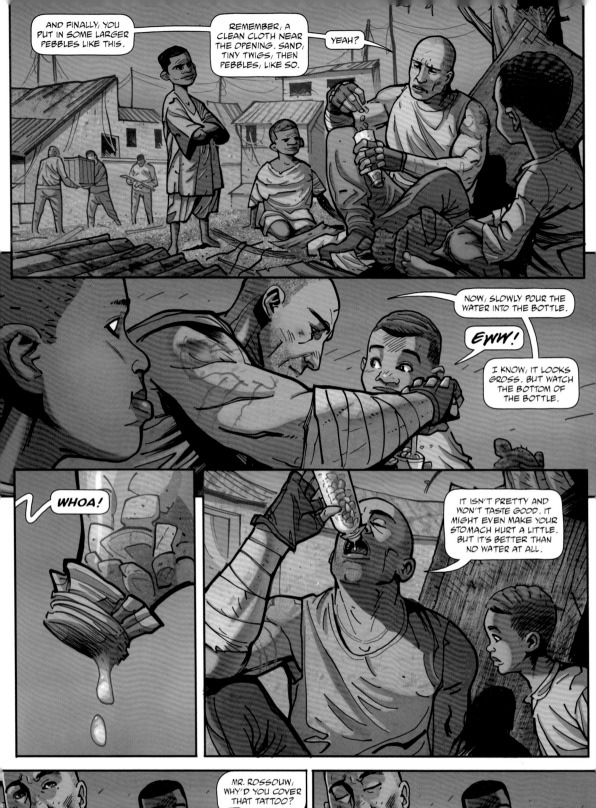

AND FINALLY, YOU PUT IN SOME LARGER PEBBLES LIKE THIS.

REMEMBER, A CLEAN CLOTH NEAR THE OPENING. SAND, TINY TWIGS, THEN PEBBLES, LIKE SO.

YEAH?

NOW, SLOWLY POUR THE WATER INTO THE BOTTLE.

EWW!

I KNOW, IT LOOKS GROSS. BUT WATCH THE BOTTOM OF THE BOTTLE.

WHOA!

IT ISN'T PRETTY AND WON'T TASTE GOOD. IT MIGHT EVEN MAKE YOUR STOMACH HURT A LITTLE. BUT IT'S BETTER THAN NO WATER AT ALL.

MR. ROSSOUW, WHY'D YOU COVER THAT TATTOO?

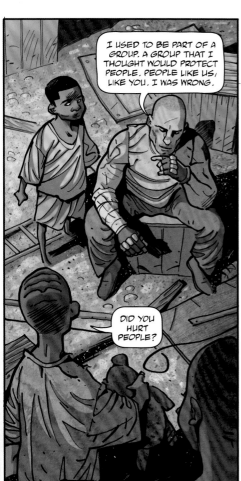

I USED TO BE PART OF A GROUP. A GROUP THAT I THOUGHT WOULD PROTECT PEOPLE. PEOPLE LIKE US, LIKE YOU. I WAS WRONG.

DID YOU HURT PEOPLE?

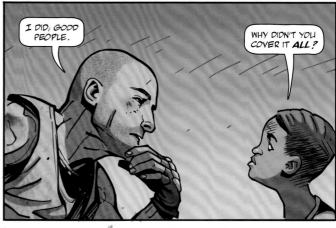

I DID. GOOD PEOPLE.

WHY DIDN'T YOU COVER IT *ALL*?

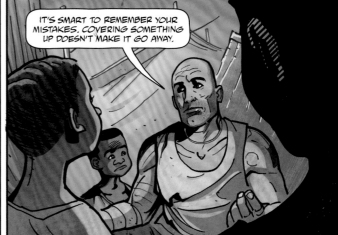

IT'S SMART TO REMEMBER YOUR MISTAKES. COVERING SOMETHING UP DOESN'T MAKE IT GO AWAY.

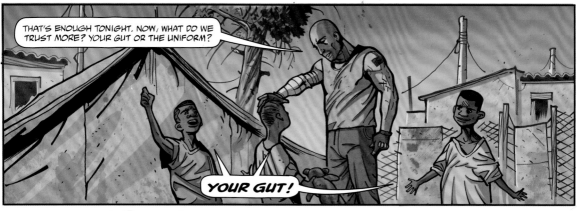

THAT'S ENOUGH TONIGHT. NOW, WHAT DO WE TRUST MORE? YOUR GUT OR THE UNIFORM?

*YOUR GUT!*

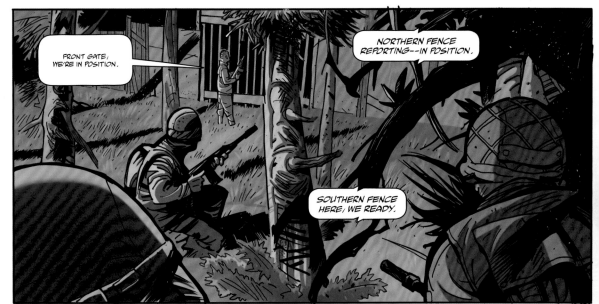

FRONT GATE, WE'RE IN POSITION.

NORTHERN FENCE REPORTING--IN POSITION.

SOUTHERN FENCE HERE, WE READY.

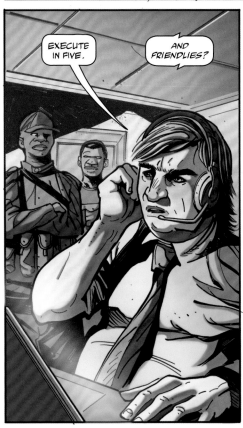

EXECUTE IN FIVE.

AND FRIENDLIES?

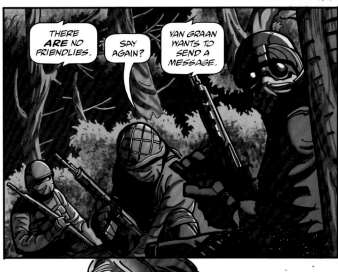

THERE **ARE** NO FRIENDLIES.

SAY AGAIN?

VAN GRAAN WANTS TO SEND A MESSAGE.

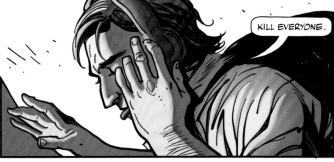

KILL EVERYONE.

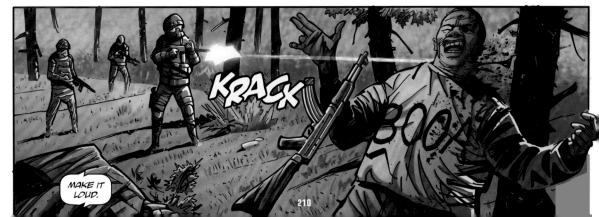

KRACK

BOOK

MAKE IT LOUD.

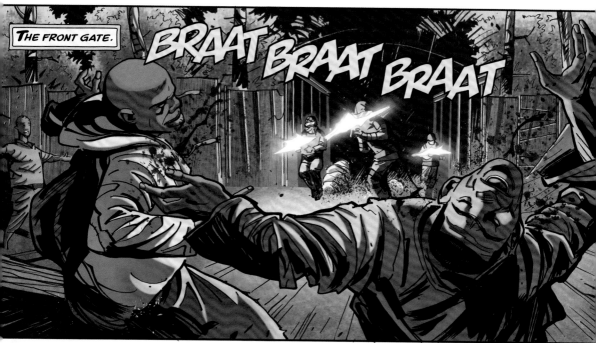

THE FRONT GATE.

BRAAT BRAAT BRAAT

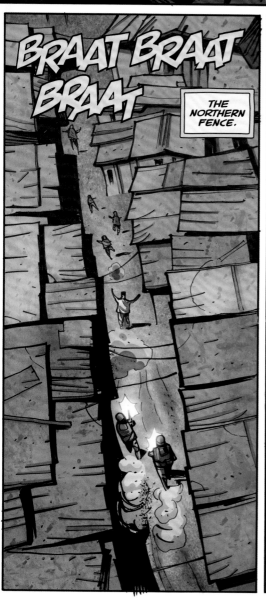

BRAAT BRAAT BRAAT

THE NORTHERN FENCE.

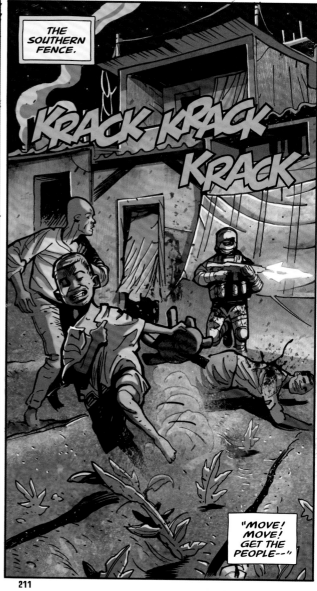

THE SOUTHERN FENCE.

KRACK KRACK KRACK

"MOVE! MOVE! GET THE PEOPLE--"

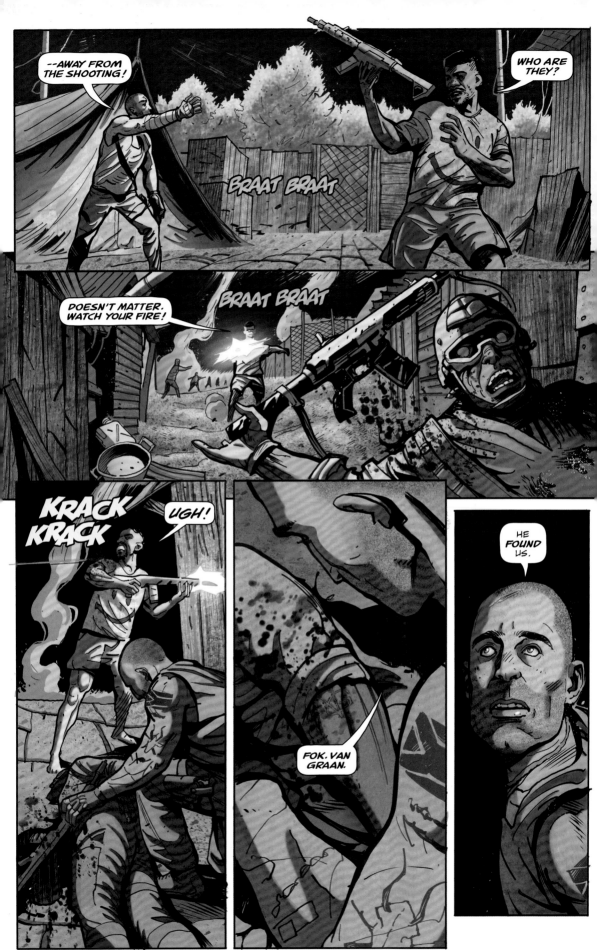

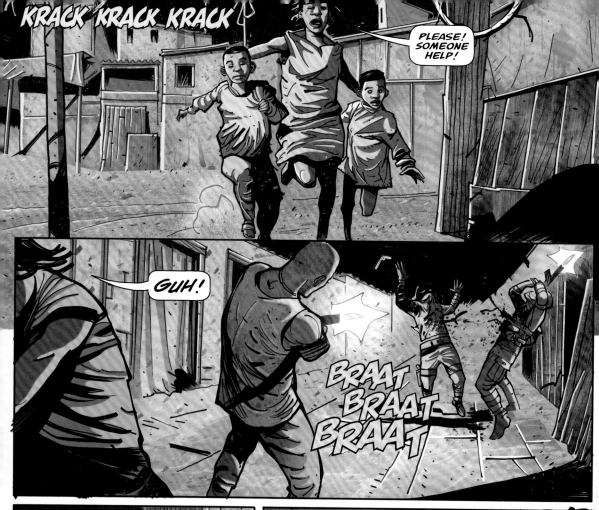

KRACK KRACK KRACK

PLEASE! SOMEONE HELP!

GUH!

BRAAT BRAAT BRAAT

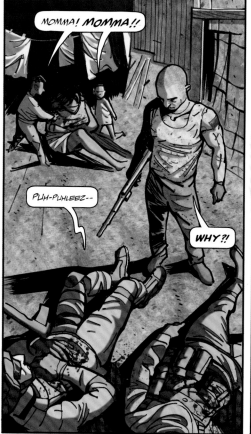

MOMMA! MOMMA!!

PUH-PUHLEEZ--

WHY?!

BRAAAT

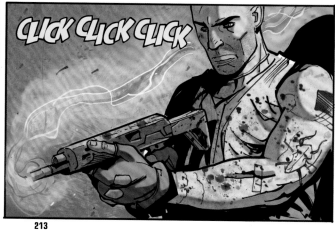

CLICK CLICK CLICK

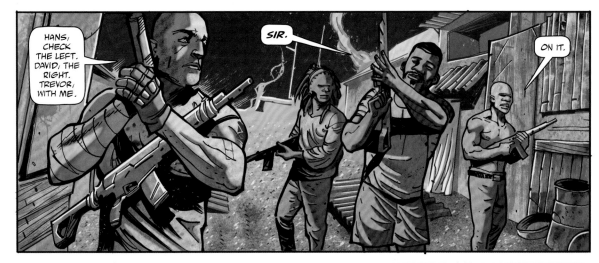

HANS, CHECK THE LEFT. DAVID, THE RIGHT. TREVOR, WITH ME.

SIR.

ON IT.

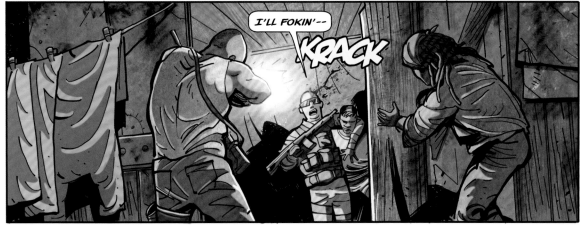

I'LL FOKIN'--

KRACK

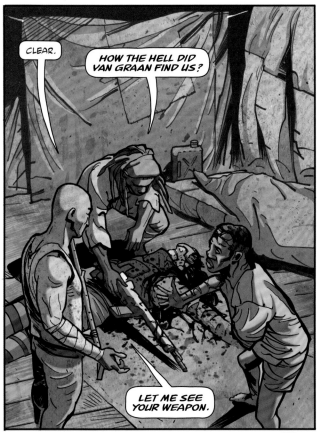

CLEAR.

HOW THE HELL DID VAN GRAAN FIND US?

LET ME SEE YOUR WEAPON.

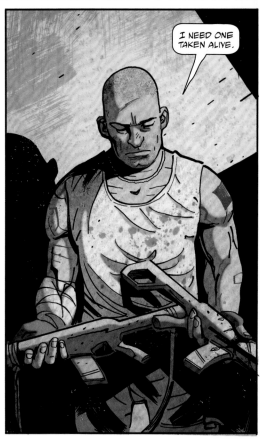

I NEED ONE TAKEN ALIVE.

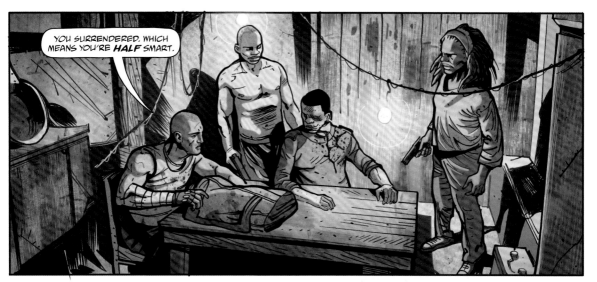

YOU SURRENDERED. WHICH MEANS YOU'RE **HALF** SMART.

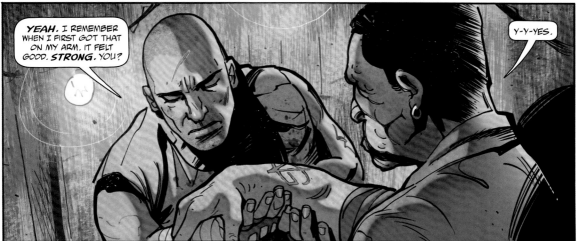

**YEAH.** I REMEMBER WHEN I FIRST GOT THAT ON MY ARM. IT FELT GOOD. **STRONG.** YOU?

Y-Y-YES.

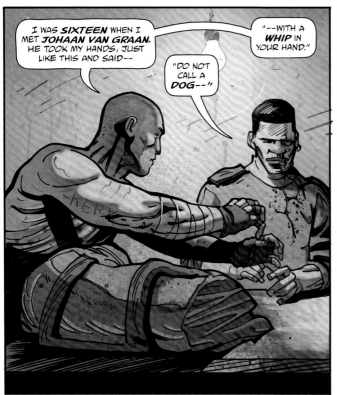

I WAS **SIXTEEN** WHEN I MET **JOHAAN VAN GRAAN.** HE TOOK MY HANDS, JUST LIKE THIS AND SAID--

"DO NOT CALL A **DOG**--"

"--WITH A **WHIP** IN YOUR HAND."

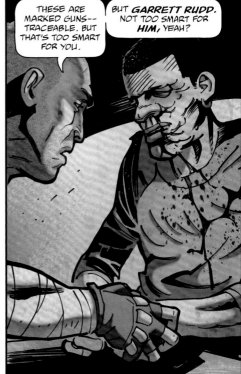

THESE ARE MARKED GUNS-- TRACEABLE. BUT THAT'S TOO SMART FOR YOU.

BUT **GARRETT RUDD.** NOT TOO SMART FOR **HIM,** YEAH?

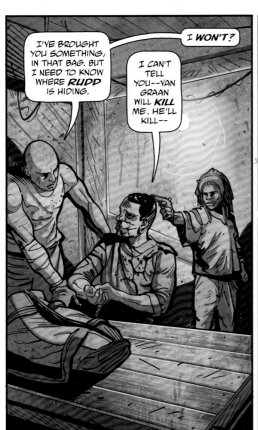

I'VE BROUGHT YOU SOMETHING, IN THAT BAG. BUT I NEED TO KNOW WHERE **RUDD** IS HIDING.

I **WON'T?**

I CAN'T TELL YOU--VAN GRAAN WILL **KILL** ME. HE'LL KILL--

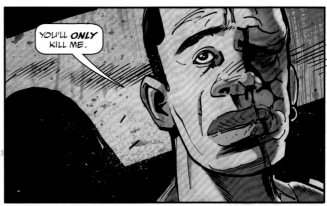

YOU'LL **ONLY** KILL ME.

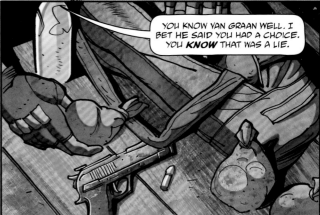

YOU KNOW VAN GRAAN WELL. I BET HE SAID YOU HAD A CHOICE. YOU **KNOW** THAT WAS A LIE.

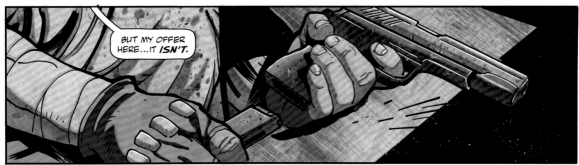

BUT MY OFFER HERE...IT **ISN'T.**

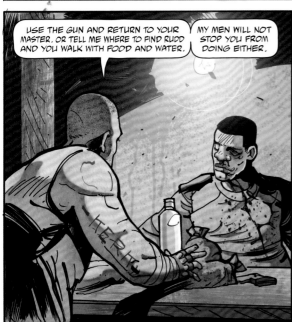

USE THE GUN AND RETURN TO YOUR MASTER. OR TELL ME WHERE TO FIND RUDD AND YOU WALK WITH FOOD AND WATER.

MY MEN WILL NOT STOP YOU FROM DOING EITHER.

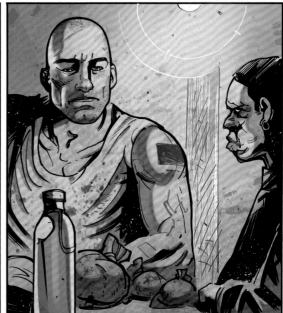

RUIN. **AJAX.**

**AJAX!** CHRIST, WHAT'S
GOING **ON?** WE'VE BEEN
SHUT OFF FROM--

STOP.

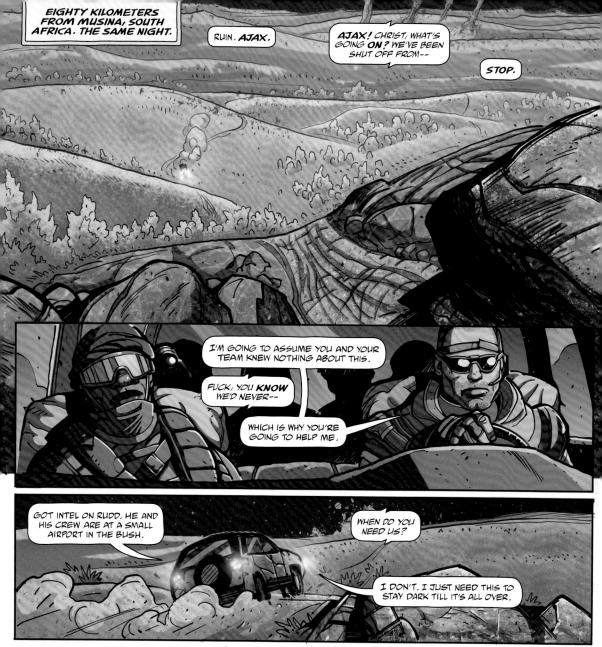

I'M GOING TO ASSUME YOU AND YOUR
TEAM KNEW NOTHING ABOUT THIS.

FUCK, YOU **KNOW**
WE'D NEVER--

WHICH IS WHY YOU'RE
GOING TO HELP ME.

GOT INTEL ON RUDD. HE AND
HIS CREW ARE AT A SMALL
AIRPORT IN THE BUSH.

WHEN DO YOU
NEED US?

I DON'T. I JUST NEED THIS TO
STAY DARK TILL IT'S ALL OVER.

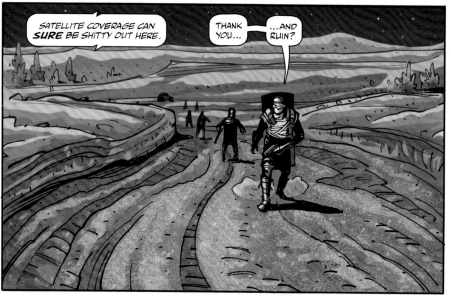

SATELLITE COVERAGE CAN
**SURE** BE SHITTY OUT HERE.

THANK
YOU...

...AND
RUIN?

THIS IS WHY
WE DON'T
JOIN YOUR
GROUP.

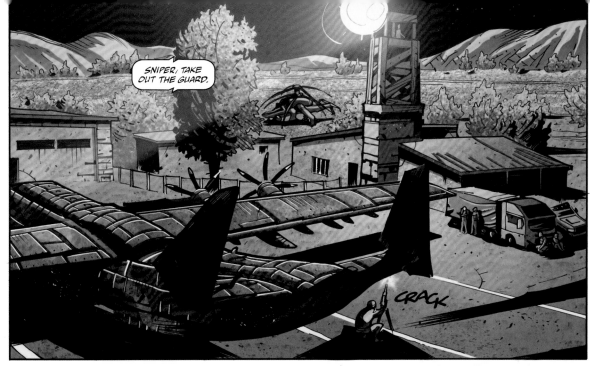

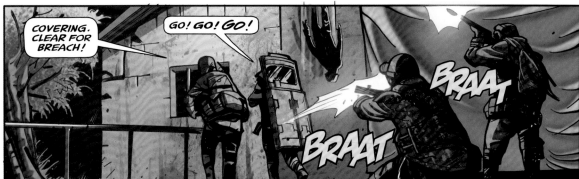

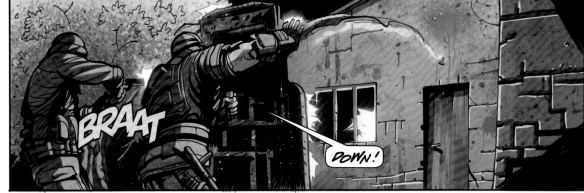

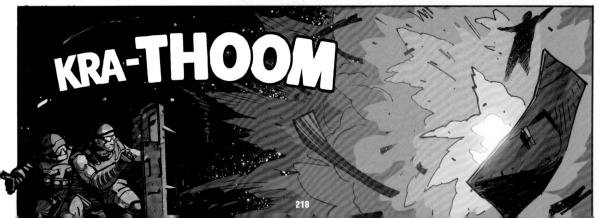

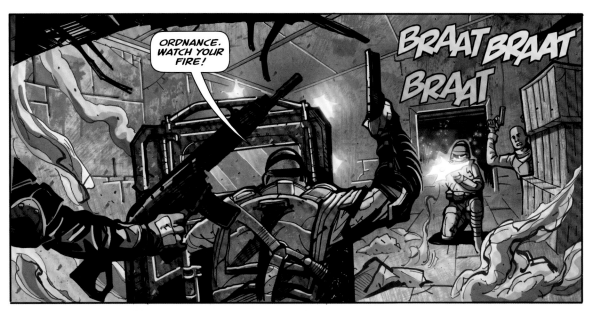

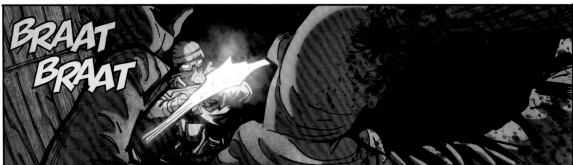

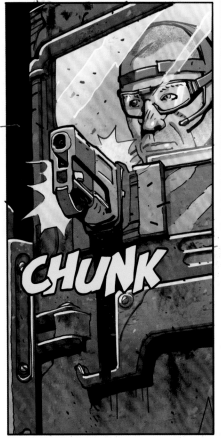

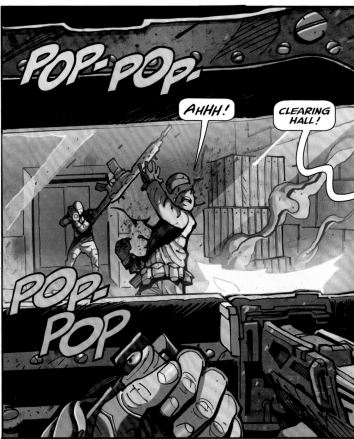

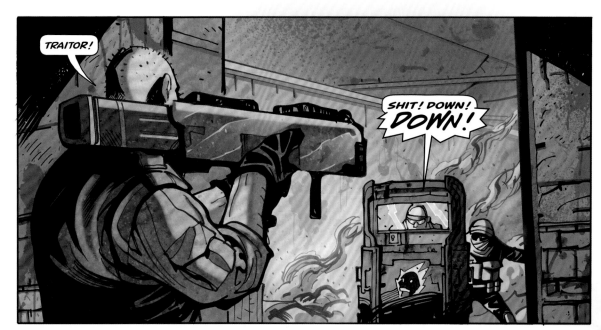

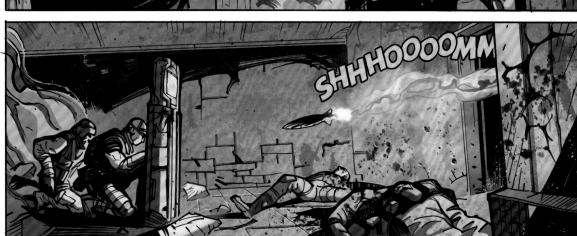

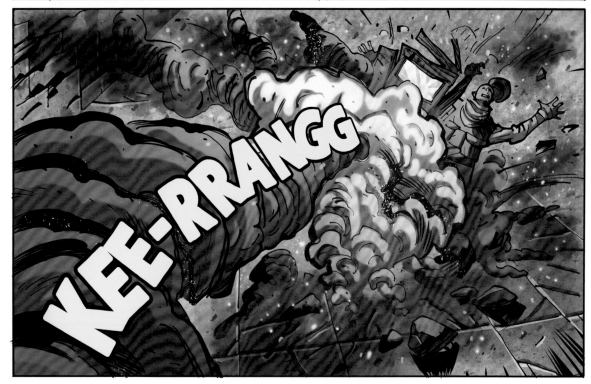

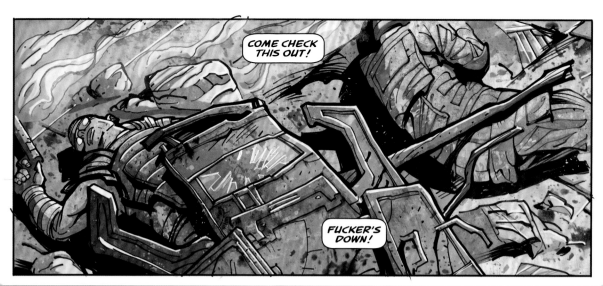

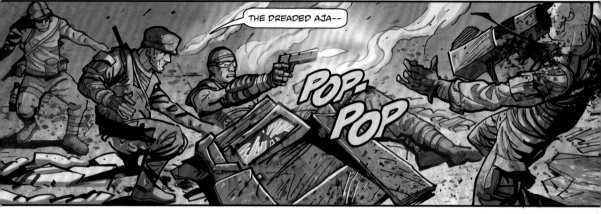

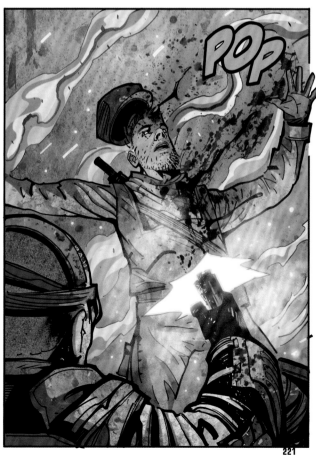

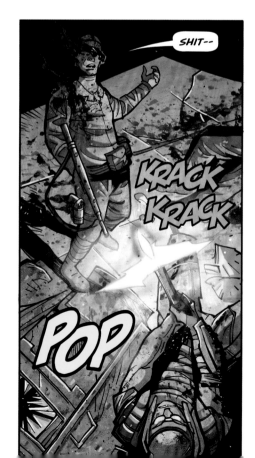

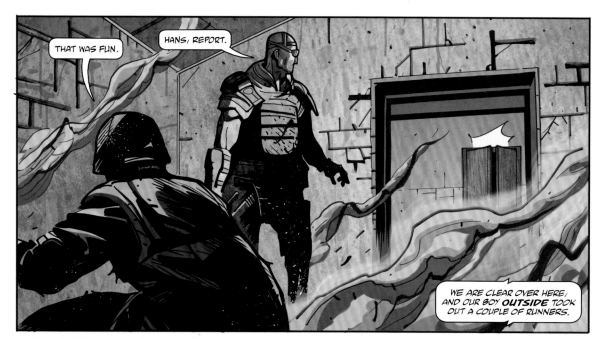

THAT WAS FUN.

HANS, REPORT.

WE ARE CLEAR OVER HERE, AND OUR BOY **OUTSIDE** TOOK OUT A COUPLE OF RUNNERS.

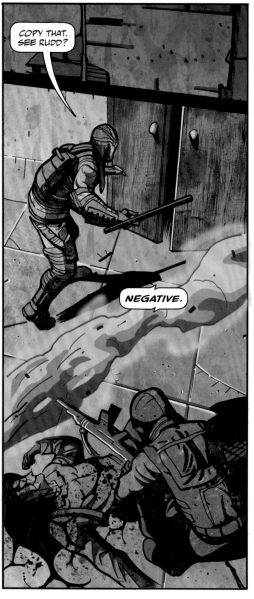

COPY THAT. SEE RUDD?

NEGATIVE.

YEAH.

AHHHHH!

CRUNCH

POP

CRACK

FUCK!

HE WAS STILL **HOLDING** THAT STUPID BEAR WHEN I FOUND HIS BODY. PROTECTING IT. WHILE I WAS FAILING TO PROTECT--

VAN GRAAN SAID--

DON'T!

DAVID. TAKE WHAT WE NEED; LIQUIDATE THE REST.

ON IT.

WAIT. *PLEASE.*

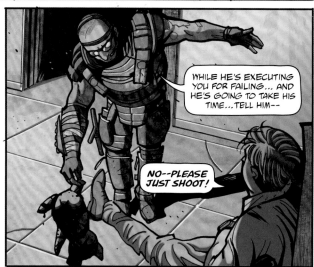

WHILE HE'S EXECUTING YOU FOR FAILING... AND HE'S GOING TO TAKE HIS TIME...TELL HIM--

NO--PLEASE JUST SHOOT!

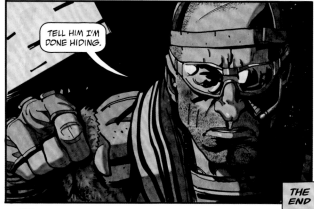

TELL HIM I'M DONE HIDING.

THE END

# B A T T E R Y

Writer: **Greg Rucka** / Artist: **Vincenzo Cucca** / Colorist: **Fabio Marinacci**
Cover Artist: **Kirbi Fagan**

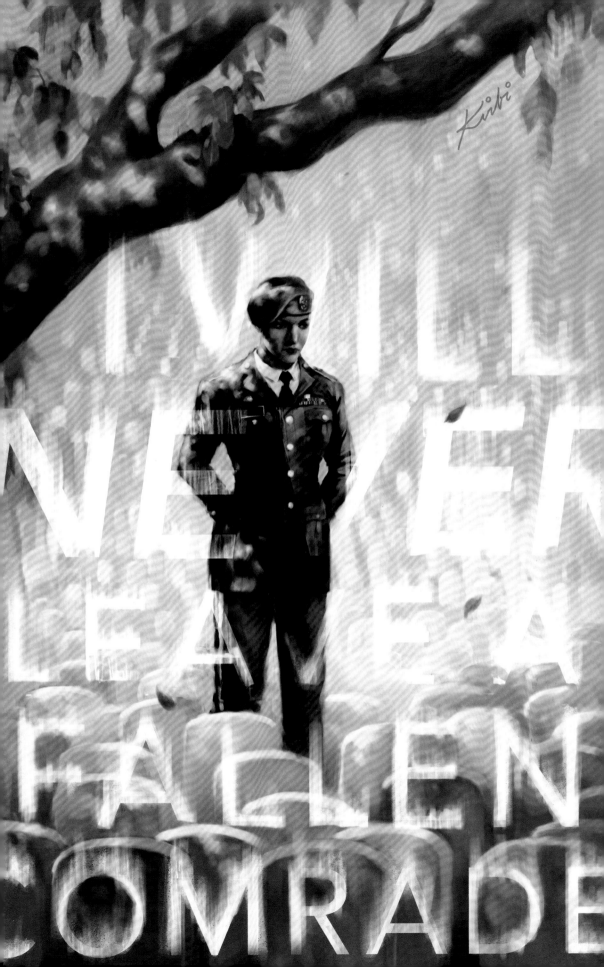

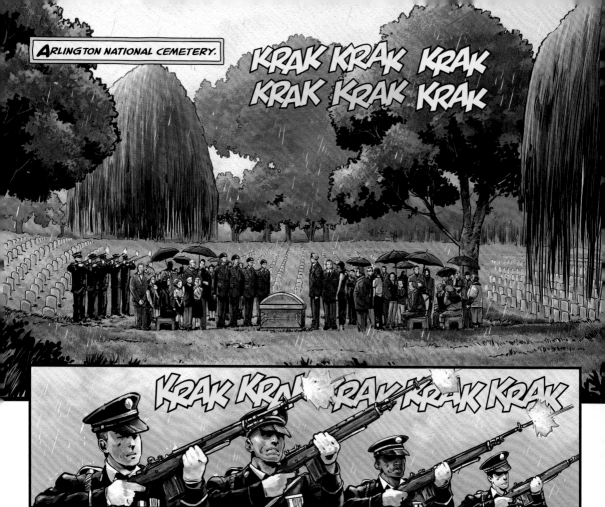

ARLINGTON NATIONAL CEMETERY.

KRAK KRAK KRAK
KRAK KRAK KRAK

KRAK KRAK KRAK KRAK KRAK

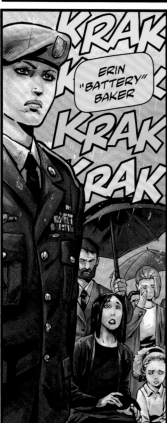

KRAK

ERIN "BATTERY" BAKER

KRAK KRAK

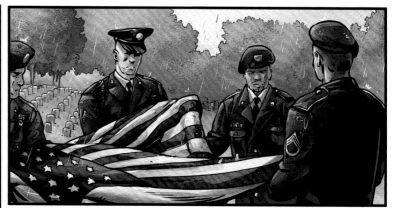

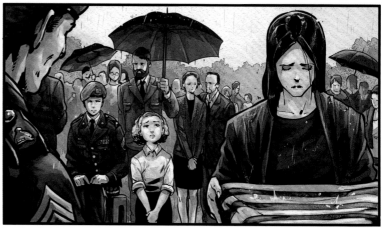

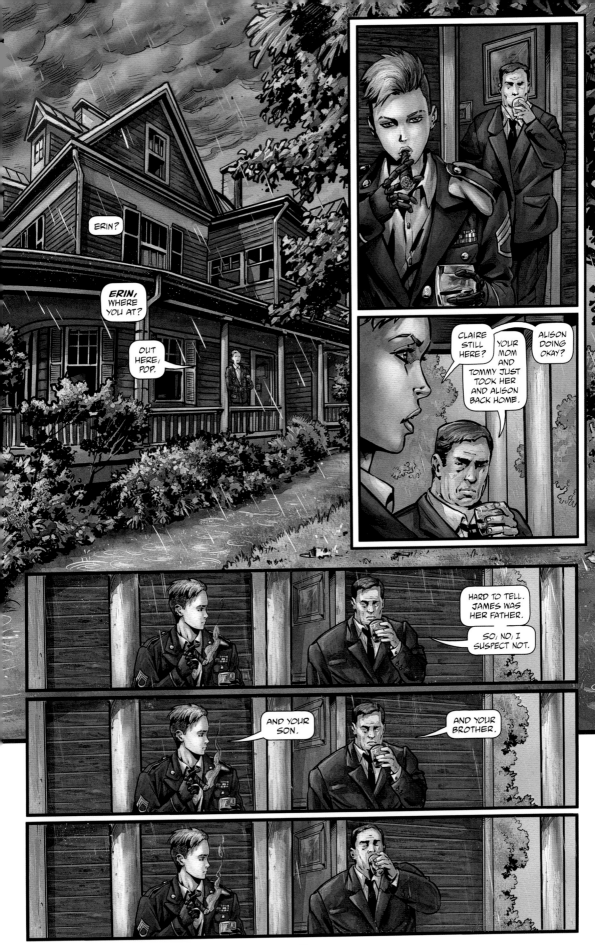

ERIN?

ERIN, WHERE YOU AT?

OUT HERE, POP.

CLAIRE STILL HERE?

YOUR MOM AND TOMMY JUST TOOK HER AND ALISON BACK HOME.

ALISON DOING OKAY?

HARD TO TELL. JAMES WAS HER FATHER.

SO, NO, I SUSPECT NOT.

AND YOUR SON.

AND YOUR BROTHER.

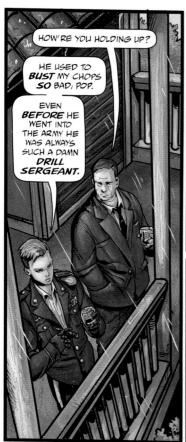

HOW'RE YOU HOLDING UP?

HE USED TO **BUST** MY CHOPS **SO** BAD, POP.

EVEN **BEFORE** HE WENT INTO THE ARMY HE WAS ALWAYS SUCH A DAMN **DRILL SERGEANT.**

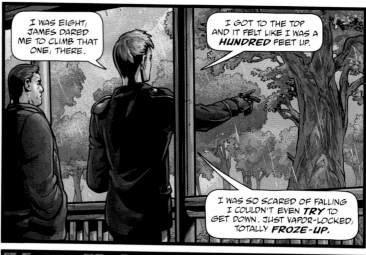

I WAS EIGHT, JAMES DARED ME TO CLIMB THAT ONE, THERE.

I GOT TO THE TOP AND IT FELT LIKE I WAS A **HUNDRED** FEET UP.

I WAS SO SCARED OF FALLING I COULDN'T EVEN **TRY** TO GET DOWN. JUST VAPOR-LOCKED, TOTALLY **FROZE-UP.**

HE TRIED **EVERYTHING**--COAXING, BULLYING, EVEN **THREW** THINGS AT ME, TRYING TO GET ME DOWN.

COULDN'T **BUDGE** ME.

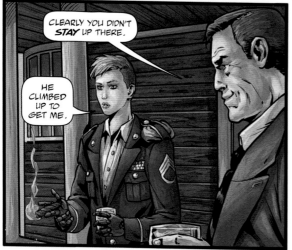

CLEARLY YOU DIDN'T **STAY** UP THERE.

HE CLIMBED UP TO GET ME.

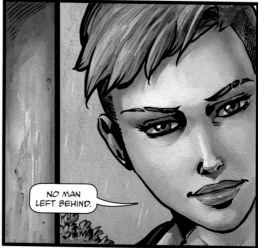

NO MAN LEFT BEHIND.

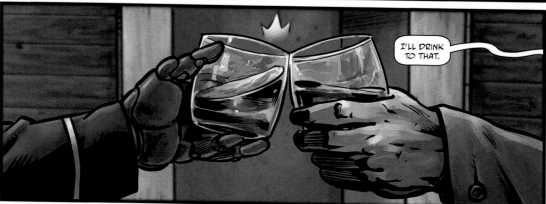

I'LL DRINK TO THAT.

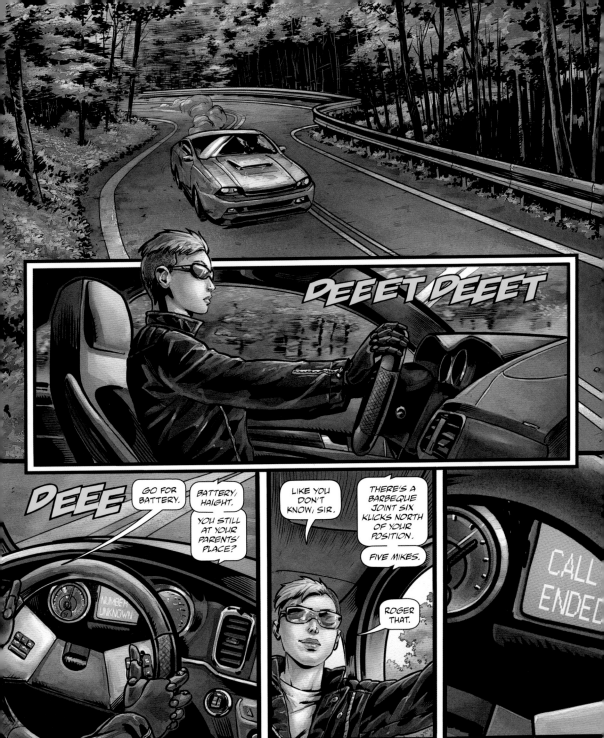

DEEET DEEET

DEEE

GO FOR BATTERY.

BATTERY, HAIGHT.

YOU STILL AT YOUR PARENTS' PLACE?

LIKE YOU DON'T KNOW, SIR.

THERE'S A BARBEQUE JOINT SIX KLICKS NORTH OF YOUR POSITION.

FIVE MIKES.

ROGER THAT.

NUMBER UNKNOWN

CALL ENDED

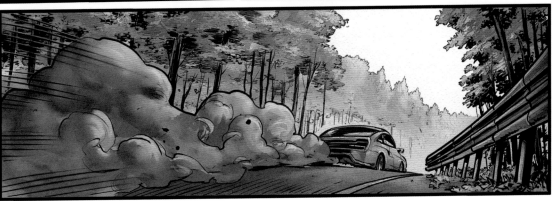

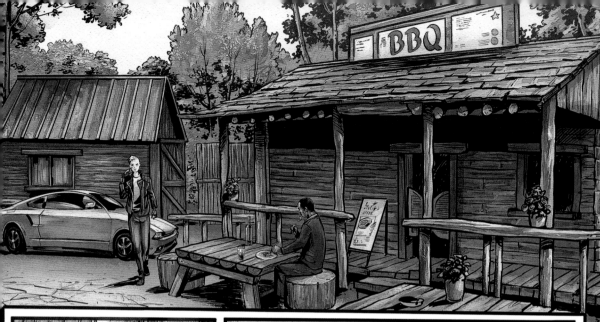

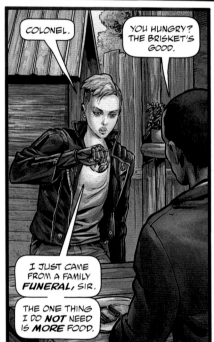

COLONEL.

YOU HUNGRY? THE BRISKET'S GOOD.

I JUST CAME FROM A FAMILY *FUNERAL*, SIR.

THE ONE THING I DO *NOT* NEED IS *MORE* FOOD.

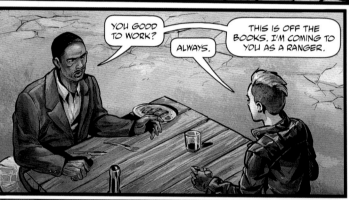

YOU GOOD TO WORK?

ALWAYS.

THIS IS OFF THE BOOKS. I'M COMING TO YOU AS A RANGER.

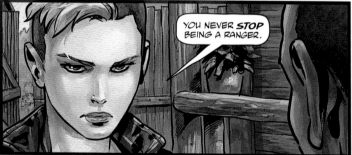

YOU NEVER *STOP* BEING A RANGER.

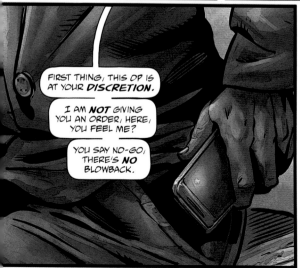

FIRST THING, THIS OP IS AT YOUR *DISCRETION.*

I AM *NOT* GIVING YOU AN ORDER, HERE, YOU FEEL ME?

YOU SAY NO-GO, THERE'S *NO* BLOWBACK.

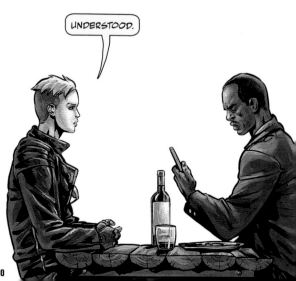

UNDERSTOOD.

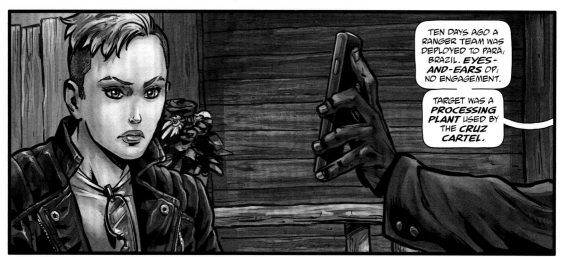

TEN DAYS AGO A RANGER TEAM WAS DEPLOYED TO PARÁ, BRAZIL. *EYES-AND-EARS* OP, NO ENGAGEMENT.

TARGET WAS A *PROCESSING PLANT* USED BY THE *CRUZ CARTEL*.

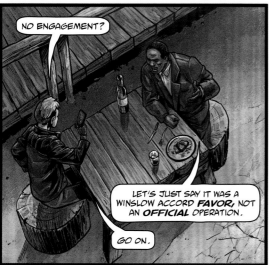

NO ENGAGEMENT?

LET'S JUST SAY IT WAS A WINSLOW ACCORD *FAVOR*, NOT AN *OFFICIAL* OPERATION.

GO ON.

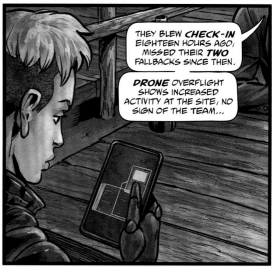

THEY BLEW *CHECK-IN* EIGHTEEN HOURS AGO, MISSED THEIR *TWO* FALLBACKS SINCE THEN.

*DRONE* OVERFLIGHT SHOWS INCREASED ACTIVITY AT THE SITE, NO SIGN OF THE TEAM...

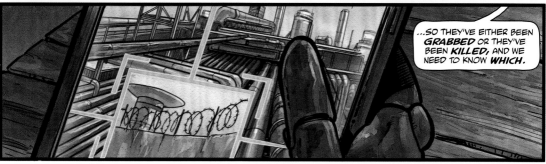

...SO THEY'VE EITHER BEEN *GRABBED* OR THEY'VE BEEN *KILLED*, AND WE NEED TO KNOW *WHICH*.

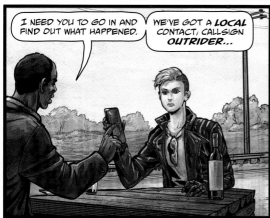

I NEED YOU TO GO IN AND FIND OUT WHAT HAPPENED.

WE'VE GOT A *LOCAL* CONTACT, CALLSIGN *OUTRIDER*...

...YOU'LL MEET HER IN RIO, SHE'LL GET YOU UP TO PARÁ, GIVE YOU THE LAY OF THE LAND.

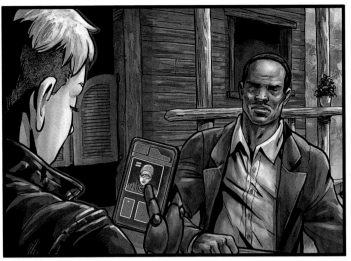

SOUNDS LIKE A GOOD TIME. WHAT'RE MY **RULES** OF **ENGAGEMENT**?

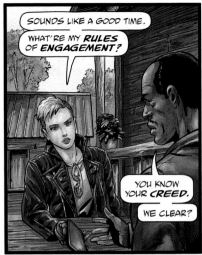

YOU KNOW YOUR **CREED**.

WE CLEAR?

AS GLASS. WHEN DO I **LEAVE**?

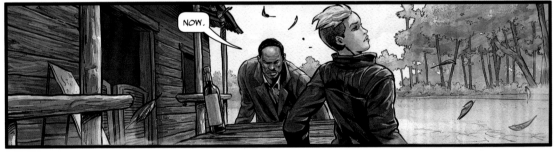

NOW.

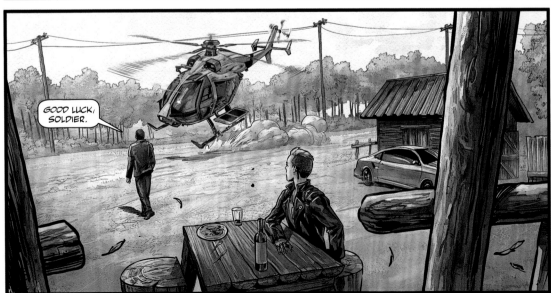

GOOD LUCK, SOLDIER.

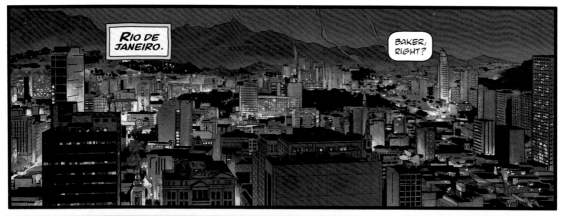

RIO DE JANEIRO.

BAKER, RIGHT?

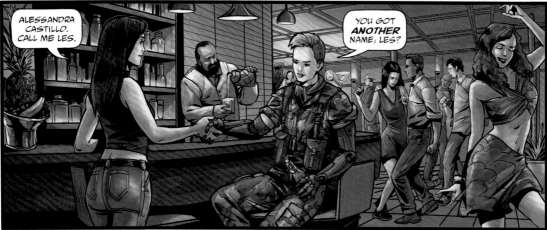

ALESSANDRA CASTILLO. CALL ME LES.

YOU GOT *ANOTHER* NAME, LES?

OUTRIDER.

BATTERY.

*Mhm.* THAT BECAUSE YOU'RE SO *FULL* OF *POWER?*

NAH...

...MORE LIKE *ASSAULT* AND.

NO TIME TO SIT AROUND.

LET'S ROLL.

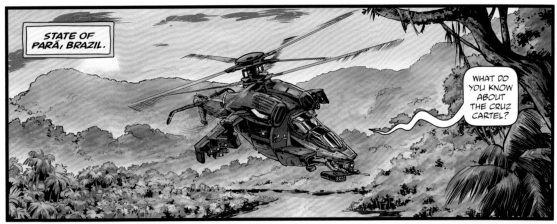

STATE OF PARÁ, BRAZIL.

WHAT DO YOU KNOW ABOUT THE CRUZ CARTEL?

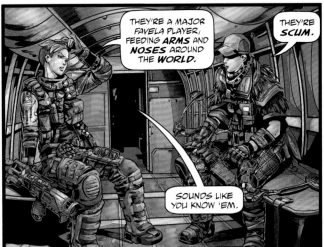

THEY'RE A MAJOR FAVELA PLAYER, FEEDING **ARMS** AND **NOSES** AROUND THE **WORLD**.

THEY'RE **SCUM**.

SOUNDS LIKE YOU KNOW 'EM.

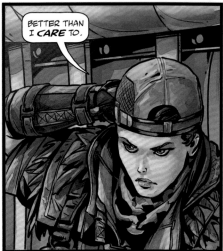

BETTER THAN I **CARE** TO.

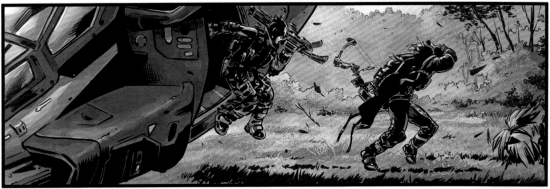

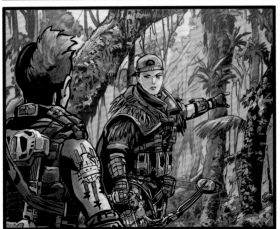

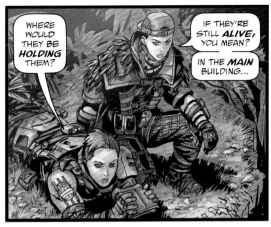

WHERE WOULD THEY BE **HOLDING** THEM?

IF THEY'RE STILL **ALIVE,** YOU MEAN?

IN THE **MAIN** BUILDING...

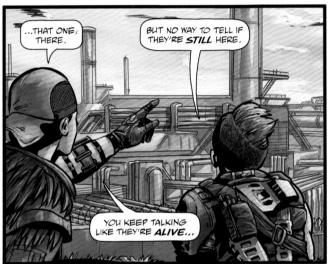

...THAT ONE, THERE.

BUT NO WAY TO TELL IF THEY'RE **STILL** HERE.

YOU KEEP TALKING LIKE THEY'RE **ALIVE**...

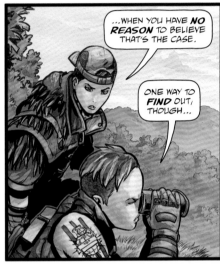

...WHEN YOU HAVE **NO REASON** TO BELIEVE THAT'S THE CASE.

ONE WAY TO **FIND** OUT, THOUGH...

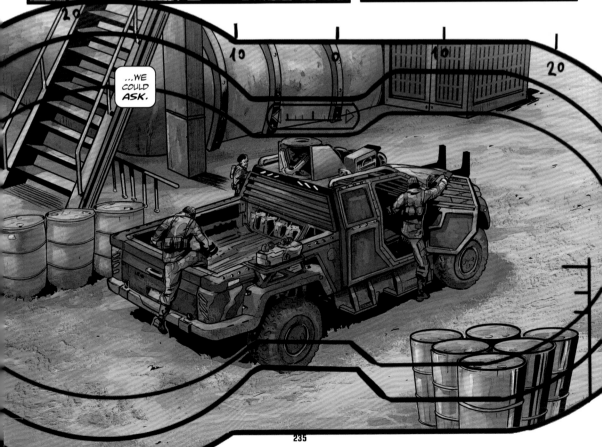

...WE COULD **ASK.**

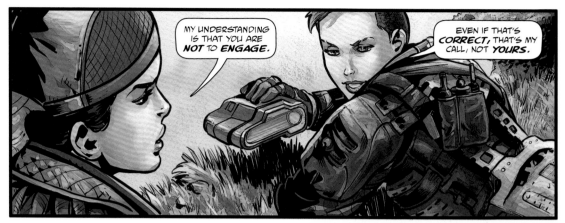

MY UNDERSTANDING IS THAT YOU ARE **NOT** TO **ENGAGE.**

EVEN IF THAT'S **CORRECT,** THAT'S MY CALL, NOT **YOURS.**

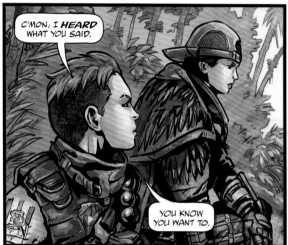

C'MON, I **HEARD** WHAT YOU SAID.

YOU KNOW YOU WANT TO.

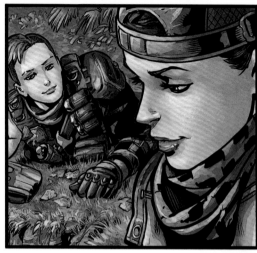

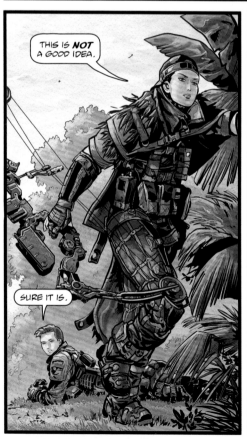

THIS IS **NOT** A GOOD IDEA.

SURE IT IS.

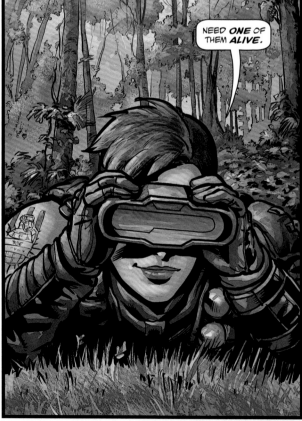

NEED **ONE** OF THEM **ALIVE.**

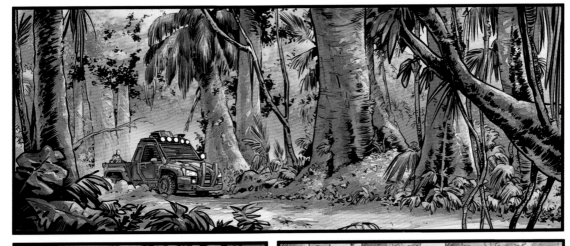

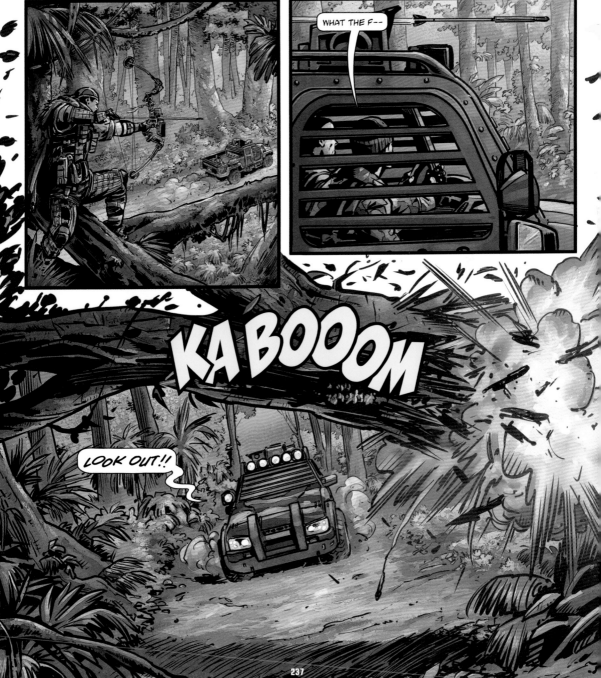

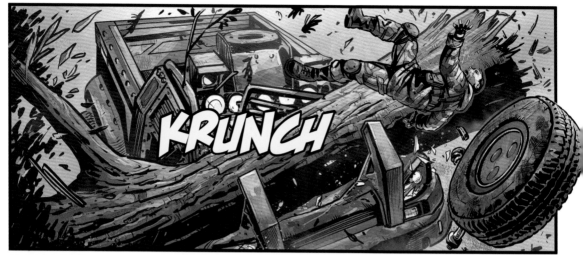

KRUNCH

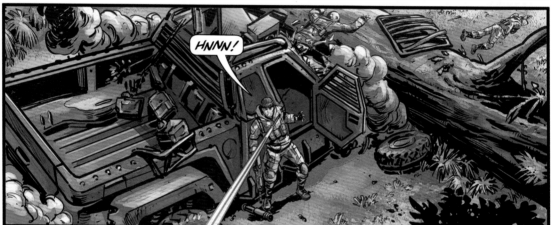

HNNN!

TOO BAD FOR YOU...

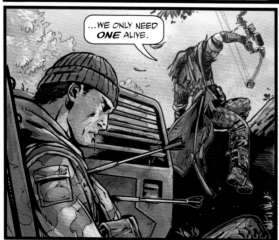

...WE ONLY NEED **ONE** ALIVE.

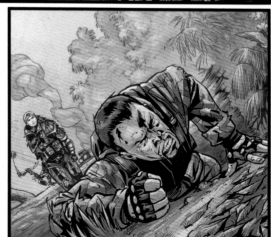

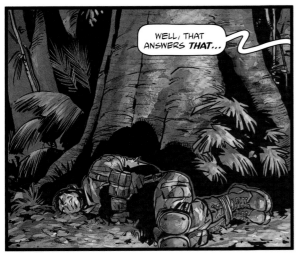

WELL, THAT ANSWERS *THAT*...

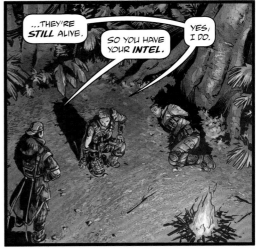

...THEY'RE *STILL* ALIVE.

SO YOU HAVE YOUR *INTEL*.

YES, I DO.

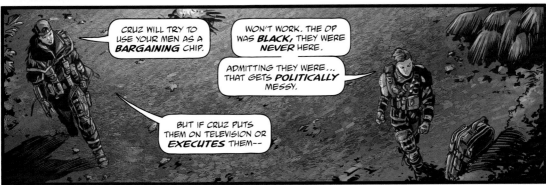

CRUZ WILL TRY TO USE YOUR MEN AS A *BARGAINING* CHIP.

WON'T WORK. THE OP WAS *BLACK*, THEY WERE *NEVER* HERE.

ADMITTING THEY WERE... THAT GETS *POLITICALLY* MESSY.

BUT IF CRUZ PUTS THEM ON TELEVISION OR *EXECUTES* THEM--

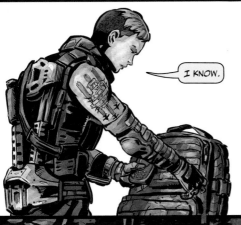

I KNOW.

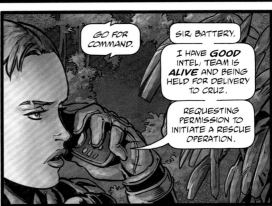

GO FOR COMMAND.

SIR, BATTERY.

I HAVE *GOOD* INTEL, TEAM IS *ALIVE* AND BEING HELD FOR DELIVERY TO CRUZ.

REQUESTING PERMISSION TO INITIATE A RESCUE OPERATION.

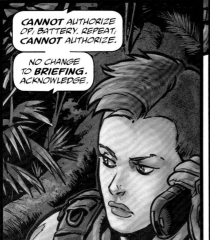

*CANNOT* AUTHORIZE OP, BATTERY. REPEAT, *CANNOT* AUTHORIZE.

NO CHANGE TO *BRIEFING*. ACKNOWLEDGE.

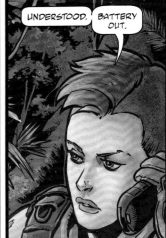

UNDERSTOOD.

BATTERY OUT.

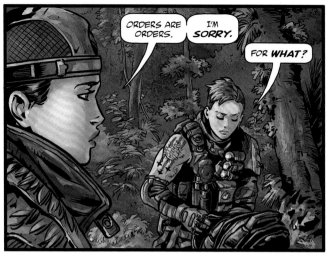

ORDERS ARE ORDERS.

I'M *SORRY.*

FOR *WHAT?*

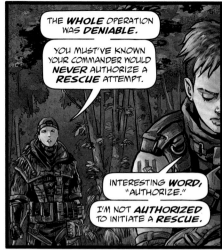

THE *WHOLE* OPERATION WAS *DENIABLE.*

YOU MUST'VE KNOWN YOUR COMMANDER WOULD *NEVER* AUTHORIZE A *RESCUE* ATTEMPT.

INTERESTING *WORD,* "AUTHORIZE."

I'M NOT *AUTHORIZED* TO INITIATE A *RESCUE.*

THAT'S *NOT* THE SAME AS HIM TELLING ME *NOT* TO DO IT. *HE* KNOWS THAT AS WELL AS I DO.

IT'S WHY HE SENT *ME* IN THE FIRST PLACE.

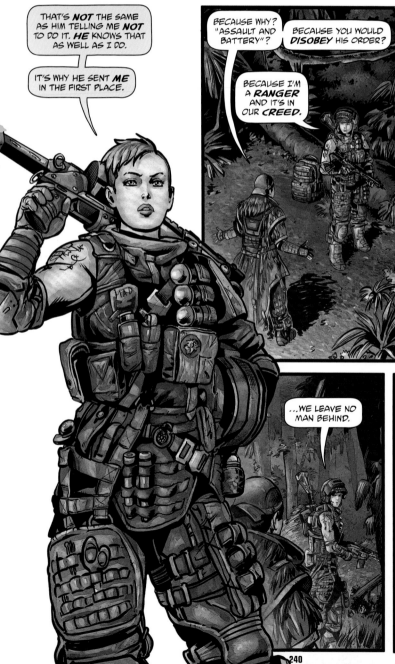

BECAUSE WHY? "ASSAULT AND BATTERY"?

BECAUSE YOU WOULD *DISOBEY* HIS ORDER?

BECAUSE I'M A *RANGER* AND IT'S IN OUR *CREED.*

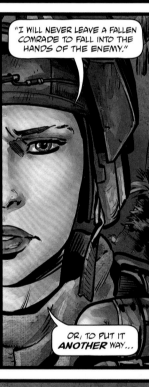

"I WILL NEVER LEAVE A FALLEN COMRADE TO FALL INTO THE HANDS OF THE ENEMY."

OR, TO PUT IT *ANOTHER* WAY...

...WE LEAVE NO MAN BEHIND.

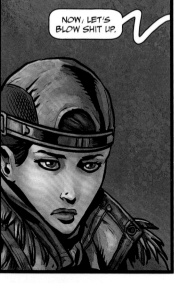

NOW, LET'S BLOW SHIT UP.

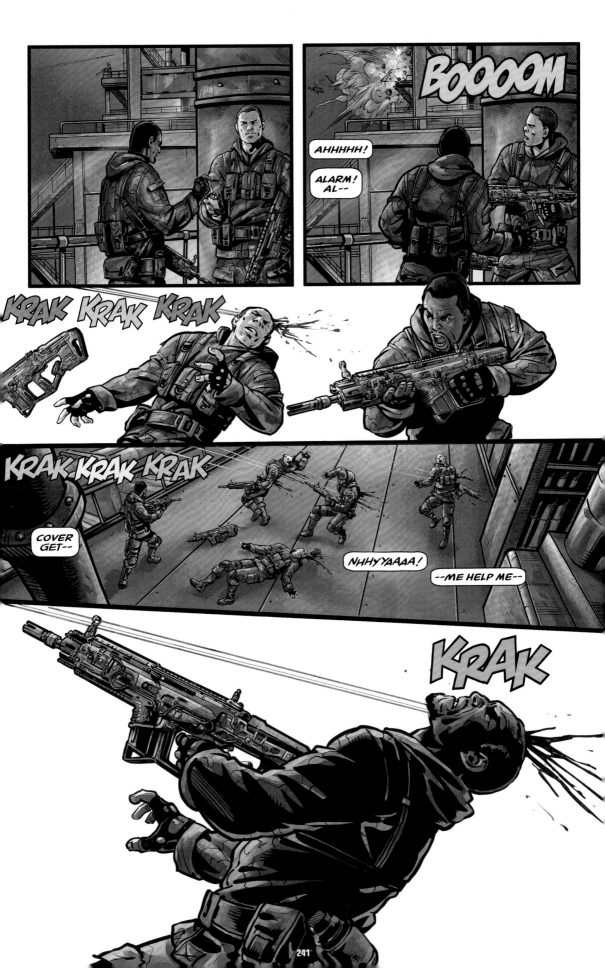

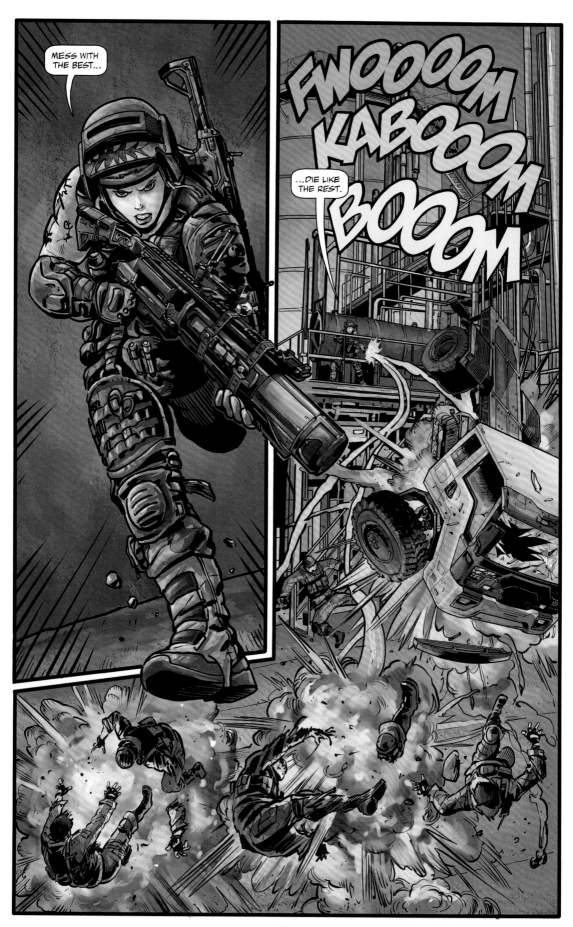

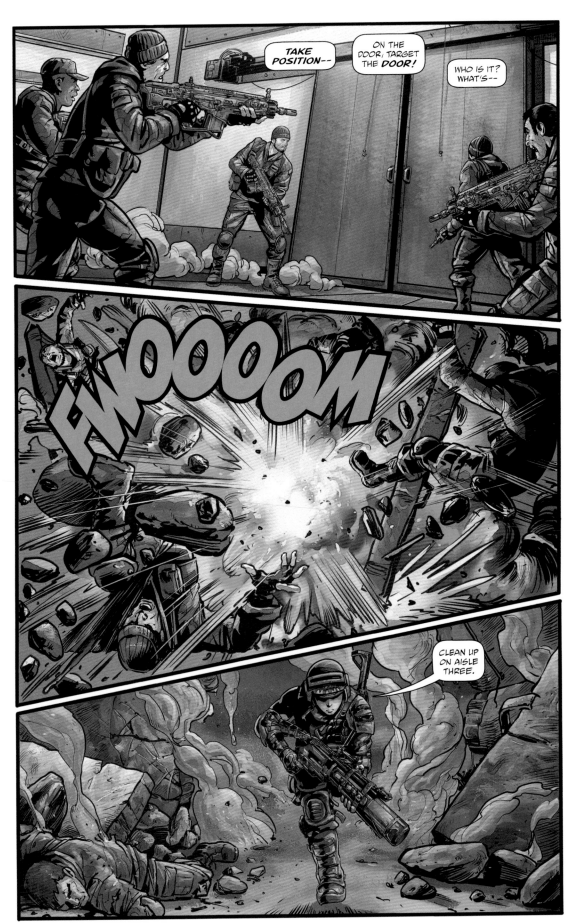

CHAK CHAK
CHAK CHAK

TING PWING
TAK

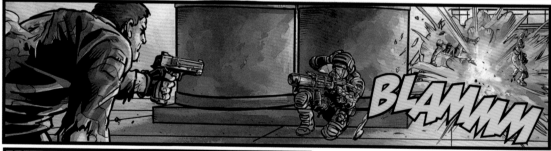

CHAK CHAK CHAK CHAK CHAK

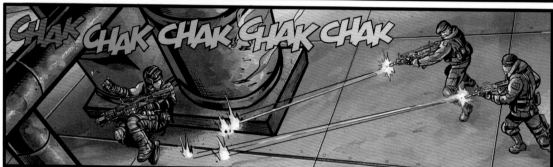

CHAK CHAK CHAK
CHAK

TING PAK SPAK TK

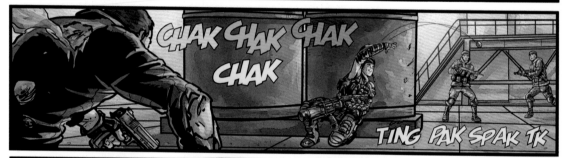

BLAMMM

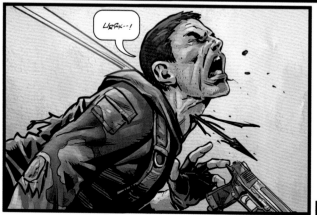

URAK--!

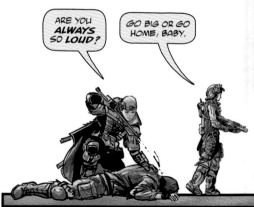

ARE YOU *ALWAYS* SO *LOUD*?

GO BIG OR GO HOME, BABY.

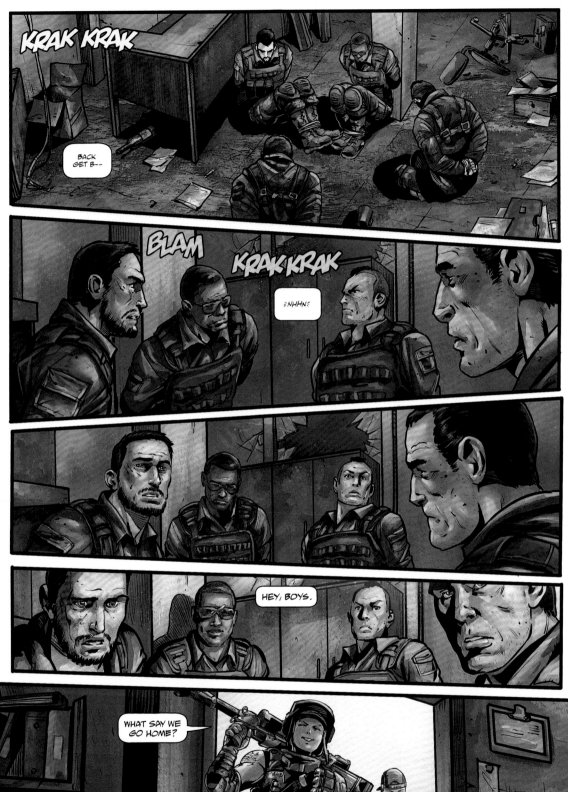
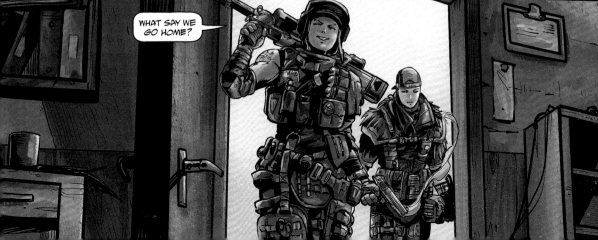

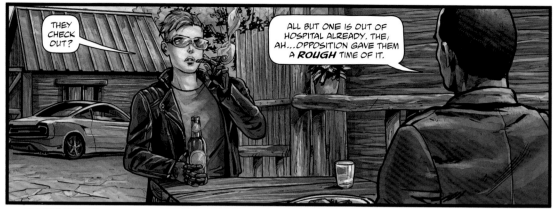

THEY CHECK OUT?

ALL BUT ONE IS OUT OF HOSPITAL ALREADY. THE, AH...OPPOSITION GAVE THEM A *ROUGH* TIME OF IT.

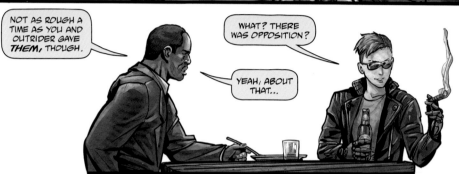

NOT AS ROUGH A TIME AS YOU AND OUTRIDER GAVE *THEM,* THOUGH.

WHAT? THERE WAS OPPOSITION?

YEAH, ABOUT THAT...

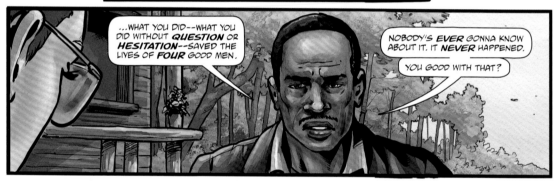

...WHAT YOU DID--WHAT YOU DID WITHOUT *QUESTION* OR *HESITATION*--SAVED THE LIVES OF *FOUR* GOOD MEN.

NOBODY'S *EVER* GONNA KNOW ABOUT IT. IT *NEVER* HAPPENED.

YOU GOOD WITH THAT?

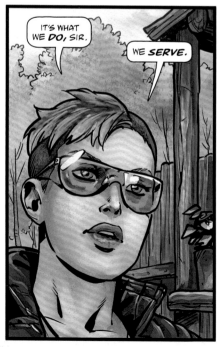

IT'S WHAT WE *DO,* SIR.

WE *SERVE.*

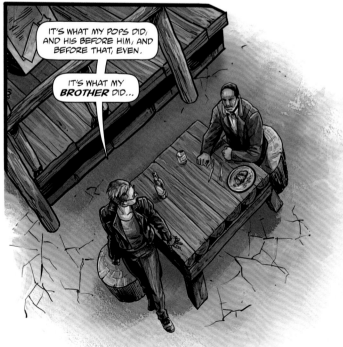

IT'S WHAT MY POPS DID, AND HIS BEFORE HIM, AND BEFORE THAT, EVEN.

IT'S WHAT MY *BROTHER* DID...

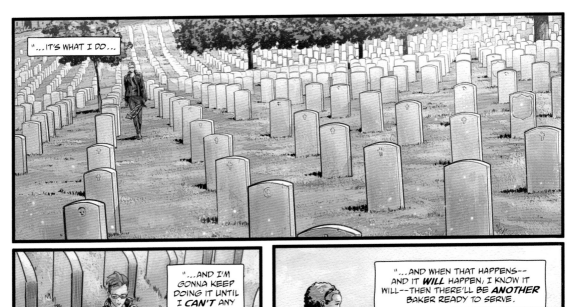

"...IT'S WHAT I DO..."

"...AND I'M GONNA KEEP DOING IT UNTIL I **CAN'T** ANY LONGER...

"...AND WHEN THAT HAPPENS-- AND IT **WILL** HAPPEN, I KNOW IT WILL--THEN THERE'LL BE **ANOTHER** BAKER READY TO SERVE.

JAMES BAKER

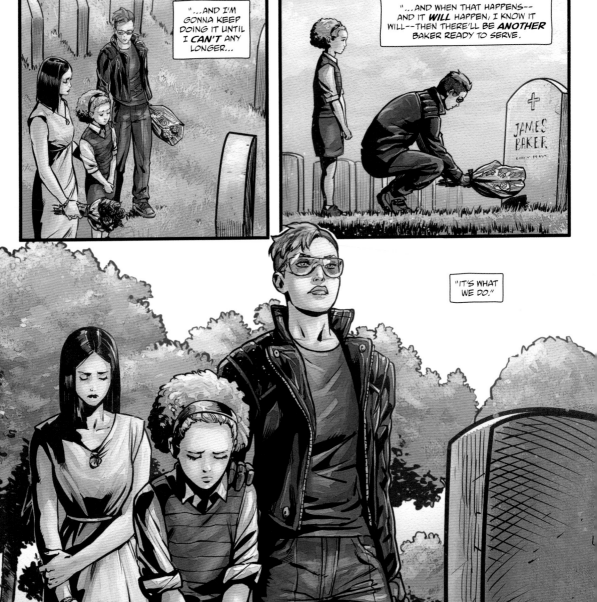

"IT'S WHAT WE DO."

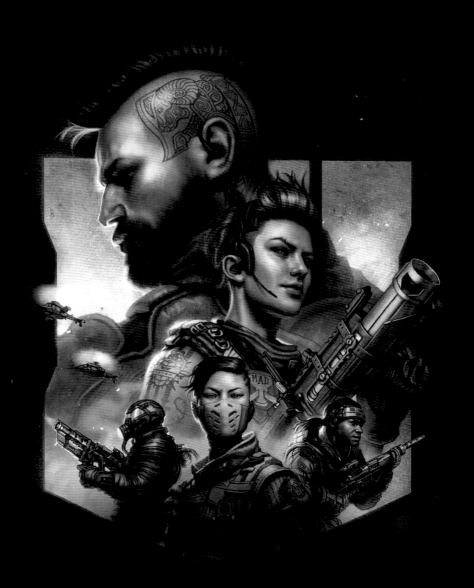